survive
&thrive™

Capture, Create and Share
Digital Movies

Gateway
PRESS™

Welcome

From introducing Digital Video in Chapter 1 through troubleshooting in Chapter 11, *Capture, Create and Share Digital Movies*, provides you with what you need to know to turn home movies into masterpieces. This product is designed to accommodate your learning style, and to make learning easy, interesting, and fun. You can stick to just the bare essentials or learn in greater depth by practicing key skills and applying your new knowledge. Our goal is to show you how technology can enhance your life, provide some fun, and open up new opportunities.

More Than a Book

Capture, Create and Share Digital Movies is more than a book; it is a blended learning system that also includes an interactive CD-ROM, Internet presentations, and activities. These tools all work together to provide a truly unique learning experience. The book presents technical information in visual, practical, and understandable ways. The CD-ROM extends the book by providing audio, video, and animated visuals of important concepts. Continue learning online by logging on to www.LearnwithGateway.com. The enrollment key provided with this book gives you access to additional content and interactive exercises, as well as reference links, Internet resources, and Frequently Asked Questions (FAQs) with answers. This Web site allows us to keep you updated on rapidly changing information and new software releases.

Classroom Learning

In addition, a hands-on training course is offered. Additional fees may apply. Our classes are ideal solutions for people who want to become knowledgeable and get up and running in just three hours. They provide the opportunity to learn from one of our experienced and friendly instructors and practice important skills with other students. Call 888-852-4821 for enrollment information. One of our representatives will assist you in selecting a time and location that is convenient for you. If applicable, please have your Gateway customer ID and order number ready when you call. Please refer to your Gateway paperwork for this information.

Learning map for
Capture, Create and Share
Digital Movies

This map shows how the elements of the Gateway System works for you. The best of an easy to understand, highly visual book, the Internet and CD-ROM are all brought together to give you a unique and truly enjoyable learning experience. Notice how the interactive CD-ROM and Internet activities extend and complement the chapters in the book. Icons in the book will direct you to each element at the proper time.

Nature of Sound

Sound Elements in Video

Microphones

CHAPTER

Digital Video Possibilities

Taking Great Videos

Planning a Video

Lighting Fundamentals

Lighting Techniques

CHAPTER

Digital Video Camera Features

CHAPTER

Storage Options

Video Camera: Connecting to a Computer

CHAPTER

CHAPTER

Adding Text and Still Images

CHAPTER

Adding Music, Voiceover, and Sound Effects

SEVEN

Video Project Editing

Video Hard Drive Transfer

FOUR

Shooting Great Video

THREE

Computer and Camcorder Basics

TWO

Digital Video Basics

CHAPTER

Introducing Digital Video

ONE

FIVE

Pinnacle Studio 8 Introduction

Capturing Video

Change Clip Properties Tool: Using

Scenes: Trimming

Scenes: Splitting

Transitions: Adding

SIX

Frame Grabber Utility: Using

Text: Adding to Movies

Title/Menu Editor User Interface

Music: Adding to Movies

Voiceover: Creating Background Music

Trim Audio: Tool Using

You can also take a Gateway class, and this is an ideal way to continue to expand your learning. Gateway instructors are dedicated to working with each individual and answering all your questions. You will be able to talk with other learners, practice important skills, and get off to a quick start. Additional fees may apply.

Call 888-852-4821 to enroll.

See you in class!

Contents

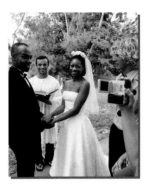

Contents

Contents

How To Use This Book

As you read the chapters in this book, you'll find pictures, figures, and diagrams to help reinforce key ideas and concepts. You'll also find numerous pictures, or icons, that serve as cues to flag important information or provide directions. Here is a guide to help you understand the icons you'll encounter in this book:

 A Note identifies a relatively important piece of information that will make things easier or faster for you to accomplish on your PC. Most notes are worth reading, if only for the time and effort they can save you.

 A Warning gives notice that an action on your PC can have serious consequences and could lead to loss of work, delays, or other problems. Our goal is not to scare you, but to steer you clear of potential sources of trouble.

 The CD-ROM flags additional materials including exercises and animations that you will find on the CD-ROM included with this book. Because some materials work better on your PC than in print, we've included many activities and exercises. These help you become more familiar with your system while practicing important skills.

 Because PC information and online resources are so dynamic, some material related to this book, including Web-based training, resides on the **www.LearnwithGateway.com** Web site. This allows us to keep that information fresh and up to date.

 The *Survive & Thrive* series includes several books on topics from digital music to the Internet. Where other titles can be useful in improving and expanding your learning, we use the Book icon to draw those titles to your attention.

 Gateway offers a hands-on training course on many of the topics covered in this book. Additional fees may apply. Call 888-852-4821 for enrollment information. If applicable, please have your customer ID and order number ready when you call.

You'll find sidebar information sprinkled throughout the chapters, as follows:

More About . . .

The More About . . . information is supplementary, and is provided so you can learn more about making technology work for you. Feel free to skip this material during your first pass through the book, but please return to it later.

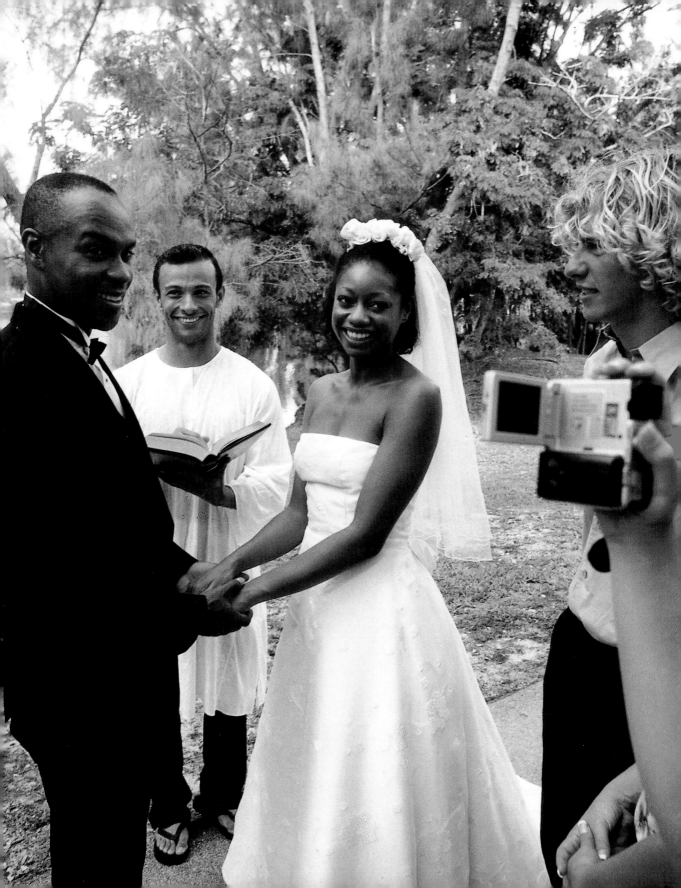

Introducing Digital Video

Welcome to Digital Video! This chapter gets you started with digital movie making. You will learn the basics of building a video project, from still images to using audio, using digital video creative tools. You will learn how to transfer video from your camera to your computer and what is involved when creating titles, transitions, voiceovers, and special effects like a pro.

Included is a discussion on digital video technology basics, how your camcorder works, and how it differs from VHS and other predecessors. You will discover what it takes to shoot excellent video, taking into consideration both technical and environmental factors. You will also know how to safely store your videos and resulting projects, as well as share your video with the world.

Digital video combines the magic of moviemaking with the power and convenience of digital technology. The entire world of movie creation is at your fingertips.

Much of what you see on TV or at the movies you can now do yourself. With a digital camcorder, fairly powerful computer, and video editing software like Pinnacle® Studio or Ulead® VideoStudio,® you can create just about any visual effect or film you can imagine. With a digital camera, you can put your favorite uncle on top of Mount Everest, but with digital video, you can show him climbing to the top.

Getting Creative with Digital Video

Your goal is not merely to shoot video, but to move it to your computer for customized editing and distribution. Video footage from your camcorder is like clay in your hands ready to be shaped into a finished product: You can change and rearrange scene sequences as you like and eliminate parts you don't like. Movie segments can also be reused in your project. For example, if you have a scene that you would like to appear repeatedly before other footage, simply copy and paste it, as shown in Figure 1-1.

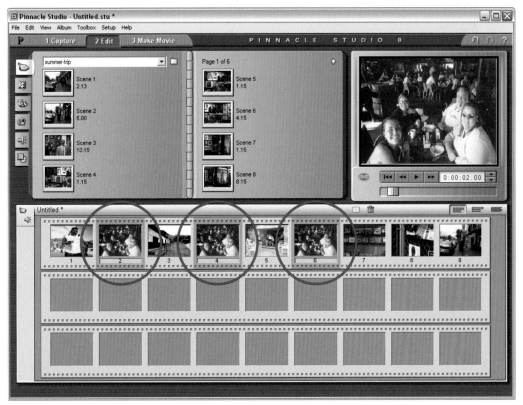

Figure 1-1
With video editing software, you can easily insert multiple copies of a video clip into a new movie project.

Depending on how elaborate your plans are, shooting video footage may be only step one in the creative process. Here are just a few examples of what you can do with your digital video. Note that all of these projects involve first transferring video from camcorder to computer. Once you've done that, you can:

✦ Add titles or text to your footage (Figure 1-2).

Figure 1-2 Adding text to video.

✦ Tighten your movie by cutting some of the boring or uninteresting frames.

✦ Color-correct your movie, for example, brightening some of the dark parts and adding color depth to the segments that look washed out (Figure 1-3).

Figure 1-3
Dark and brightened video side-by-side.

✦ Create an elaborate video project involving many types of media elements.

Digital Video Editing Steps and Stages

Digital video editing is a series of sequential tasks. Whether you are placing your home movies online, or developing a million-dollar video project, your basic workflow will be similar. For all video projects, here are the basic digital video development steps:

❶ **Shooting.** You must first shoot your video. Keep in mind that if you will be editing your footage on a computer, then you don't have to shoot it in sequence.

❷ **Transferring.** You must upload your video to your computer. This process involves hardware, cabling, playing with wires, and having both your camcorder and computer up and running at the same time.

❸ **Editing.** Now for the fun part, once your footage is on the computer, you can cut, trim, rearrange scenes, add multimedia elements of all types, and bring your project to reality.

❹ **Project output.** Now you must determine how your audience will view your finished product. Are your movies destined for the Web? Will you send it using e-mail or package it on DVD?

❺ **Storage and archiving.** When your project is complete, you will need to store it in a manner that is safe and accessible.

More About...Storing and Archiving

To keep your video for posterity, you have some options. You may want to archive your original footage, your project files, your finished work, or all of the above. You can store any of these on MiniDV copies, your computer's hard drive, CD, or DVD. The question is what to store and where. Since you will already have your original footage on MiniDV, it's good practice to keep that tape archived for later use. You can also archive your project files and finished video on MiniDV, CD, or DVD, or just keep everything on your hard drive. While using your hard drive as a main means of storage is easy and easily accessible, it is also the least reliable, since, unlike permanent media such as tape, CD, or DVD, hard drives can fail. Depending on your equipment, the choice is yours.

Developing a Video Project

A video project is the result of making your video as watchable and compelling to watch as possible. Here are examples of what you can include in your video.

Your Video Footage

Once you shoot your video, you will view it and quickly realize some segments are better than others. Your video project could include trimmed-down clips that retain only what you want to show. For example, if you've shot footage of a race, you don't need to show the whole race from start to finish. You might want to focus on just the key parts, such as

the starting rush of the race, the neck-and-neck competition of the runners, the break away, and the finish line.

Your video is a story. In fact, most video editing software facilitates showing a story. The workspace where you lay out and sequence video clips is called the Storyboard. As shown in Microsoft® Movie Maker in Figure 1-4, each frame represents a few seconds or perhaps a few minutes of footage, which is essentially one segment of an unfolding story or narrative.

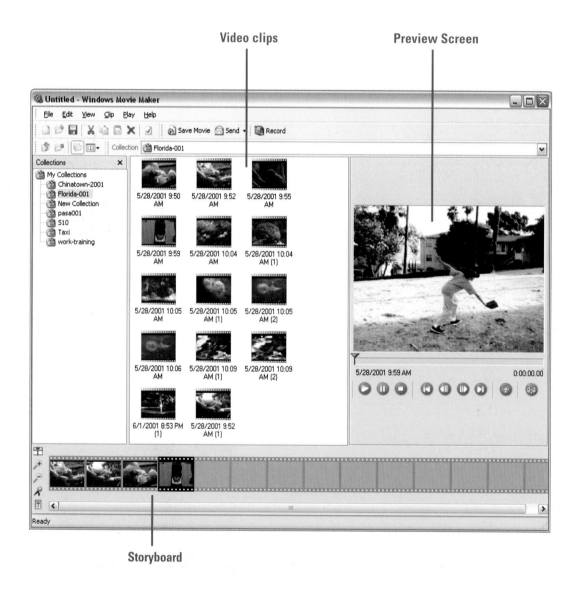

Figure 1-4

Video clips arranged in the Microsoft Movie Maker Storyboard view.

Text and Titles

You can add headings, titles, scrolling credits, thought bubbles, or all kinds of text to your video project. Text can scroll from the top down like credits at the end of a movie, fade while in place, or just remain stationary. Most video editing programs come with text creation tools that let you do all kinds of interesting things with words.

Transitions

Transitions determine how one video clip—whether it's a single frame or several minutes of video—will fade into the next (Figure 1-5). You can choose a simple fade, a swipe, or have the first clip fly to the left or right while the second clip appears, or any number of sweeps and spins.

Figure 1-5 A video transition

Most digital video editing programs come with dozens of transitions, but clever transitions can grow tiresome. Most professional movies use simple fades since geometric transitions tend to distract.

Still Images

Not everything in a video project needs to be set in motion. Still images can be used to contrast the video movement. You can weave a single frame or an image into your video, or overlay the video (like Picture-In-Picture on a television) so that it appears atop the still image, as shown in Figure 1-6. Where will you get these images? More than likely, your digital camcorder can shoot still images. You can also employ still images from other sources such as stock photography, scanned pictures from your own collection, artwork from a digital art program, or shots from a digital camera.

Figure 1-6 A video clip appears inside a still image.

Sounds, Music and Voiceovers

One of the most underutilized benefits of digital video is the easy inclusion of high-quality sound. To obtain the best sound through your camcorder, try using an external microphone to improve sound quality or add music from a digital audio source such as CD or DVD. Once your video has been uploaded to your computer and ready for editing, depending on your software, you can add nearly unlimited amounts of audio (Figure 1-7). Digital editing software comes with plenty of sound effects such as explosions, crashes, and musical moments. Note that these software programs let you synchronize sounds and video with exact precision.

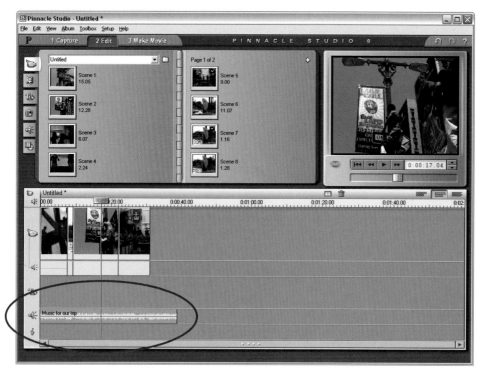

Figure 1-7

Adding music and sound tracks using your video editor is an important part of almost any video project.

Movie Effects

Digital video editing programs come with many types of special effects. You can add motion blur, add particles that resemble snow or rain, make your movie look like a painting, or dramatically alter the movie's colors (Figure 1-8). Some special effects are less flamboyant and are used instead to fix video problems that were shot in imperfect lighting conditions. You can, for example, brighten up dark footage, remove colorcasts, or restore color to video that was shot in direct sunlight.

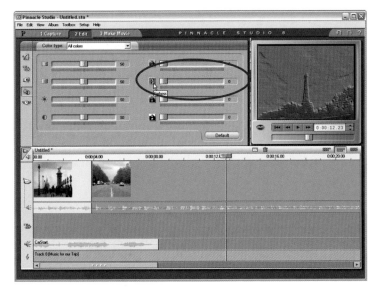

Figure 1-8 Applying special effects to a video clip.

Hyperlinks and Other Web-based Features

If you're designing Web pages, it's easy to include video. You can link your videos with online menus (Figure 1-9), format and optimize video especially for online viewing, and create unique backgrounds that include images and other Web elements.

Figure 1-9 A Web page with links to video clips.

Understanding Analog vs. Digital Video

TV and film are attempts to realistically capture and record what we see and hear. Creating a world that simulates our visual and audio experiences is a huge job. Let's talk for a moment about the technology that initially brought us this form of entertainment, how it mirrors the way our eyes and ears work, and the transition to the digital world.

The digital camcorder you carry in the palm of your hand is actually a portable TV studio. Not long ago, a roomful of electronic gear was required to accomplish what you can do with a few buttons and menus. You will now get a glimpse of how all of this came to be so brilliantly miniaturized.

The World of Analog

The medium of film, as well as TV, captures light and sound as it fluctuates along a wave (Figure 1-10). Changes in light intensity and brightness and sound wave amplitude and frequency are recorded along a continuum. Even subtle fluctuations are converted to changes in electrical voltage and recorded on tape or other analog medium. This is known as analog recording.

Figure 1-10
The world we perceive through our eyes is analog.

Our eyes and ears are also analog. We perceive light—as well as sound—through waves. These waves are different sizes, or amplitudes, and vibrate at different speeds, or frequencies. Our eyes process changes in color and brightness very quickly, thus we are able to see millions of color shades. Similarly, our ears detect sound waves, and our brains process an huge array of volume and timbre combinations, distinguishing subtle changes in sound quality and character (Figure 1-11).

Movies and TV undertake a vast challenge to recreate our world onscreen in all its splendor of sound and color. Not surprisingly, movies are very large.

Figure 1-11
We perceive sounds by distinguishing between their wavelike characteristics.

Movies are a series of images—rapid-fire snapshots filmed at 24 frames per second. At about 16 frames per foot of film, a typical movie requires about two miles or 11,000 feet of film. When the projectionist trudges up to the booth at the local movie theatre to provide an evening's entertainment, he's carrying 5 or six heavy reels under his arm.

By contrast, the mini-cassette that records and plays back about an hour's worth of digital video is less than the size of a pack of cards. The computer you can use to professionally edit your movie is fast becoming as much of a household item as a refrigerator. So how did video get small enough to edit on our own computers? By compressing the video data.

The Need to Compress Video

Even a few years ago, consumer-level computers could not edit and distribute a five minute digital home movie without considerable upgrades. Camcorders capable of professional results were pretty much the domain of professionals. To bring this capability to your fingertips, video data would have to become digital which would reduce space requirements considerably and make it possible to edit video on a computer. But there's more. To make digital video truly portable, so that you can move it from your camcorder to your computer and back again, it would have to be compressed.

Video compression removes as much information as possible from your video, without destroying its quality. There are many types of video compression, and later, as you prepare your video for distribution, you'll be choosing just what type, and how much compression to apply. For example video saved onto DVD uses a compression scheme called MPEG-2.

> ### More About...MPEG
>
> MPEG is a popular compression scheme that dramatically decreases the amount of hard drive space required for digital video. MPEG is an acronym for Moving Picture Experts Group, the committee of experts responsible for its development.

The basic concept of compression is as follows: If you compare one frame of video to its neighbor, there's not much difference. Hold up a reel of film and look at a few frames, and you'll notice how similar most of them look to each other. Watch any given one to

three minute segment of video, and you may notice that the background behind the characters doesn't change all that much. Video compression recalculates the differences in data frame by frame, cutting redundancy and the amount of information required to create a movie. For example, compressing a segment which shows a couple walking in a park toward the camera would cut some frames where the movement is minute and the background scenery hasn't changed at all.

The Changing Face of Television and Video

Television and video technology have changed drastically over the years, and the result is that movies now come in many shapes and sizes. Whether a movie is digital, analog, or a digital/analog hybrid, there are different system formats and standards to allow it to be played the world over.

For instance, in North America, an analog television picture is composed of 30 Frames Per Second (FPS), and is based on the NTSC (National Television System Committee) standard. Japan and other Asian countries also use NTSC. In much of Europe, on the other hand, 25 frames are used, based on the PAL (Phase Alternating Line) standard. France and a handful of other nations have a yet another system, called SECAM (Systeme Electronique Couleur Avec Memoire). To make sure you can create video playable in all formats, your software's output choices will typically include these and other options.

How a Television Works

Inside a TV, electron guns draw a picture, scanning the screen one line at a time. This is called a "scan line."

NTSC and PAL use different numbers of scan lines. NTSC requires that 525 scan lines be used, while PAL uses 625 scan lines.

On the inner back of the TV screen is a phosphorus coating covered with light receptor dots, and each electron gun scans the screen line by line, illuminating the dots with specific light and color information as it moves down and across the screen (Figure 1-12). Thus, a television picture is made.

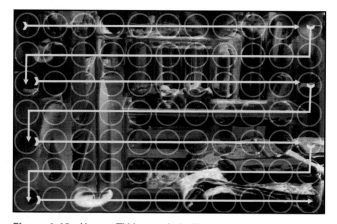

Figure 1-12 How a TV image is built.

In early television technology, however, the image would appear to flicker. This is because the image near the top of the screen would start to dim by the time the electronic gun finished drawing the lines at the bottom.

To fix this problem, the electron gun would have to zip along twice as fast, creating a single TV picture in two passes. In the first pass, the guns would illumine the odd lines (lines 1, 3, 5, and so forth), and in the second pass, illuminate the even lines). Thus, two passes of the gun were required to create one TV frame (one picture). Each pass is called a field, and a single picture is called a frame. And so, to create a seamless TV image (frame) required a technology for weaving these two fields together. This is called interlacing (Figure 1-13).

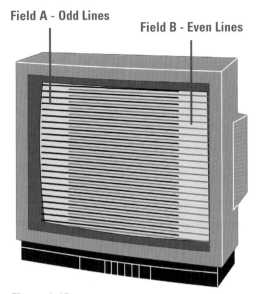

Figure 1-13
TV images are interlaced.

Although digital, your camcorder can accommodate TV, capturing images as lines of resolution (MiniDV tapes, the most common medium for saving digital video, records 500 lines per screen). To make TV compatible video, your camcorder utilizes interlacing. You'll discover this yourself when it comes time to save your video project in its final format for viewing. Interlacing will be one of the options set in your output choices (Figure 1-14).

Figure 1-14
You can save your digital video project in a TV-friendly format.

High-Definition TV

High-Definition TV (HDTV) uses principles similar to a computer monitor, with extra-clear pictures and ultra-high resolution. They can display Progressive Scan broadcast, and accommodate up to 1080 lines of resolution, compared to analog TV's 525 lines. Broadcasters, however, had to find ways to transmit these higher quality pictures using the same bandwidth (6-MGHz) that analog uses. In fact, just like DVD and the computer world, they often compress the signal using MPEG-2, the compression technology referred to previously. If you own a digital TV, you'll probably find it can display Interlaced and Progressive Scan. If your digital picture is flickering, it may be because it requires a bit too much bandwidth (transmission power). Switch to Interlaced and the flickering will stop. The best part is that with a digital camcorder and editing program, you will be able to optimize your video for all types of output options.

In all of this, you can see that digital video, combining the analog science of cameras and TV with the flexibility and power of digital storage, brings you the best of everything.

More About. . . Progressive Scan

Your digital camcorder may have a mode of filming that bypasses the use of interlacing all together, recording individual frames of beautiful, high-resolution video, rather than the TV-friendly, "alternating fields" method. This is usually called Progressive Scan, and is used especially for high-speed action videos that will be played back on a digital medium, such as hard drive playback or DVD.

Why Digital Is Better

Fundamentally, a digital camcorder operates on similar principles as its predecessors. Light is focused through a lens and processes sound through a microphone. The main difference is how clear the footage looks, and how it is saved. Thus, digital video exceeds analog by producing a better image, facilitating easier storage, and also offers a few more advantages.

The Digital Picture

Your digital camcorder can use the same principles to create images that your computer does. Because of how they are made, digital images are generally clearer and have more definition than televised images .

Digital images are created using pixels, which are digital bits of color information, combined to form a single "dot" in your computer image. On your PC, the greater the number of pixels per square inch, the higher quality the image. This is called screen resolution, and a higher screen resolution (for example, 1024 x 768), translates into a better looking image on your computer screen. Your digital camcorder, then, can produce movies with enough pixel data to look good on your computer screen, or on DVD, not just on TV or saved onto old fashioned analog VHS tape.

Ease of Digital Storage

When it comes to storing your video, digital is a vast improvement over analog. Your movies are saved as binary code onto a digital medium such as MiniDV tape or MiniDVD. As such, your movies can be transferred, edited and copied without quality loss. Let's take a quick look at a variety of advantages of digital video over analog:

✦ Digital camcorders are much smaller than analog camcorders such as VHS or 8mm. Digital videocassette tapes are smaller than their analog counterparts as well.

✦ Digital video is easy to transfer and edit on a PC, then transfer back to your camcorder on digital tape. From there, it can be played back from your camcorder, or stored indefinitely.

✦ Digital video incorporates CD and higher than CD-quality audio.

✦ Digital images are sharper and richer. Digital video uses color component information that transmits each primary color as a separate (component) value rather than blending the color data into a single composite (combined) signal. Thus, colors are often more accurate than an analog video shot under similar conditions.

✦ It's very easy to save a "sync code" onto digital tape. Sync codes link the video to a soundtrack, other digital recorders, or professional time code devices that make it easy to correct frame errors.

✦ A digital video copy is as high a quality as the original. A digital copy of a digital copy also preserves original quality.

Mechanics of Digital Video Cameras

So how does a camcorder shoot and record digital video? Chapter 2 will cover the components of a digital camcorder in more detail. For now, you should know that a digital camcorder is an combination of at least eight different devices:

✦ The physical lens, shutter, and aperture—the camera—that captures moving pictures

✦ A Charge Coupling Device (CCD) for converting the light as seen through the lens into electronic voltages

✦ An Analog-To-Digital converter that converts the specific voltages to digital video

✦ A microphone for recording audio data

✦ A Pulse Code Modulation (PCM) chip which converts audio data to digital audio

✦ A digital VCR or recording device that stores the video and audio data

✦ A small LCD (Liquid Crystal Display) monitor and/or viewfinder that allows you to see what you are shooting

✦ A FireWire connection for transporting the video to a computer for editing and back again

Using these eight components, here's how a digital camcorder works, step-by-step:

1 Light passes through the camera aperture onto the CCD. The amount of light and focus is adjusted by shutter speed and lens.

2 If you swivel the LCD into place, it receives power and begins to display the scene that will be recorded.

3 The CCD (Charge Coupling Device) receives moving images from the beams of light that pass through the lens. Tiny diodes on the CCD convert each minute image detail to thousands of individual electronic charges.

4 The Analog-to-Digital Converter converts the electronic voltages to digital information (binary code).

5 At the same time that visual data is being processed, analog audio data is received via microphone or Audio In cable. The PCM chip samples and quantizes the sounds, converting them to digital information.

⑥ The data has now been fully digitized. A small VCR-like recorder with digital tape saves the video onto special digital tape, for example a MiniDV tape, as shown in Figure 1-15. Alternately, a disc recorder saves the data to CD or MiniDVD.

⑦ When recording is finished, an IEEE1394 FireWire connection can be used to upload data to a computer for editing.

Figure 1-15 Inserting a MiniDV cassette into a camcorder.

TO KEEP ON LEARNING . . .

Go to the CD-ROM and select the segment:

✦ *Digital Video Basics* to learn more about basic concepts of digital video.

Go online to **www.LearnwithGateway.com** and log on to select:

✦ *Internet Links and Resources*

✦ *FAQs*

Gateway offers a hands-on training course that covers many of the topics in this chapter. Additional fees may apply. Call **888-852-4821** for enrollment information. If applicable, please have your customer ID and order number ready when you call.

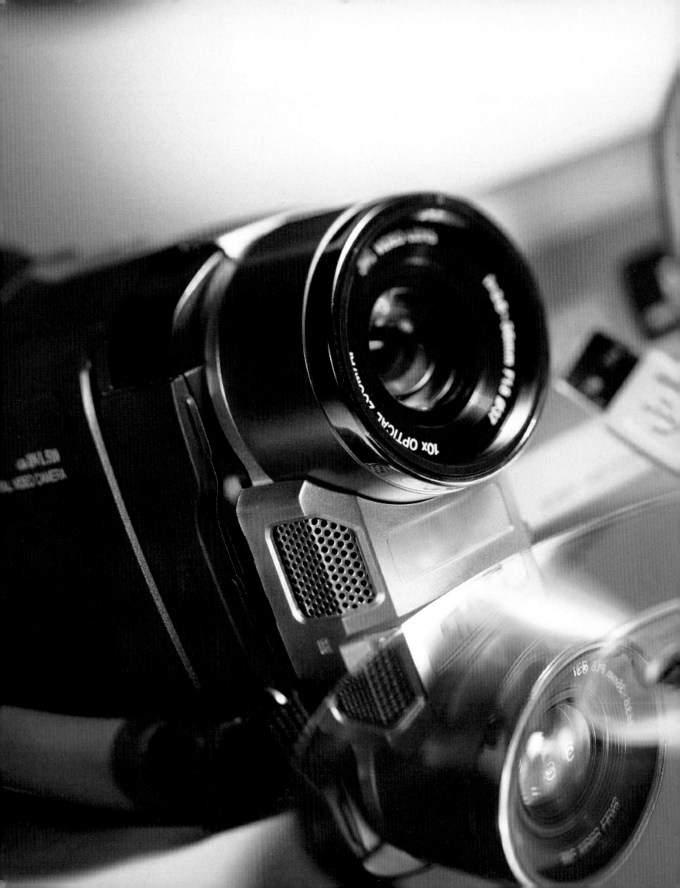

Computer and Camcorder Basics

Y our computer may need a little prepping before it can transfer and edit your movies. This chapter will discuss hardware and software requirements for editing digital video. You will learn how video editing software creates a complete video project. We will also cover specific camcorder specifications and features and talk about video storage options; the tapes and other media used to save and archive your digital video.

Computer Preparation and Requirements

Few tasks demand more from your computer than capturing and editing digital video. Your computer's Central Processing Unit (CPU) power, Random Access Memory (RAM), hard drive space, and graphics capabilities will all be put to the test. If you've ever edited a few graphic images, then fasten your seat belts for the thousands and thousands of sequential images that are edited when using digital video. For the tasks of shooting, editing, and distributing digital video, the following is recommended:

- An Intel® Pentium® 4 1.4GHz or AMD® Athlon® 1.7GHz processor

- Microsoft® Windows® XP or 2000

- 256 MB RAM

- Two EIDE Ultra DMA/133 hard drives, 80GB, 7200 RPM with 8 MB buffer

- A DirectX® compatible, 1024 x 768-resolution capable video card

- A 1024 x 768-resolution capable monitor

- IEEE 1394 FireWire card

- Recordable CD-RW or DVD-R drive

Below is a set of minimum recommendations. It is not recommended to attempt to capture and edit digital video on a computer with less than the following specifications.

- A Pentium® III 600MHz or AMD Duron® 900MHz processor

- Microsoft® Windows XP® or 2000

- 128 MB RAM

- Two EIDE Ultra DMA/100 hard drives, 80GB, 7200 RPM with 8 MB buffer

- A DirectX® compatible, 1024 x 780-resolution capable video card

- A 1024 x 780-resolution capable monitor

- A FireWire card is required for digital video transfer

These specifications provide enough power for editing large videos with minimal wait times. You can edit with a smaller system, but with varied results.

Video Transfer and Cabling Requirements

Digital Video is transferred from your camcorder to your computer (and back again) via a FireWire connection. FireWire is currently the best technology for high-speed data transfer between devices and computers. Certain scanner models, external hard drives, and even external DVD drives may include FireWire as an option, but for digital video transfer, FireWire is a must. The reason for this is no other transfer medium comes close to FireWire speed, with the exception of expensive and uncommon UltraWide SCSI. FireWire transmits up to 400 Mbps (Megabits per second). Compare this to the current USB spec of 12 Mbps.

All digital camcorders have FireWire ports. A separate cable plugs your camcorder into your computer's FireWire port. If your computer does not have one, you can install a FireWire card into any available PCI slot. FireWire card installation is discussed in more detail in Chapter 4. Additionally, some sound cards have FireWire ports, for example, the SB Audigy.

 FireWire technology has several names. Apple developed the term and FireWire is a standard feature on most Macintosh computers. FireWire's proper engineering specification is IEEE 1394, a moniker derived from the international board of engineers who developed the technology. Sony licensed FireWire for its own digital camcorders and refers to it as i.Link. In fact, most digital camcorders of all brands label their FireWire ports with a tiny and inconspicuous "i."

The FireWire cable has two ends that look nearly identical, but are not (Figure 2-1). The smaller 4-pin port connects to the camcorder, and the 6-pin port connects to the computer. In some cases, for use in older devices, you may find FireWire cables with six pins on both ends.

Figure 2-1 For most digital camcorders, one end of the FireWire cable is slightly larger than the other.

More About ... Digital Video Transfer

FireWire may soon have some competition. Efforts to improve USB technology have been underway. You can now purchase computers with USB 2.0, which boasts a top speed of 480Mbps, exceeding FireWire. If digital camcorder manufacturers embrace USB 2.0, then videographers may have a choice of transfer technologies.

 Transferring analog video such as copying VHS tape to your computer for editing will be covered in Chapter 4.

Digital Video Editing Software Requirements

Video editing programs, especially those for beginners, take a step-by-step approach to creating video projects. Some provide separate workspaces for each major step, allowing you to access each workspace by clicking on a tab at the top of the screen (See Figures 2-2 and 2-3).

Figure 2-2 Pinnacle Studio 8's tabbed menu.

Figure 2-3 Ulead VideoStudio 6's tabbed menu.

Video Capture

The first video editing task is to transfer video from your camcorder to your computer (Figure 2-4). This involves the software establishing a connection with your video camera, verifying that enough room exists on your hard drive, compressing, recognizing breaks between video scenes, and finally, uploading the video to the computer. If that sounds like a lot, the software pretty much takes care of it for you.

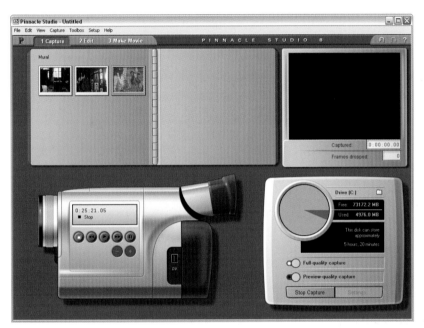

Figure 2-4

Pinnacle Studio 8's video capture workspace.

Editing

Video editing is where the bulk of the video project creation work takes place. The program must provide an interface for laying out and rearranging video clips, and adding various elements to them. This is also where you'll spend time adding effects, creating transitions, correcting mistakes, and molding your raw footage into a finished product.

Outputting

Good video editing programs provide many output choices (Figure 2-5), allowing you to save your video to e-mail and Web-friendly formats, VCD and DVD formats, as well as a host of other video file format options.

Figure 2-5

Determining final video project format choices for output.

Getting Instant Updates

Software companies still continue to improve programs even after marketing has begun. Problems are addressed that arise when the program is installed on certain hardware, or fixes are issued that simply make the program run smoother. When you first install video editing programs, you will be prompted to establish an Internet connection and allow the program to connect to the company's site and download the newest product updates (Figure 2-6). Obtaining and installing these updates can initially make the difference between a smooth or problem-plagued video editing experience.

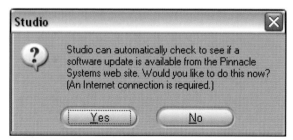

Figure 2-6 Upon installation, Pinnacle Studio 8 prompts for access to download product updates.

Digital Camcorder Specifications and Components

Let's take a closer look at the components of a digital camcorder and touch on the specifications that make up a good camera. This will help you understand what your camcorder is capable of and how you can reasonably expect it to perform. After that, some of the most significant digital camcorder features will be described.

The Camera Component: A Closer Look

In chapter 1, you learned that the inside of a digital camcorder is a uniquely featured camera. Like other cameras, a digital camcorder has a lens, shutters and adjustable aperture, except that it generally shoots 30 to 60 frames per second, recording movement. Let's break down the camera components into their main parts.

The Lens

When you point your camcorder towards an object, the lens gathers the light and focuses it precisely on the CCD (Figure 2-7). As you continue to do this with different objects, the camcorder determines what it is you are focusing and adjusts the lens position accordingly. A small motor automatically moves the lens closer or farther from the CCD while always attempting to keep in focus whatever it is you are filming. This process is called Autofocus. If the camcorder doesn't do a satisfactory job of keeping your picture in focus, you can override Autofocus, and adjust the lens yourself.

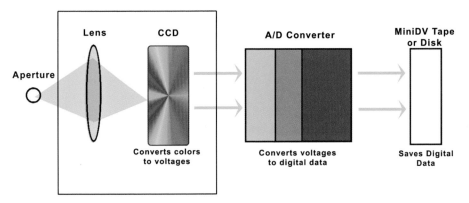

Figure 2-7 A lens focuses light on the CCD.

The Aperture

The CCD is very sensitive to light and your camcorder is always busy adjusting the amount of light illuminating the scene you are filming. It does this by adjusting the size of the opening facing the scene (called the iris or aperture). Very precise aperture adjustments are needed or your video will be too bright or too dark. Again, your camcorder pretty much takes care of this automatically.

 In camera lingo, changing the aperture opening is called adjusting the f-stop, and if your camcorder is shooting video that is too bright or too dark for your tastes, you can manually adjust the f-stop.

Shutter Speed

Shutter speed also has a hand in determining video brightness and clarity. The shutter determines how long light strikes the CCD during the filming of a frame of video. A digital camcorder generally shoots video at thirty frames per second, but the shutter is not open for the entire duration of a frame. By default, most camcorders have shutter speeds set at 1/60th of a second, but there are times you may want to override that speed. For example, if you are filming a car that is moving at 60 miles per hour, the car will have moved significantly during the fraction of a second that the shutter is open. The result is blurred video. Sports action, or anything with moving lights is easily blurred as well. Thus, most camcorders allow you to manually set a higher shutter speed, even as high as 1/15,000th of a second. (This is great for setting straight those questionable referee calls. Not much gets past you at that speed). Also, filming at night may require a lower shutter speed or your figures will be indistinct and not well defined.

 Video shot at night with a tripod and a low shutter speed often has a particularly deep and richly colored quality to it, a nice break from the typical "flat" look of video filmed in direct sunlight.

The CCD: A Closer Look

The Charge Coupling Device (CCD) receives image data from the lens and converts it to electrical signals. A CCD is an approximately half-inch panel of tiny sensors (Figure 2-8). Each sensor measures the amount of light and color that strikes a particular point on that panel. The combination of all sensor data recreates the entire image. Think of the CCD as the camcorder's film.

Figure 2-8 A Charge Coupling Device (CCD)

Most new digital camcorders have CCDs with 300,000 to 700,000 photosites and a higher photosite count creates better pictures. Image accuracy is increased if one single CCD is set aside for each primary color. That's why professional digital camcorders have three CCDs (called 3-chip

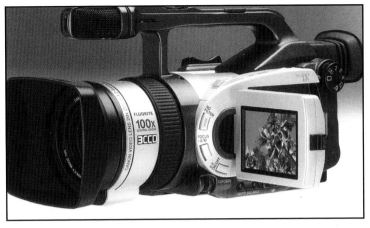

Figure 2-9 The tape mechanism of a digital camcorder

camcorders, see Figure 2-9). For all but the most demanding professional situations, a single-chip CCD will perform very well.

More About..... CCDs and resolution

Whether produced by digital cameras or camcorders, a higher pixel count results in better images. A CCD with more photosites produces images with higher resolution. Your video will be clearer and sharper. Roughly speaking, the number of photosites roughly translates into pixels. So, for example, a 700,000-photosite CCD creates a 700,000-pixel image.

One measure of a digital camcorder's quality is its ability to shoot video in very low light. How well does the CCD respond to low-light situations? Camcorder specifications express this as a Lux rating, one Lux being the light generated by a single candle on an object about 3 feet away.

If a camcorder has a 2 Lux rating, then your video will have good color and contrast as long as it was shot with lighting equivalent to the power of two candles. A zero Lux rating means that the camcorder can shoot in total darkness. One way camcorders increase the ability to film in darkness is by electronically amplifying the amount of light hitting the CCD. However, increasing the gain also adds noise to the signal. Adding noise to your video introduces grain and smear. When checking out camcorder stats, keep in mind that higher signal-to-noise rating is desirable.

 Chapter 3 will address how to work with low-lighting situations and other environmental factors affecting your video.

How MiniDV Tapes Work

Digital camcorders that use MiniDV tapes have a small panel of buttons—much like a VCR—for inserting, using, and removing the tape (Figure 2-10). After the tape is inserted, playback and record heads are positioned over the tape. MiniDV tapes are remarkable. A MiniDV tape contains 65 meters of tape. This is half the size of its predecessor, the 8mm cassette.

Figure 2-10 The VCR-like panel on a digital camcorder.

To store a single frame of video, a MiniDV tape (Figure 2-11) records between 10 and 12 tracks onto a hair-width tape segment. MiniDV tapes record up to 11 GB of data (how that translates into movie length will be discussed shortly). As you can imagine, such precision requires perfect tape-to-head alignment.

Since MiniDV tapes are engineered for such precision, you should never bump or jostle your digital video camcorder. MiniDV tapes that you've recorded should never be tossed around as if they were an audio cassette.

Figure 2-11 The tape mechanism of a digital camcorder

More About . . . MiniDiscs

Sony produces digital camcorders that record onto Sony's own MiniDiscs. These camcorders, called Discams, are pretty much digital video cameras with an optical disk recorder attached. Each disk can record 650 MB of data. The main advantage of these camcorders is the ability to access any movie on the disk without having to rewind or fast forward to find it.

Recording Digital Audio

One of the most overlooked digital video advantages is high-quality digital audio. Digital video records audio that exceeds CD quality. Just as the visual component of a video will suffer no quality loss when copied, your original audio track, soundtrack, voiceover, or audio effects will sound as good as the original.

Digital camcorders record audio using a process called Pulse Code Modulation, or PCM. This technology has been kicking around the professional audio world for a number of years. To achieve the most from your digital audio tracks, it's helpful to understand two aspects of this technology: sampling and quantization.

Sampling

When audio is recorded onto your DV camcorder through a microphone, or introduced through some other source, it is converted from analog to digital. As mentioned previously, the world of sound is analog, expressed in waves. It's amplitude (wave size) and frequency (number of waves), that determines sound. To reproduce sounds digitally,

your DV camcorder saves exact snapshots of each sound at frequent intervals (Figure 2-12). Upon playback, the camcorder reassembles each interval and plays them. The more digital samples (snapshots) of the sound that are obtained, the more accurately the sound can be played back. This process is called sampling.

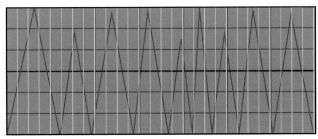

A higher number of small samples = more accuracy

A smaller number of large samples = less accuracy

Figure 2-12 Audio is saved digitally by sampling.

Quantization

The other digital audio recording component is quantization. A sound is more accurately rendered if it can be defined uniquely. A sound's true uniqueness on a computer is accurately expressed if more data bits are available to describe it. Digital camcorders can either record samples using 16 bits (using 65,536 possible digit combinations to describe each sound), or 12 bits (4,096 digits can be used to describe a sound). Sounds using 16-bit samples are more accurate. However, using the highest quality setting limits the number of tracks you can record directly onto your MiniDV tape.

On your camcorder, you will probably notice a menu option for choosing between 12-bit and 16-bit stereo. Since 16-bit recording accuracy takes up more room on the DV tape, you will only be able to record one stereo track of music. If you select the 12-bit sampling option, you can record two stereo tracks. The difference between 12-bit and 16-bit sound will not be noticeable in most instances, unless your video utilizes a high-quality soundtrack destined for DVD.

 The information above pertains only to what you can directly record on your DV tape without computer tape transfer. Once your video is on your computer, you can record many stereo tracks using video editing software. You can add music, voiceover, audio special effects, and even edit your existing audio track any way you like. While you are planning and filming your project you can be thinking of music and audio ideas, what you can add in the way of sound that will help bring your project to life.

Taking Still Pictures with Your Camcorder

Newer digital camcorders allow you to take still images, either by providing a separate shutter button, or extracting single frames from video. Some allow both. You will not have to go fishing through your MiniDV disk to find your still shots. Camcorders store your still images on separate media, allowing you to access them quickly. This is accomplished using expansion slots that accommodate Multimedia Cards, Memory Sticks or Secure Digital (SD) Memory Cards (Figure 2-13). The media type used will vary from camera to camera.

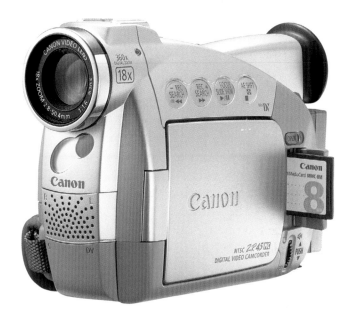

Figure 2-13

Memory Cards for storing still pictures on your camcorder.

 Your still pictures are uploaded to your computer separately from video, and can be stored on a separate, easy-to-access folder on your hard drive.

The number of still images your camcorder allows you to shoot depends on the storage media's available capacity. Some digital cameras accommodate hundreds or even thousands of still shots. The other factor affecting the number of stills you can store is the size of each image. Digital cameras let you choose between storing many images at lower quality, or fewer images with higher resolution. However, even shooting at the upper end of the quality range, digital camcorder still images are at far lower resolution than digital cameras. The best most camcorders can do is around the 1Megapixel range. This creates a decent picture but not of professional quality. For the best pictures, choose a newer digital camera, capable of images in the 3Megapixel range.

Common Digital Camcorder Features

Beyond the fundamental components of a digital camcorder, there are many features, some essential and some not, that we can address now. Some features will be discussed in Chapter 3, "Your Camcorder's Shooting Options."

Viewfinder

The viewfinder is the small eyepiece for viewing your scene (Figure 2-14). Most new digital camcorders provide color viewfinders. The viewfinder uses far less battery than the LCD, so you may want to keep this in mind in low-battery situations.

Figure 2-14
A Digital camcorder viewfinder.

LCD

The LCD electronically monitors the view from your lens, displaying your picture in Liquid Crystal Display technology (Figure 2-15). The view is identical to what is shown through your viewfinder and LCDs provide a nice view of your shot without having to squint. Most new digital camcorder LCDs are color. Also, LCDs can usually swivel, allowing you to view your shots from difficult angles that make the viewfinder inaccessible. On the downside, LCDs are big battery hogs. If you use it, expect to deplete your battery about twice as fast as you would if you were using the viewfinder alone.

Batteries

Your digital camcorder has either rechargeable NiCad (Nickel-Cadmium) or Lithium Ion batteries, Lithium Ion being superior due to reduced recharge requirements and better charge retention. No matter what battery, charge depletion is never uniform. Some sessions will require recharging far sooner than others.

Figure 2-15 A camcorder's LCD.

Battery power can be affected by using the LCD and long recording or playback without pauses. For longer sessions and for situations in which recharging is not an option, consider purchasing extra-large batteries, available from the manufacturers of most digital camcorders. These provide more than twice the battery life of standard batteries.

Zoom Power

Zoom lenses work by increasing the distance between the lens and the CCD (or in standard cameras, the film). A zoom lens is extended, the distances increased, and the subject in the lens appears closer (Figure 2-16). In digital camcorders, however, there are two types of zoom. Optical Zoom physically extends the lens, just like standard cameras. Consumer-level digital camcorders are equipped with up to 24x zoom power. This means that you can magnify the subject up to 24 times its original size using physical lens adjustments. The process is mechanical and image quality is not affected.

Figure 2-16 A video subject at normal view and zoomed.

 Highly zoomed scenes often require more light. Before filming, make sure your zoomed subjects are not darker than you would prefer.

Your camcorder also has digital zoom capabilities. Digital zoom electronically magnifies selected pixels, and does not involve the lens at all. Camcorder manufacturers claim digital zoom powers well into the hundreds, however, digitally zoomed images lead to a significant loss of image quality. So, when using digital zoom, pay special attention to image clarity. Before actually shooting, make sure your video is not fuzzy.

Some digital camcorders seamlessly move from optical to digital zoom as you zoom in on a subject. The only indication you have moved into digital zoom territory may be a small zoom indicator icon in the viewfinder or LCD.

Camcorder Remote

Many newer camcorders include battery-powered, wireless remote controls (Figure 2-17). A remote control for your camcorder may seem like an inconsequential extra, but consider how it frees up your hands to get other material ready for your shoot. It can be

very handy to have a remote control to rewind, fast forward, record, adjust zoom, access menus, and all kinds of camera settings. When you are cabling, crouched behind a computer fussing with wires, it can be quite helpful to access the camcorder using the remote. Some remotes work 16 feet away from the camcorder. You can place your camcorder on a tripod, then arrange your subject matter, use the remote to fine tune your settings and prepare the camcorder for recording.

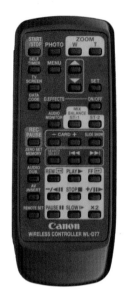

Figure 2-17

A camcorder remote.

White Balance Control

It is desirable to have color consistency no matter what environment you use to film. At times, you may find yourself shooting video outdoors, where colors are especially bright, then move inside, and suddenly all your whites have a blue or yellow tinge. What has happened is that your camcorder is still mapping colors based on what "white" was when filming outside. You need a way to reorient your camcorder to what "white" means in this new environment. That's because each environment has a different type of light source, and that light source introduces a bias, or a color cast primarily noticeable on the whites.

What you must do is manually adjust the White Balance. Bring a plain white page about the size of a piece of notebook paper and place it where your video subject will be positioned (or you can point the camera at a continuously white surface somewhere in that room). You may need to have somebody hold it for you. Next, point the video camera at the paper and press your camcorder's White Balance button. The camcorder will adjust for what "white" is in that environment, and all other colors will shift accordingly, resulting in more uniform colors in any filming environment.

Image Stabilization

If you use the zoom lens, you will notice that even small amounts of camera shake results in unsteady video. This is because when filming at a distance, any change in camera position causes drastic view realignment. To minimize shaky images, your camcorder has an image stabilization feature (Figure 2-18). Not only that, the feature actually works! Apply image stabilization, and your video will indeed come out less jittery.

There are three types of image stabilization. One utilizes a prism that redirects light when

shake is detected. Another uses a shift mechanism to reposition lenses when shaking is detected. The type of image stabilization used most often in consumer-level camcorders is electronic. However, since pixels are electronically modified to compensate for shake, video resolution is somewhat diminished. So, when using Image Stabilization, make sure your subject matter doesn't look a little blurry around the edges as a result.

Figure 2-18 Image Stabilization at work.

 To learn more camcorder features, go to the CD-ROM segment *Digital Video Camera Features.*

Storage Options

What follows is a quick discussion on storage media choices, and how your videos can be safely archived and retrieved later. In Chapter 9, you will learn the nuts and bolts of video transfer for storage, as well as sharing your video with the world.

Storing your videos digitally is convenient and well worth the investment. After you've been filming and collecting tapes for a while, the tapes start to add up, and many of those moments will be worth protecting. You can store completed video projects on your hard drive, however, the source files will take up more space than is practical. The exact space requirements depend on the amount of compression used (covered in Chapter 9) and frame size. Here are some basic figures to keep in mind:

✦ A half an hour of video captured from a MiniDV would require approximately 7 GB storage space.

✦ Set at the highest quality, with no compression at all, an hour of MiniDV-transferred video would require in the neighborhood of 20 GB.

✦ Somewhat compressed MiniDV video requires 13 GB per hour of video.

Projects that are optimized for distribution on other media (such as CD, DVD and online) will be far less burdensome to your hard drive, but the video footage you edited in order to create your projects will more than likely take up several gigabytes of space. This "source" footage should be saved onto MiniDV or DVD, and stored away from the elements and temperature extremes.

MiniDV

MiniDV cassettes are the most popular medium for storing digital video (Figure 2-19). Capable of recording up to either 60 or 90 minutes (depending on which record mode is used), MiniDVs are lightweight and reliable. Time Stamp, Error Code, Frame, linking information and Disk ID can be stored on MiniDVs.

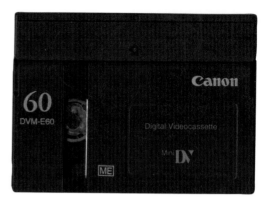

Figure 2-19 A MiniDV cassette.

MiniDVs are more durable and archival than previous videotape types. The tape used in MiniDVs is multilayered. It includes:

✦ Dual magnetic evaporated metal layers

✦ A protective carbon layer

✦ A friction reduction layer that reduces skipping during rewinding and fast-forwarding

Besides the advantage of small size, convenience and durability, MiniDV tape's most important feature is its permanence. Sock away a recorded MiniDV tape in a drawer, come back years later and play it, and the recording will still retain its original quality.

Safely Archiving Video on MiniDV Tapes

Though MiniDV tapes are durable, they are not indestructible. Frequent MiniDV playback can create dropped frames due to alignment slippage or because of contact with foreign matter like dust or moisture. If your camcorder detects tape problems of any sort, it will more than likely eject the tape and not play it back. Here are some suggestions for safely archiving your video on MiniDV tapes:

✦ Create a MiniDV copy of your initial footage and store it away.

✦ Create a MiniDV copy of your edited, completed project and store it away.

✦ Create a non-MiniDV copy for frequent playback, either on DVD, VCD or VHS cassette.

MiniDV Tape Tips

Here are some general MiniDV tape tips for protecting your footage:

- ✦ Don't drop the cassette.

- ✦ Discard wet cassettes.

- ✦ Cassettes must be room temperature before use.

- ✦ Always store a cassette rewound and in its case, non-tape side exposed.

- ✦ Don't touch the tape.

- ✦ Don't store a recorded tape in adverse environments, for example in luggage where temperature may exceed 90 degrees.

- ✦ Fully rewind or fast-forward a tape after a session that requires frequent rewinding and/or fast-forwarding.

CD-ROM

CD-ROMs can store approximately 700 MB of data, which is only enough for a small amount of raw video footage, but could store several tightly edited video projects. Completed video projects are compressed, and can be stored more compactly than raw footage. CD-ROMs are a durable storage medium, and are not easily damaged if mishandled like magnetic tape.

DVD

You can also store your movies on DVD, but only in compressed MPEG-2 (video output choices will be discussed in Chapter 9). If your computer lacks a DVD burner, you can add an internal DVD burner if you have the bay space. An external device like ADS's USB Instant DVD will also do the trick, by allowing you to control writing movies to DVD from your computer using a USB connection. External drives bring you into the world of DVD recording without having to install an internal DVD recordable drive.

TO KEEP ON LEARNING . . .

Go to the CD-ROM and select the segment:

◆ *Digital Video Camera Features* to learn more on camcorder features

Go online to **www.LearnwithGateway.com** and log on to select:

◆ *Internet Links and Resources*
◆ *FAQs*

Gateway offers a hands-on training course that covers many of the topics in this chapter. Additional fees may apply. Call **888-852-4821** for enrollment information. If applicable, please have your customer ID and order number ready when you call.

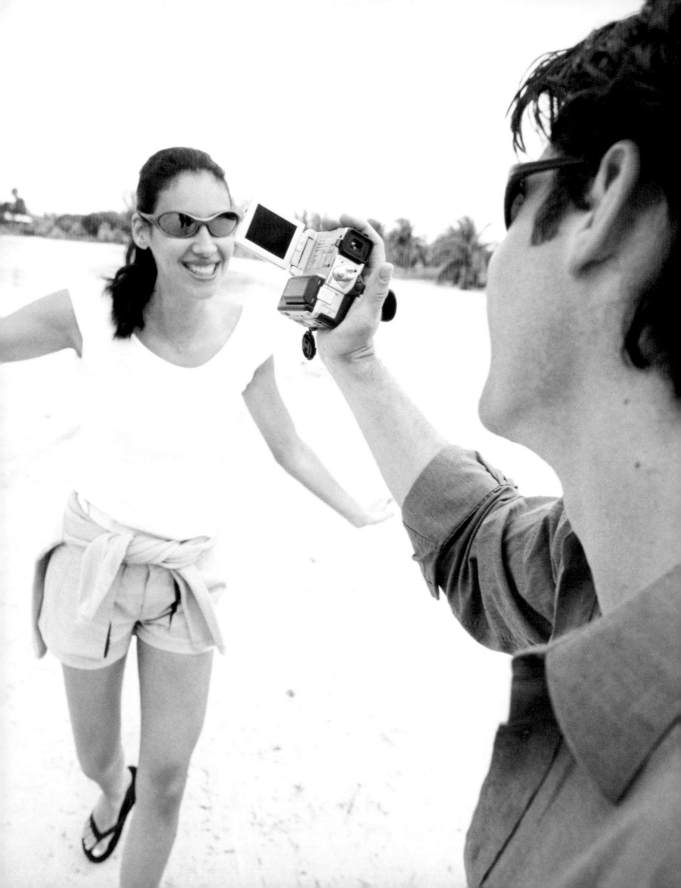

Shooting Great Video

The goal of this chapter is to show you how to shoot the best video possible. You will discover how to anticipate factors that will affect movie quality, and how you can shoot good footage in spite of these conditions. You will also learn about digital camcorder accessories, and the situations in which auxiliary gear becomes essential, not optional. You will learn what pieces to bring along, and when to use them.

Your digital camcorder has special settings for shooting in different types of light. These are options you access through the camcorder menu. You will learn how each can come in handy, and when to apply them. We will also discuss shooting techniques, how to avoid "flat" video, frame shots, and different types of zoom shots.

Preparing for Your Shoot

The most important steps for getting the best footage are taken before you arrive on the scene. You will want to anticipate weather, noise, lighting, time constraints, human traffic, and also have an idea of how much control you will have over these factors. Then, once you arrive on the scene, you will have the resources you need to shoot great video.

 Don't forget to let others prepare as well. Some people very much appreciate advance warning that they are going to be filmed, even if the event only involves family and friends.

Lighting

Digital video is very sensitive to light. Either by looking through your viewfinder or LCD, you will notice that a subject will face one direction and appear too shiny in the forehead, then the subject repositions, and suddenly is in a shadow. Without some control over lighting, getting a balance can be nerve-wracking (Figure 3-1). It's best to position your subjects under a uniform source of light. To ensure this, you may want to bring a couple lights of your own. This is especially important if you are filming inside or at night.

Figure 3-1 Video filmed in too much light.

Video filmed in direct sunlight can look a little flat (Figure 3-2), partially because of the absence of shadows. To avoid bleached out or overly bright shots, pay close attention to the amount of direct sun on your subject matter Subject positioning makes a huge difference. Turning people slightly to the left or right seems to drastically change the amount of direct light that a digital camcorder sees on a subject. Also, if possible, position some subjects behind others (Figure 3-3). The

Figure 3-2
Video filmed in direct sunlight can look colorless and flat.

3

resulting shadows will give the subjects a little depth. And finally, if you have any say over such matters, try moving the subjects towards a more shaded area.

In any environment, be sure to set the White Balance before filming. As mentioned in Chapter 2, White Balance may have to be adjusted each time you change filming environments.

To learn more on lighting, go to the CD-ROM segment *Lighting Fundamentals* and *Lighting Techniques*.

Changing Lighting Conditions

Be aware of the changing lighting conditions, as they will tend to creep up on you while you are busy behind the camcorder. When filming outdoors in the afternoon, watch the sun movement. As evening approaches, you will have the choice of either finishing your filming quickly, or changing the light adjustment settings on your

Figure 3-3 Subjects positioned in varying distances from the camera gives your video a little depth.

camcorder. Increasingly over the course of the event, you will notice more shadows, while faces are harder to make out.

As night approaches, you will need to add more light. Some camcorders have built-in spotlights that are great for illuminating the area directly in front of you. Others provide a "hot connection" for attaching an external light, available from your

Figure 3-4 When using your camcorder's "night filming" feature, people in motion can leave trails.

camcorder's manufacturer. Note that your camcorder's "night filming" option has limitations. For example, figures may still appear dark, and filming people in motion can leave trails (Although that effect can be rather artful, as shown in Figure 3-4).

Filming in artificial light can require frequent lighting adjustments. There's an amazingly short distance between a well-lit face and a ball of white light sitting atop someone's shoulders. If the lights were only a few feet from the subjects, it is recommended to position them just outside the direct beam of light, rather than shining it directly on them.

Weather

If you are filming outside, and rain is a possibility, beforehand check around for a convenient change of venue, should it come to that. Perhaps just an overhang or improvised shelter of some sort is all that's required.

High winds will create three distractions. Props will be blown out of place, leaving you or an assistant to go chasing after them. Hair and loose fitting clothing will get that "wind tunnel" look, which may or may not be desirable. And finally, the wind will record on your audio track as a howl, rendering inaudible most other sounds. If you are not in possession of huge tarps or wind breaking baffles, consider a nearby change of venue offering some protection from the elements.

A nemesis to all high-tech gear is dust and sand. Fine particles such as these are a big camcorder no-no. If filming in a dusty environment, try to move the show behind a structure of some sort, such as cliff, or a large building. And, of course, if filming on the beach or in the desert, never place the camcorder or cassettes on a surface anywhere near the sand, and protect your gear from wind whip-ups by not leaving it exposed.

Filming in hazy light, fog, or subjects behind glass requires special filters, which we will discuss momentarily. If these filters are available, be sure to bring them along. Additionally, wide-angle (Figure 3-5) and zoom lenses are not just for specialized work. Many situations require close-ups and peripheral shots. Don't forget to bring them along, even if you don't anticipate needing them.

Figure 3-5 A shot with a wide-angle lens.

Precipitation

If you notice clouds gathering, try to push things along, so everything can be wrapped up before it starts to rain. Even a few drops of moisture in the wrong place can ruin your footage and damage your camcorder.

If high humidity is likely, consider the toll that moisture takes on high-tech equipment. Keep the MiniDV tapes dry and avoid leaving the camcorder where it can get damp. If a digital camcorder detects any moisture at all, it will display an error and shut down until components are dry (this usually just involves waiting).

Filming Indoors

If you're filming indoors, especially at home, consider shooting with lots of windows open. Sunlight helps keep your subjects brightly lit and minimizes shadowy, darkish video. Also try to steer the action so your subjects are facing open windows, or other light sources. If the light source is behind them, faces and other details will be darkened. Finally, move the action to the center of a big room as much as possible. You'll have fewer instances of subjects obscured by coffee tables and chairs. Your video will have a more open look.

Noise

Camcorder microphones are designed to pick up the most prominent sounds in an environment, and generally, those will be the voices you are trying to record, and perhaps music. But if the microphone zeros in on other sounds, and measures those as the loudest, those noises could overwhelm your recording. If you have any say in planning ahead where a video shoot will occur, consider the probability of foot traffic, hallway noise, cars, people wandering by with raised voices, and the like. Push for a more isolated local.

Also, if you have external microphones and mic stands available, be sure to bring them. Except for situations requiring extreme mobility, video shots with an external microphone is a great improvement over using the built-in mic. You will pick up far less environmental noise, and the verbal clarity of your subjects will be improved. Video subjects tire of repeatedly being asked to speak louder. It's good to have planned ahead to accommodate recording various speech volume levels.

 It is nearly impossible to record audio at the beach. You can neither block nor filter out the sounds of the surf. Don't try. If you want to film at the beach, either accept the fact that the surf will be almost as loud as the voices, or plan to add voiceover tracks later.

Planning a Backdrop

Some filming situations require control over what is seen in the background. A busy background can distract from the subject matter (Figure 3-6). If you have access to such material, bring along large, banner-sized white or black cloth. Employing these helps focus the viewers' attention on what is being filmed, filtering out visual distractions.

Figure 3-6 A subject filmed against a solid background is easier to distinguish.

 If you are frequently asked to video people in various settings, you may want to keep a mental list of favorable locations, environments where the factors discussed here will not work against you. Try to have as much control over your video environment as possible. Also, when selecting a time of day, consider noise and traffic as well. Consider filming in front of old red brick structures, for a "historical" feel, or in front of high-tech corporate centers for just the opposite effect. Does your city have public art on display, or interesting graffiti that hasn't been painted over yet? These can be interesting backdrops as well. And what about way on the "edge of town" where nobody goes anymore? How about shooting your video over there? And for something completely non-urban, you can get out of Dodge and move your entourage to a setting where nothing in your camera's view is man-made. A video's locale contributes greatly to the feel and mood of the project.

 To learn more on video planning, go to the CD-ROM segment *Planning a Video*

The Right Equipment at Your Fingertips

Most digital camcorders have an accessory shoe, which is an electronic hot connection atop the camcorder, for attaching a video light or external microphone. In most cases, the video light and external mic are purchased separately. The light and microphone are powered and controlled by the camera.

External Video Light

An external video light is a lighting accessory you can plug in as needed to illuminate the area you are filming. Most often, they are very bright, and subjects should be directed not to look at it directly. They are also quite hot to the touch, and a significant power drain on the battery. When using a video light, position subjects so that their faces are not shadowed, which may happen if they are far to the right or left of the light beam. However, avoid that bright-beam shiny-forehead effect as well.

External Microphone

An external microphone provides high quality directional audio, and is a near essential for video in which live audio plays a significant role. External mics plug into the camcorder's accessory shoe, and like the video light, receive power from the camcorder, and are a significant power drain.

Some external mics have more than one setting. In this example, the Canon DM-50 (for use with the Canon ZR series camcorders) is used:

✦ Shotgun: Picking up a directional sound just in front of the microphone. Records a mono track (not stereo).

✦ Stereo 1: Records a stereo track onto the camcorder's record medium (MiniDV in this case). Records sound from the camera's perimeter, not just in front.

✦ Stereo 2: Records stereo sound from a wide range perimeter around the camcorder. Good for live music recording and stereo ambiance.

Filters

There are two fairly inexpensive screw-on filters that can make a difference between mediocre footage and a movie you will be proud of. Made of specially treated glass, not all digital camcorders can accommodate these filters. If these filters are available for your model, they are worth a small investment, especially if you anticipate lots of outdoor filming.

Ultraviolet (UV) Filter: A UV filter is a good general protective filter for protecting your lens from dust, scratches and fingerprints. It also absorbs the sun's Ultraviolet rays, which reduces optical distortion. Since a camcorder's CCD is very sensitive to light, this filter is a wise purchase.

Neutral Density Filter: A Neutral Density filter helps combat the flat colors caused by hazy, diffuse light (Figure 3-7), or too much direct sun on your subject. For example, if

Without Neutral Density Filter

With Neutral Density Filter

Figure 3-7 No filter and Neutral Density filter footage shown side by side.

you visit the Grand Canyon and you notice the colors just don't seem very rich, shoot your video with a Neutral Density filter, and you will see the difference.

Polarizing Filter: Use a Polarizing filter to cancel reflections (Figure 3-8). This is helpful for filming subjects behind glass, for example, zoo exhibits or filming from an airplane. It can also be used to combat dull video caused by glare and reflective haze.

Figure 3-8 Use a Polarizing filter to shoot through glass.

Lenses

There are essentially two types of lenses you can purchase separately and use with your camcorder—telephoto and wide-angle.

Telephoto lenses provide zoom, but do so with much more optical accuracy than a standard camcorder zoom lens. For those who regularly video subjects at a distance, such as nature or live-performance footage, a good telephoto lens is a necessity.

At times, a wide-angle lens is just as important. Our view of the world includes peripheral vision. Through a standard camcorder lens, you will see only what's right in front of you. A wide-angle lens is much more inclusive, and if you're trying to film something near to you that is slightly to the right or left, you will need one. A wide-angle lens is most likely not included with your camcorder and must be purchased separately.

Batteries and AC Adapter

Camcorder batteries never seem to last as long as you need them to. If you have an extra battery, bring it, and if not, bring your camcorder's AC adapter, as well as a lengthy extension cord so you will not be tethered by your camcorder to the area right next to the wall. Also, most digital camcorder manufacturers offer extra-length batteries for sale. These attach and function just like regular camcorder batteries, but provide sometimes more than twice the duration.

Tripod

If you have a tripod, remember to bring it. For video shots in a single location (as opposed to roving and wandering with your camcorder), tripods are a near necessity. Tripods are fairly interchangeable model to model, and not only elevate your shooting plane, but rotate up and down, side to side and right to left. Tripods minimize shaky video, allow you to use slower shutter speeds when lighting is low, and provide a solid location for your camcorder (less capricious panning and camera movement). Also, if you need to return to a certain local and reshoot some footage, if you have used a tripod, you will have an easier time reproducing your previous position.

Your Camcorder's Shooting Options

Your digital camcorder can choose optimal settings for most lighting conditions. Rather than manually adjust shutter speed and aperture, just select a setting. These settings are based on time of day or type of lighting, for example "Evening," "Nightshot," or "Spotlight." The camcorder will then adjust shutter speed and aperture for the condition you indicated. Some manufacturers such as Canon refer to Auto Exposure settings as A/E Programs. In describing these settings, we will borrow the terminology from the Canon ZR and Elura series of digital camcorders. These settings are common to most digital camcorders, although the names will vary.

3

Easy Recording

The camcorder automatically adjusts focus, exposure and shutter speed. You simply point and shoot, and the camcorder does the rest. Use this setting if you like what you see through your viewfinder or LCD – not too bright, not too dark. If you think the camcorder is getting it right, no need to adjust things yourself.

Auto

Auto is the same as Easy Recording, except that you can manually adjust focus, shutter speed and aperture if you so desire. Choose this setting if you want to fine-tune the camcorder's automatic lighting and exposure settings.

Sports

Use the Sports setting for recording fast action, such as athletic events or movement from a car (Figure 3-9). Without this option, your video may look blurry. Sports does not use interleaving, so the camcorder is shooting a full picture every frame, rather than the odd, then even lines. That means each frame is a complete image, rather than using the odd-even standard required for TV broadcast. This setting is also useful for frame-by-frame viewing of high-speed activity, for example, close-up nature filming.

Figure 3-9 Filming sports requires use of the progressive scan setting, so that the video doesn't appear interlaced.

Portrait

The Portrait setting focuses the main subject sharply in the scene, softening the foreground and background (Figure 3-10). Best used for close-ups, make sure the main subject fills a good deal of the scene or the lens won't be able to pick out enough detail to properly display the effect. The more zoom lens you use, the easier it is for Portrait to find the subject matter. For best results, try zooming with about half the power of your optical zoom capabilities. For example, if your optical zoom supports X20, stand back far enough from your subject so you can use X10 zoom. On most digital camcorders, the LCD or viewfinder displays the current zoom amount as you apply it.

Figure 3-10
Video shot with the Portrait setting.

Spotlight

The Spotlight setting does an amazing job of removing glare from a subject lit by a concentrated bright light. Without this setting, subjects would be bleached out and indistinct (Figure 3-11).

Figure 3-11 Video shot without the Spotlight setting.

Sand & Snow

Filming against bright, reflective surfaces can make your subject look underexposed. These can include the beach, snow, or a bright white wall. The Sand & Snow setting helps the camcorder define the subject with a more even light.

Low Light

Use your Low Light or Evening feature for filming in dimly light rooms or just before nightfall in the outdoors. The Low Light setting fixes the shutter to a low speed, allowing in more available light. Video will not be as vibrant using Low Light and moving subjects will leave trails as they pass. Low Light is best used when filming stationary objects.

Night

The Night setting automatically adjusts the setting according to the brightness of the subject. It's a very dynamic setting, always altering shutter size and adjusting for optimum use of any light available. Moving subjects will almost definitely leave trails and bright objects may appear haloed. Still, when little to no lighting is available, you can obtain reasonably good video with this feature.

 Image Stabilization was discussed in Chapter 2, but don't forget to use this feature to defeat shaky video, when needed. Of course, a tripod would be the best way to stabilize an image, and would not have the impact on resolution that electronic Image Stabilization has.

Effective Camerawork

While you certainly need not be a professional cameraman to shoot effective video, there are simple techniques that you can apply that will make your scenes more interesting to view even before you do any editing to them. If your footage is effective going into the editing process, your completed video project will be that much better.

Camera Movement

The camera is your audiences' eye on the world. It should be fairly stable. It is more pleasing to the eye to have subjects move in and out of the camera view than it is for you to try to follow every step they make. Try to minimize sweeping camera movements and sharp right-to-left pans. Your audience (and their stomachs) will appreciate it.

Framing a Shot

When filming a subject, you are introducing both the subject and their environment. The audience would appreciate context. Where is this person standing and why are they standing there? How the viewer feels about the person they are watching is often determined by where you place them in the shot. As the videographer, you can determine who is central, who is peripheral, and how people move in relation to others on the screen.

The Rule of Thirds

There are some basic rules for shot framing that when followed will result in more watched footage, viewers will have an easy time understanding what you want to convey. The fundamentals for framing a shot are summed up in what is called the Rule of Thirds. The Rule of Thirds is designed to avoid unnatural symmetry in your subject's positioning. Unless you are filming "The Changing of the Guard," you will want to avoid regimentation.

The Rule of Thirds can be broken down in the following way. Imagine the video screen is a tic-tac-toe board. Using two horizontal and two vertical lines, the screen is divided into nine rectangles (Figure 3-12). The eyes of your subject should be close to where any of your horizontal and vertical lines intercept, never centered in one of the boxes. Especially avoid having a subject's eyes exactly in the center of the middle box. If you use the Rule of Thirds, your video will have a spontaneous look. Subjects are less likely to appear posed.

Figure 3-12 Using the Rule of Thirds, imagine your scene divided by two horizontal and two vertical lines. Notice that no one's eyes fall exactly in the center of one of the rectangles.

 Use the Rule of Thirds to frame subjects of varying heights. Avoid positioning faces in the center of any open squares, and instead, stick to the lines.

When framing your shot, also keep in mind the following:

◆ A subject near the edge of the screen facing out looks awkward to the audience, appearing strangely uninvolved in the scene (Figure 3-13).

◆ A subject with eyes at the exact center of a scene will look boring quickly. The scene would seem to lack direction.

Figure 3-13

Avoid positioning a video subject at the edge of the screen facing outward.

Camera Angles

Use of camera angles and angle transitions should be deliberate. The small size of newer digital camcorders makes it easy to jolt your camcorder around with an abruptness that can rather annoy your viewers. The following are the names of typical camcorder angles and movements. One method for minimizing the amount of camera movement is to repeat the name of the changed angle as a reminder. You will be less apt to alter the camcorder viewpoint without thinking.

Pan Left and Right

Moving the camera to the right or left is called panning. Panning moves the camera only on its vertical axis, not up or down.

Tilt Left and Right

Tilting right or left alters the slope that the subject is being viewed on. Use this camera position to, for example, exaggerate a hill's angle, or reorient an object held at an obscure angle, such as with medical, industrial, or nature filming.

Upward Tilt

For upward tilt, place the camera on a relatively lower plane and face it upwards. Use this view to exaggerate a subject's size and height, or to view nearby subjects that are above the normal camera view.

Downward Tilt

For downward tilt, place the camera on a relatively higher plane and face it downwards. Use this view to shrink a subject or to view nearby subjects that are below the normal camera view.

Dolly Forward/Dolly Backward

Named after the human-sized trucking device used to move cameras on movie sets, dolly means to physically move the camera forwards or backwards. Physically moving yourself closer or father from the subject does not introduce distortion, which can occur with zoom usage.

Type of Shots

How much background (environment) you include in your movie depends on what you are trying to say. For example, if you shoot from very far away, you are conveying that the environment is just as important as the subject. If you shoot an extreme close-up, you are conveying intimate detail about the subject. Be sure you have a reason for these types of shots. Here are named examples of shots and how they can be used.

Long Shot

The long shot establishes the context between subject and environment. The viewer gets the "big picture (Figure 3-14)."

Figure 3-14

The long shot involves the subject of the scene with the environment.

Medium Long Shot

The medium long shot displays subject and environment, showing the subject from head to toe. Use it when the subject is changing position, for example, the way they are sitting or standing (Figure 3-15).

Medium shot

This is the half-a-person shot, used to show upper body activity and detail. It looks unnatural to cut the subject off exactly at the torso, so always try to include a little bit of lap and lower body, for continuity (Figure 3-16).

Close-up

Close-ups show people in conversation, displaying the upper forehead to the upper chest. A close-up is close enough to show facial expressions and mouth movement, but still includes upper chest (Figure 3-17). This avoids the look of disjointed "talking heads."

Figure 3-15 The medium long shot shows the subject from head to toe.

3

Figure 3-16 The medium shot is the half-a-person shot.

Figure 3-17 A close-up shows the head

Big Close-up

Used to convey subtle emotional nuances in people's faces, convey intimacy and hidden detail about what a person may be saying or doing (Figure 3-18). Use sparingly, as the audience will feel uncomfortable watching this view unless the reason for it is evident.

Extreme Close-up

Use the extreme close-up to convey emotions that are quickly hidden, extreme surprise, fear, or exclamation in the eyes (Figure 3-19). Again, this shot should be used sparingly.

Filming Tips

Included here are handfuls of camcorder filming tips that will make your video more fun to watch.

If you can choose a locale for your video shoot, consider locations where your subject can be seen clearly, and be seen from various angles, should you move the camera to take in a different view. Examples are elevated places such as raised walkways and stairs, public outdoor stages as well as arches (Figure 3-20). Places where you can film in the round (make a half-circle around your subject) are especially effective locales.

Figure 3-18 The big close-up shows the entire face without any background.

Figure 3-19 The extreme close-up shows facial expressions for a brief flash.

Whenever possible, employ high contrast between subject and background. If filming against white, encourage the subjects to wear colors that will stand out. Avoid filming subjects in front of distracting backgrounds such as murals. The audiences' eyes will be drawn to the background and the subject can get lost.

Avoid backgrounds that interplay embarrassingly with the subjects. In many lighting conditions, video tends to look flat, without clear definition between foreground and background. Thus, The annals of home video are filled with footage of bookcases that seem to be sprouting from ears, and lampshades that seem to circle the head like a halo. The best way to avoid these problems is by using an uncluttered background as possible.

Figure 3-20 If possible, use locales of various elevations for shooting video.

 To learn more on capturing great video, go to the CD-ROM segment *Taking Great VIdeos.*

Go to the CD-ROM and select the segment:

✦ *Digital Video Possibilities* to learn more about your video editing options.

✦ *Taking Great Video* tp review tips and suggestions on recording video.

✦ *Planning a Video* to understand what it takes to plan shooting a video.

✦ *Lighting Fundamentals* to learn more about the basics of lighting and the available equipment.

✦ *Lighting Techniques* to review different lighting techniques.

Go online to **www.LearnwithGateway.com** and log on to select:

✦ *Internet Links and Resources*

✦ *FAQs*

Gateway offers a hands-on training course that covers many of the topics in this chapter. Additional fees may apply. Call **888-852-4821** for enrollment information. If applicable, please have your customer ID and order number ready when you call.

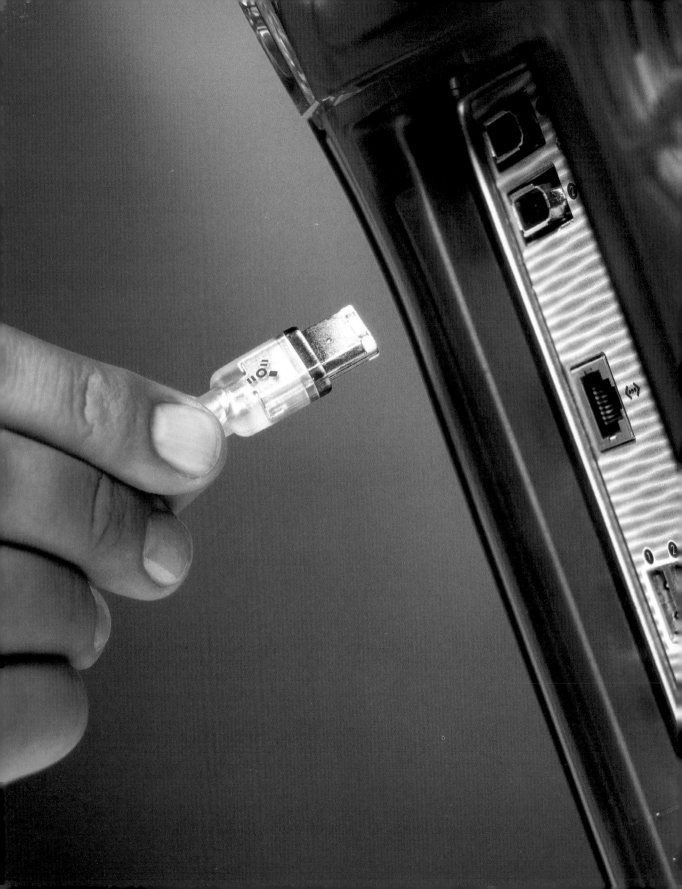

Video Hard Drive Transfer

The ability to get you video from the camcorder to the computer is a critical step toward creating a video project. This process is called "capturing," and in concept, is almost as easy as it sounds. Almost. You will need to make sure the video feed is making its way to your capturing program, and know how best to capture your raw video footage, including which formats and compression to use.

In this chapter, you will find about the mechanics of both installing a FireWire card and the video transfer process itself. By walking through the process step-by-step, you will see how to keep an eye on uptake speed, dropped frames, and other factors that indicate video transfer quality. Your transfer settings will be determined by your creative goals. Do you want to make a video CD, DVD, video for the Web, or just edit, then transfer the video back to your camcorder? You will know how to choose transfer options with those choices in mind.

Video compression options are also discussed. It's because of video compression that we have the ability to transfer and export video, and you will learn the type and degree of compression suitable for your project. You will also discover how to transfer video to your computer from an analog source, such as VHS tape or analog video camcorder. When you've applied the skills discussed in this chapter, you will be ready for computer video editing.

Installing a FireWire Card

To transfer digital video, you will need a digital video camcorder with a FireWire port, (all DV camcorders have them), a FireWire card in your computer, and a cable. Since your computer may not have a FireWire card pre-installed Let's briefly discuss how to install one.

 Your computer may already have a FireWire card and thus a FireWire port installed. If so, you do not need to install one. If you do need to purchase one, they can be purchased from most computer stores. However, many digital video programs are bundled with FireWire cards, while some sound cards, such as the SoundBlaster Audigy, come with a FireWire port built-in.

Add-on cards such as video accelerators, sound cards, and FireWire cards are inserted into expansion slots inside your computer. These slots are the thin bays designed to hold the circuit boards for various types of additional devices. Once you open your computer, you will find these slots arranged for convenient access. You need not be a computer expert to insert a card into a slot, and the FireWire card you purchased will provide step-by-step installation instructions.

Your FireWire card will be inserted into a PCI slot. PCI (Peripheral Component Interconnect) slots are shorter than older, longer ISA (Industry Standard Architecture) slots, and are generally made of off-white formed plastic (see Figure 4-1).

Transferring Video to Your Computer

With a FireWire card installed on your computer and video footage on a MiniDV tape in your camcorder, you are ready to move your video from camcorder to computer. You will use the video capture capabilities of your video editing software package. We'll begin with an overview of how video capture works, then work step-by-step with Windows Movie Maker, Pinnacle Studio 8 and Ulead VideoStudio 6.

Figure 4-1
PCI slots inside a PC computer.

Video Capture Overview

To move digital video from your camcorder to computer requires video capture software installed on your computer. However, note that video capture is one component in a video editing program. You will not have to purchase separate capture software. Capturing is usually presented as "Step 1" in a menu of editing tasks. Every video capture program has common methods and goals. They are the following:

✦ Transfers video from your MiniDV tape (or MiniDisc) and saves it on your computer's hard drive. A workspace with VCR-like controls so you can play, rewind and fast-forward through your footage without having to physically touch your camcorder.

✦ Divides your movie into scenes, or segments. Once your video is captured, these scenes automatically appear in the program's video editing workspace, where they can be moved around, deleted, or otherwise edited.

✦ Allows you to determine the video's format, frame size, and compression amount. This is important because you don't want "too much" video to work with. Too large a file will slow down your computer and makes each editing step into a major chore. On the other hand, if you choose a small frame size and high compression, you will have "too little" video to work with. The resulting movie will have a low-quality picture and be too small on the screen.

✦ Monitors the recording process. As you transfer video, you will want to keep track of elapsed time, hard drive usage, and number of dropped frames. That way, if any of these factors go awry, you can stop the process, tend to the error, and again begin to transfer.

 Previewing your video before transferring is important because since movies take up so much hard drive space, you will want to avoid transferring segments that will be of no use to you.

Before moving through the steps to capturing your video, here are important settings you want to note or modify before you begin:

✦ **Dropped Frames.** Most capture programs let you specify that recording should automatically stop if too many frames have been dropped. That's because dropped frames indicate that your computer cannot keep up with the recording. You can specify that if a certain percentage of frames have been dropped, recording should cease.

✦ **Time.** Some capture programs let you limit how many seconds of video are filmed at once. This is a great safeguard. For example, if the phone rings while you are recording and you get sidetracked, having this feature engaged could avoid inadvertently filling your entire hard drive with a single video.

✦ **Disk Space.** A safety feature similar to the above, filming stops after the movie has reached a specified file size. Use this setting to keep your movie segments manageable and easy to edit.

✦ **Automatic Scene Detection.** Some programs automatically divide your movie into scenes as soon as capture is completed. You will know this is happening when you notice the video program's workspace gradually filling up with thumbnail views of your movie, broken into segments.

✦ **Compression.** All video capture programs present you with several compression choices before recording.

Video Capture: Basic Steps

Below is an overview of the steps involved in capturing video to your computer. Although the feature names and exact process will vary from program to program, the following steps will provide a guide to let you know what's involved.

❶ Turn on your camcorder. Choose Play/VCR, rather than Record (Figure 4-2). This is the setting for playing back previously recorded footage.

 Since video transfer can involve a few false starts and take a little more time than intended, make sure your camcorder has lots of battery life left, or that your camcorder is plugged into a power source.

❷ Position computer and camcorder near each other, and plug the FireWire cable into computer and camcorder.

❸ At this point, the video editing program installed on your computer may open immediately, and display the Capture screen. If not, open the program and display video capture options.

❹ When the program first starts, note that it recognizes your digital camcorder model, and displays information about your computer. You will be informed how much video footage your hard drive is able to save.

❺ Using the VCR-like controls on the Capture screen (Figure 4-3), locate the first few frames of the video you want to upload. The computer can control camcorder playback options without you having to touch the camcorder.

❻ Review the segment you want to transfer to your computer. Make a mental note of "In" and "Out" points so that you don't inadvertently record much more than intended. Some programs let you set "In" and "Out" points, and will begin and end transfer according to your selections.

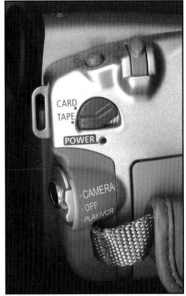

Figure 4-2 The camcorder button for switching between Record and Play (VCR) mode.

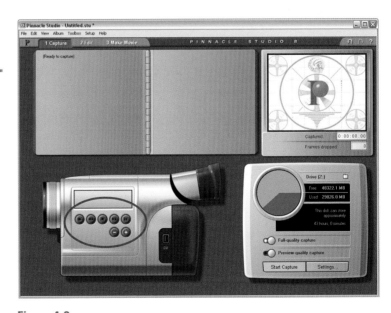

Figure 4-3

The Pinnacle 8 Video Capture screen displays VCR-like buttons for remotely controlling your camcorder.

There may be Dropped Frame and Timer options to choose, and these options vary somewhat from program to program (Figure 4-4). Settings for these options let you control the amount of footage saved onto your computer during transfer and the number of dropped frames you will tolerate. Settings for controlling the amount of footage will typically be called File Size, Time Limit, or something similar. Settings for dealing with dropped frames will be similar to Error Tolerance or Frame Drop Percentage.

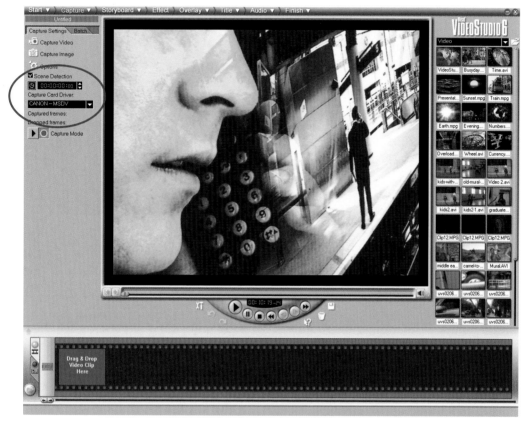

Figure 4-4 The Ulead VideoStudio 6 video capture screen displays dropped frames and elapsed time.

7 The capture program will display the folder where your video is being saved. You may or may not be given an option to change this.

8 Set compression options. These options determine frame rate, movie dimensions, audio quality, and other options.

9 As you begin recording, the capture screen may display file size, elapsed time, and dropped frame rate. Keep an eye on this information, if available, as well as when in your video you want the recording to stop.

⑩ When finished, press **Stop.** Note that the movie has already been transferred to your computer. There may appear a Save Movie dialog box so you can name your movie, but the actual transfer has taken place.

⑪ More than likely, it is your saved movie that now appears in the preview screen, not the video from your camcorder. You can safely disconnect your camcorder, turn it off, and put it away.

Your capture program may be busy detecting scenes, or may have already placed your video clip in the program's editing area so you can begin building your video project (Figure 4-5). If scene detection did not take place automatically (if your video appears as one single thumbnail, not broken into segments), you may need to locate the Scene Detection option in a menu, and start it manually.

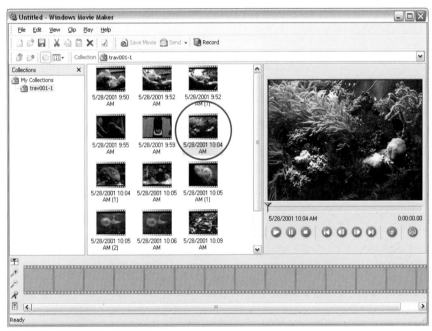

Figure 4-5 After capturing video with Windows Movie Maker, the captured video appears divided into scenes, ready for editing.

Frame Dimension

You may want to specify a frame dimension for your project. Here are some examples:

✦ If your video is destined for DVD or VHS, you can create a Wide Screen Format movie. Keep your video at 748 x 480 pixels, or see if you have a 16:9 dimension option available.

✦ Video that will be viewed mostly on a PC looks good at 640 x 480 pixels.

✦ If you are creating video for 56kbps Internet connection or slower, your movie should be about 120 x 160 pixels, almost the smallest size possible.

✦ Movies for CD distribution are generally 320 x 240 pixels.

Keep in mind that you cannot go from small to big. If you choose to transfer your video using a small frame size, you will want to avoid enlarging it. For example, if you import your video at 120 x 160, and try to enlarge it later, the quality will be poor:

 A 120 x 160 pixel movie is very tiny. Movies with detail and lots of subtle nuances will not look their best at this speed.

Frames Per Second

Another significant setting is frames per second (fps). Playback devices differ in how many frames of video they can smoothly display in any given second. Specifying an appropriate fps setting for your playback device is essential for smooth video playback. Figure 4-6 shows Pinnacle Studio 8's compression options, which include frames per second (fps) settings.

Figure 4-6 In Pinnacle Studio 8, selecting compression options includes fps settings (Framerate).

✦ If your video will be played back from a computer hard drive, DVD, or MiniDV tape, choose 30 fps. These mediums can accommodate fast video uptake.

- For video distributed in Europe (using the PAL standard), choose 25 fps

- For CD or VCD distribution, choose 15 fps. To avoid jerky video, you will want to choose this slower speed for this slower medium.

- Video on the Web moves between 6 and 12 fps.

Keep in mind that if you capture video at a slower speed, you will not be able to bump up the frame rate later. So, if you are creating a CD-based project, but you think there's a possibility you may create a VHS tape from it as well, go ahead and capture the video at the higher, 30 fps rate. You can always export your completed project at the slower rate, but you will not be able to go back to the faster speed to accommodate a faster output need.

Video Data Rate

4

Data Rate targets your video for specific transfer capabilities. For example, online video projects require a low data rate, since even DSL or other high-speed Internet options cannot support full-quality high-speed video transfer. CD-ROM-based projects also require a relatively low data rate (1100 to 1600 kilobytes per second). For VCR or broadcast video, data rate should be very high to ensure the highest possible quality.

 To learn more about connecting your camcorder to your computer, go to CD-ROM segment *Video Camera: Connecting to a Computer.*

More About . . . Compression

Your choice of video compression is one of the most significant decisions you will make at upload time. Too much compression, and your video quality suffers. Too little, and your computer chokes every time you try to make a simple edit. It's a bit like crumpling up paper into a ball. The tighter the ball, the harder it is to read the writing when you uncrumple it. Always go for the smallest amount of compression your system can handle without editing becoming a chore. When you're ready to distribute your video later on, you can decide to compress more.

Video Capture with Windows Movie Maker

Capturing video with Windows Movie Maker is convenient. Computers with Windows XP come with Movie Maker, and as soon as the computer detects a FireWire connection to a digital camcorder, the Movie Maker screen appears, ready to capture video. Let's explore how this process works:

1. With a FireWire connection established between camcorder and computer, turn your camcorder on, and switch it to the Play/VCR setting.

❷ Movie Maker may start on its own, with the Record screen up and running (Figure 4-7). If not, click **start**, point to **All Programs**, **Accessories**, then select **Windows Movie Maker**.

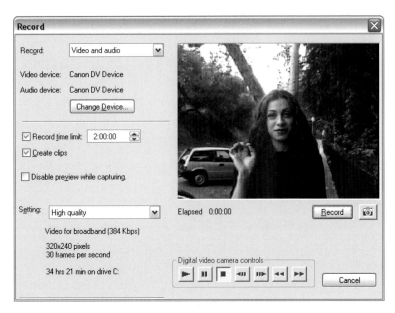

Figure 4-7 The Windows Movie Maker Record screen.

❸ Choose **File**, **Record**. The Record screen will appear.

❹ When the Record screen appears, the Preview area will be black until you press play. This is a good time to choose your record settings.

❺ In the Record drop-down menu, choose one of three options: **Video and audio**, **Video only**, or **Audio only**.

❻ In the Settings drop-down menu, choose one of the three preset video capture quality settings, or click **Other** to create a customized setting.

❼ If you click **Other**, the drop-down menu displays video transfer quality options. You have high and low compression options to choose from, and everything in between. For example, you can record full-quality MiniDV tape video without any compression at all, or record video so that it can play back on a 28.8kbps modem connection.

 If you change your setting from High Quality to Medium, you will be able to record more video. That's because when you reduce the quality, a given amount of footage will take up less hard drive space. What you give up in quality, you make up in storage capacity. The choice is yours.

❽ Before video transfer begins, the destination folder for these video files will be noted (Figure 4-8). Just so you know, some programs prompt you to specify a folder for saving your video, but most simply select it for you.

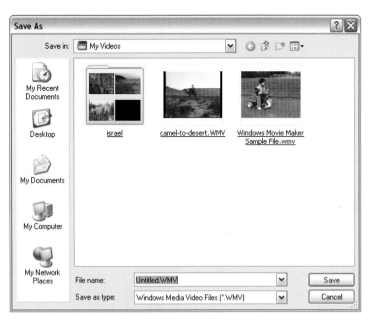

Figure 4-8 Windows Movie Maker lets you know where the video files will be saved.

9 Use the VCR controls to locate the tape position to record from. The Preview window will display the video just as it appears in the LCD.

10 Press the **Record** button that appears at the bottom right of the Preview window. The video is now being transferred to your computer. It will be displayed in the Preview window while uptake is occurring. An Elapsed Time counter displays how much video you've recorded thus far, in minutes and seconds.

11 While recording, the Record button reads Stop. Press **Stop** to stop recording.

12 A Save menu appears for naming and saving your footage. This allows you to verify the location and choose a memorable name for this film clip, should you ever need to locate it without first starting the Movie Maker program.

 Microsoft Movie Maker does not provide a Dropped Frames counter while recording. However, if you notice jerky movement while watching the Preview window during record, you can be sure you've dropped a significant number of frames. You may want to stop the transfer and start over.

Once the video is saved, Movie Maker automatically begins dividing the video into scenes. Depending on the speed of your computer, this process may be near-instantaneous, or may take a few minutes.

Video Capture with Pinnacle Studio 8

Pinnacle Studio 8 is a digital video editing program suite that offers all editing tools in one common interface. You capture, edit, and distribute video from one program. Before stepping through the capturing process, you should be familiar with the highlights of Studio 8's capture workspace, called Capture Mode. Much of your work will be completed there. Capture Mode has four sections (Figure 4-9).

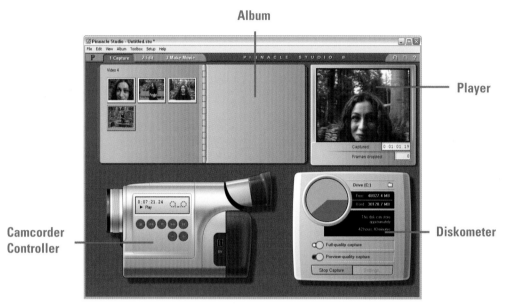

Figure 4-9 Pinnacle Studio 8 Capture Mode.

◆ The Album, on the upper left, will display your video clips as you capture them.

◆ On the upper right is the Player, which displays both the video in your camcorder before you transfer it, and the same video once it has been uploaded to your computer. Once capture has begun, the Player displays the number of frames captured and frames dropped.

◆ On the bottom left is a graphic representation of your camcorder, called the Camcorder Controller. It displays your camcorder's current mode of operation. Rather than reach for your camcorder, you can click the screen controls to operate it

◆ A control panel, dubbed the Diskometer, lets you view available hard drive space for video capture and control video transfer settings. Located on the lower right, the Start Capture and Stop Capture buttons are found here.

Before you get started capturing, one of the sections above bears more explanation. In the Diskometer, the Settings button—also accessible via the menu by clicking **Setup, Capture Source** or **Setup, Capture Format**—contains a number of important features to help you determine your capture source and capture format.

The Capture Source Tab

The Capture Source tab (Figure 4-10) confirms your Video and Audio source, and lets you choose between NTSC or PAL TV broadcast standards. You can choose the type of scene detection for your movie as well. There are two types of automatic scene detection.

Figure 4-10 The Pinnacle Studio 8 Capture Source dialog box

◆ One type creates a new scene every time you started recording (Your MiniDV tape records the date and time of each recording instance, no matter how short).

◆ The other automatic scene detection option is based on video content. If the program detects significant changes in video brightness, it will create a new scene. You can also direct the program to create a new scene at specific time intervals (ten seconds is the default amount), or create a new scene only when you press the space bar during record.

The Capture Format Tab

This very important tab lets you specify video format, type of compression, frame size, settings for specific output conditions, and so forth (Figure 4-11). There are specific options for DVD, VCD , and Video CD, but also, a capture tool unique to Pinnacle Studio 8 called SmartCapture.

Figure 4-11 The Pinnacle Studio 8 Capture Format dialog box

SmartCapture lets you capture video at "preview quality" now, conserving hard drive space and putting less strain on your computer system. When you are ready to make your finished movie, SmartCapture will recapture the scenes included in your movie at full quality, automatically locating and capturing your footage!

SmartCapture works best if the MiniDV tape which contains your footage has continuous DV timecode. If your camcorder has a timecode-striping feature, consult your camcorder's manual to learn its procedure for "striping" your tape. There are also two other ways to ensure that your tape has continuous timecode:

✦ Prepare your tapes beforehand by recording black through the entire tape to create a continuous timecode source track. To do this, put the lens cap on, and press record. Again, do this before using your camcorder to record any video, not afterwards. If you do it afterwards, you'll just erase the video you've already recorded!

✦ If you didn't have time to record black throughout the entire tape, overlap your shots if you start and stop the camcorder during shooting. Before beginning a new shot, rewind a few frames so that there are no blank spots between segments.

SmartCapture can still be used with camcorders that do not have continuous timecode, but SmartCapture will stop capturing when a break is detected. To continue capturing, you will need to cue the tape to the beginning of the next video segment, then start the capturing process again.

The Capture Format tab also lets you choose different screen dimensions and the data rate in Kbps (KiloBits Per Second). To specify a custom video Resolution and Data Rate, choose MPEG Custom Capture. You can also specify audio settings by selecting a compression type, Channel and Sample rate from drop-down menus.

Step-by-Step Video Capturing

Capturing video with Pinnacle Studio 8 is straightforward. To capture video, do the following:

1 With the FireWire cable plugged into both computer and camcorder, turn on the camcorder, and set it to the Play/VCR position. The camcorder will be detected and Pinnacle Studio 8 will start. If not selected initially, click the **Capture** menu button at the top of the screen.

2 The Player window will appear black. You must use the VCR-like controls to locate video on your tape for transfer. As you search for video on your camcorder, you will see it display on the Player window.

3 After previewing your video satisfactorily, click the **Settings** button on the lower right to choose compression and video format options for your project, as discussed in the last section.

4 Once you've selected settings, you are ready to capture video. However, if you want to change the folder where your video will be stored, you can do so. On the control panel, above the Free Space indicator is a folder button (Figure 4-12). Click this folder button and choose a folder for your video. Note that Pinnacle Studio 8 project files will also be saved into this folder.

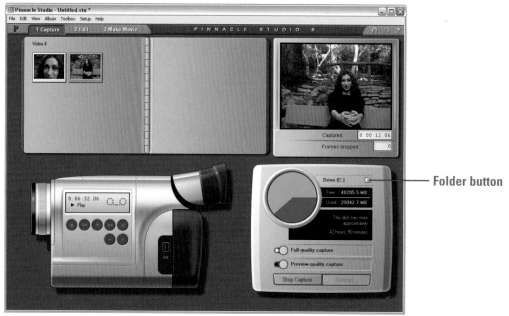

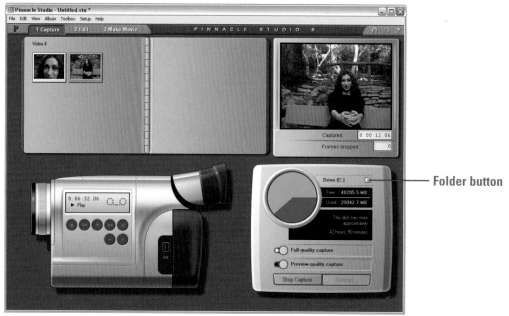Folder button

Figure 4-12 Click the folder button to verify or change where your video will be stored.

⑤ To begin capture, press the **Start Capture** button on the control panel. A Capture Video dialog box appears, prompting you to provide a name for this footage, and specify a "Stop Capturing After" time limit.

⑥ Finally, press **Start Capture**, and video transfer begins.

⑦ While transfer is taking place, note the Elapsed Time and Frames Dropped digits under the Player window.

⑧ Capture will stop when you press the **Stop** button, or when the time limit you specified in Stop Capturing After has been reached.

If you chose to capture your video as an MPEG movie, Pinnacle Studio 8 will continue to MPEG-encode the video after capture has completed. A blue progress bar appears on the screen. Be patient while this process completes. After capture is completed, your video will open in Pinnacle Studio Edit Mode. The scenes will be laid out in thumbnails, ready for editing to begin.

 To learn more about capturing video using Pinnacle Studio 8, go to Web segment *Capturing Video*.

Video Capture with Ulead VideoStudio 6

Ulead VideoStudio 6 is a popular and full-featured digital video editing program. The VideoStudio 6 interface provides a unique and convenient environment for all video editing chores. To capture video using Ulead VideoStudio 6, do the following:

1 If you haven't already done so, plug the FireWire cable into your camcorder and computer.

2 Start VideoStudio 6.

3 Before you can capture and edit video in VideoStudio 6, you must create a project. To do so, click **Start** at the top left of the screen

4 Click **New Project**. The New Project dialog box appears (Figure 4-13).

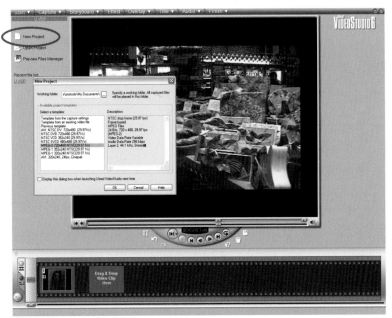

Figure 4-13 Before you can capture video, you must create a New Project.

5 Indicate a name for your project. The program will create a folder with the same name. This folder will contain your video, still images, project files, and other media associated with your project. If you like, click the folder icon to verify or change where your video will be stored

6 Under Select a Template, choose video format and compression options from the drop-down menu that appears. Click **OK** to close the New Project dialog box.

7 Click **Capture** at the top of the screen. The Capture workspace appears (Figure 4-14).

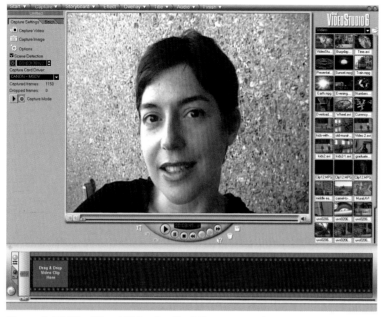

Figure 4-14 The Ulead VideoStudio 6 Capture workspace

⑧ Click the **Capture/Playback** button so that Capture Mode is selected.

⑨ To preview your video, use the playback controls on your camcorder. The video will appear in the VideoStudio 6 Preview screen.

⑩ Using the camcorder's controls, rewind the video to right before you'd like the capture to begin.

⑪ Press the **Capture Video** button. The program will start video capture.

⑫ Monitor video capture in the Preview screen (Figure 4-15). Also, note the Dropped Frames and Elapsed Time digits.

⑬ To stop capturing video, press the **Capture Video** button again. You will also have to manually turn off your camcorder.

The captured video is divided into scenes. Each scene will appear in the Video Library, on the right side of the screen (Figure 4-16). Any scene in the Library can be added to any currently open project, just by dragging its icon to the Storyboard. Although your video scenes are saved

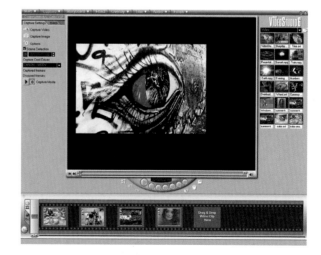

Figure 4-15 As with most video capture programs, in Ulead VideoStudio 6, you preview video and monitor capture from the same screen.

in the library, they have not yet been added to your project. To do so, click the Storyboard button at the top of the screen, and when the Storyboard appears, drag a video scene from the Library to any slot in the Storyboard.

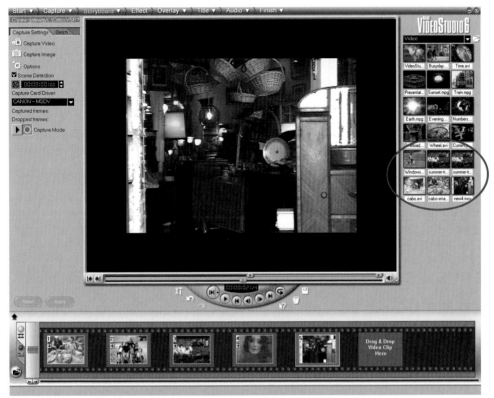

Figure 4-16 Captured video automatically appears in the VideoStudio 6 media Library.

If you exit the program now, your captured video has already been saved, but your project has not. To do so, click the **Finish** button, and choose **Save Project**. You can then choose a name for your project, save it, and close the program.

Video File Types

When video is digitized and stored on your computer, it carries information about its frame speed and size, color mode, operating system compatibility, and other playback data—in addition to the actual video data itself. These characteristics, along with the way in which the video data is arranged and stored, make up a video file format. You will know video formats by their filename. Here are the most common digital video formats:

AVI. Audio Video Interleave (.AVI) is the standard Windows movie format. Figure 4-17 shows an .AVI video file in a hard drive folder. Most any .AVI movie can be played on a Windows computer.

Figure 4-17 An AVI video file in a Windows folder.

The advantage to .AVI is that it is not highly compressed, so the quality is fairly high. You can transfer your movie from camcorder to computer as .AVI, then save it to a more portable format for output, such as MPEG or one of the Web-friendly streaming formats such as ASF or WMA.

QuickTime. QuickTime is the Apple video and media format. QuickTime movies can be played on the Web, Mac and PC computers (Figure 4-18). Recognized by the .MOV file extension, QuickTime movies are efficiently compressed, look very good, and compatible with a number of screen dimensions, frame and data rates. QuickTime is an ideal format for sharing movies across the Internet or computer-based playback. The only downside is the viewer must have the QuickTime movie viewer installed.

Figure 4-18 A movie in QuickTime.

DVD. You will use MPEG-2 compression to create DVDs, and your DVD movie creation program will walk you through the steps of preparing your movie for DVD formatting.

VCD. VCD is a CD-friendly video format that uses MPEG-1 compression to create a movie that will look good and play back smoothly on most any CD-ROM drive, 8X speed, or higher. VCD easily facilitates cataloging still images onto the CD as well as video, so you can include digital photo albums along with your movie.

SVCD. SVCD allows DVD-ready movies formatted with MPEG-2 compression to be saved onto standard CDs. Many DVD players will also play SVCD-formatted CDs. SVCD movies require fast CD-ROM drives with Pentium III computers or higher.

Video Compression and Codecs

Video compression is the science of making video files smaller by removing non-essential information. Compression is a necessary element to video editing. The goal of the technology is to provide you with a movie that is easily transportable, but still looks good. It does this by meeting other needs as well:

- Video compression is designed to accommodate a number of format requirements. For example, if your original video is 740 x 480, at 30 frames per minute, you may want to maintain that specification even after your movie is compressed, and not have to reduce your movie frame size.

- Compression is flexible. At times, you will need to reduce your movie's frame size significantly, as well as its frame rate.

- Compression allows you to choose your own tradeoff between file size and movie quality. For example, a movie to be viewed on the Web must be small in every way, and accommodate a slow frame rate. It will thus, have to be very compressed. A DVD movie can be much larger. Compression schemes let you choose the amount of compression based on your needs.

Video compression comes in many types, each using differing algorithms to remove data that affects your viewing experience as little as possible. However a compression scheme requires two components to work: First, the video is compressed. Then, when preparing to be viewed, it must be decompressed. Compression schemes are referred to as codecs, (Compression/Decompression). When saving your movie for output, you will see many codec choices. Below are the codecs most significant to non-professional videographers:

MPEG. MPEG is unique in that it compresses video by comparing each frame of video to its neighbor and throwing away redundant information. MPEG only recompresses the new information between each frame. The result is a very efficient compression and good looking movie. Currently, MPEG-1 and MPEG-2 compression are in high use, as described below:

- MPEG-1, generally used for 352 x 240 pixel movies 15 to 30 fps (frames per second) MPEG-1 is the best choice for CD-ROM movies, and small clips to be downloaded from the Web or Intranet. Because MPEG works by comparing video information from frame to frame, you should choose MPEG-1 compression after you've edited your video, not before. That's because part of the editing process is making frame cuts, which is not a tidy process on MPEG-1 video. If MPEG-1 is required, its best to choose that option at output time, not when transferring video from camcorder to computer.

✦ MPEG-2 is the compression used for creating DVDs, and is becoming the standard broadcast compression for High Definition TV and other digital broadcast requirements. The picture is large (720 x 480) at a possible 60 fields per second), looks good (Figure 4-19), and the compression is very efficient. Beyond use of DVDs and broadcast, you should only use MPEG-2 compression if the viewers will have Pentium II computers or above, or high-powered Macs.

Figure 4-19

An MPEG movie in an MPEG viewer.

Sorenson. Sorenson works well with 320 x 240-pixel footage when played back from a hard drive, or Internet connection faster than a dial-up, such as DSL or ISDN. It is not a preferred method for compressing video for CD-ROM drives. One issue with Sorenson is it takes a long time to encode. That means if you select Sorenson as your output choice, you will be waiting a long time for the job to complete.

Intel Indeo 4 and 5. The Intel Indeo codecs produces high-quality .AVI video with decent compression rates for fairly fast computers. With Indeo-coded .AVI movies, if the viewer does not have the correct codec installed, the program playing back the movie will try to open an internet connection and download it. .AVI with Indeo is a good choice for transferring video to your computer from your camcorder. You can edit your .AVI file, then choose a more portable, highly compressed option for your final output.

Cinipak. If your movie will be played back on older computers or older CD-ROM drives, choose the Cinepak codec. It is already installed on most machines. Cinipak can be used efficiently for movies 320 x240 pixels or smaller. Its real value is its usability on even old 486 computers. There's no real reason to choose this codec if all your viewers will be playing your movie on computers that are less than five years old.

Capturing Analog Video

You can use your digital camcorder to facilitate digitizing older movies. Your old VHS, Super 8, and other analog tapes can be made digital, and be edited and archived just like other digital movies.

Many digital camcorders—the Canon ZR45 and ZR50, for instance—provide an S-Video input, and some provide a complete set of analog line-in and line-out connections. Also, many newer VCRs and analog camcorders have S-Video connections. Using these, you can transfer your movie to digital camcorder MiniDV tape, or directly to your computer. These are used to digitize movies from your analog tapes, such as VHS or Super 8. If you have movies on VHS that you want to make more permanent, you can make digital copies by plugging a cable into the Analog Line-In connection of your camcorder. This option requires that your output device (VCR or analog camcorder) have an S-Video connection. After doing this, you have a choice.

You can record the VHS data onto a MiniDV tape. To do this, simply have a tape in the camcorder and press record as you begin playing back the VHS tape. Once you have your digital MiniDV master, you can then send it to your computer via FireWire for editing, if you desire.

The other option is to save your VHS data directly onto your PC, essentially using the camcorder as a digital converter. The Canon camcorders mentioned here have this capability. Two cables are required, one from the VHS to the camcorder, and the other from the camcorder to the computer. The camcorder-to-computer cable would be FireWire. You would then capture the video via FireWire card using the same tools and methods previously described. You would press Play on your VCR, and Record on your video capture program on your computer. The camcorder would simply allow the data to pass through.

Go to the CD-ROM and select the segment:

✦ *Storage Options* to explore the different storage options available.

✦ *Video Camera: Connecting to a Computer* to learn more about connecting your camcorder and your computer.

Go online to **www.LearnwithGateway.com** and log on to select:

✦ *Capture, Create and Share Digital Movies*
✦ *Internet Links and Resources*
✦ *FAQs*

Gateway offers a hands-on training course that covers many of the topics in this chapter. Additional fees may apply. Call **888-852-4821** for enrollment information. If applicable, please have your customer ID and order number ready when you call.

4

Video Project Editing

In terms of technological evolution—some would say revolution–digital video editing has finally arrived. The quality, performance, and features of today's crop of video editing applications are light-years ahead of what was available less than a decade ago—and back then, it would have cost you a small fortune and years of your time just to learn how to edit! Today, video editing is not only affordable, it's fun, reliable, and will allow you to produce compelling videos without needing a degree in film editing.

In this chapter, you will take the first important steps towards editing a video project. Whether your project requires removing a little unwanted footage or a more extensive rearrangement of your material, this chapter will teach you what you need to know. You will learn the process of assembling and editing your video down to the length you need. You will also discover transitions, and how to set them up just the way you want them. In later chapters, we will discuss adding images, music, and special effects.

Digital Video Editing Software - A First Look

You may have heard that digital video editing is "non-linear." In a very real sense, this is true, since, unlike the days before digital editing, you do not have to physically cut and splice film or tape from beginning to end.

In another sense, video editing is still very much a linear process. From a creative standpoint, most good videos have something resembling a beginning, middle, and end. This is also true on a practical level, where you will take the same steps time and time again on the road to a completed project. The fundamental steps to editing any video project are:

1. Gather video files for your project.
2. Assemble video clips on a video editing storyboard or timeline.
3. Cut away undesirable footage.
4. Position repeating segments.
5. Add transitions.

These steps are covered in detail in this chapter using three popular and easy-to-use video editing programs.

Essential Definitions

Before diving into the process of video editing, let's review some important terms you will need to know:

- **Video clip.** A video clip is the source video, or raw video footage, that you will use in your video project. Though most of your raw footage will likely be video you've captured using your camcorder, you can also use video clips from other sources. Nature videos, footage of historical events, or video captured from broadcast are examples.

 Before using video from another source, always obtain permission to use it from the owner of the video.

- **Video scene.** A video clip is divided into many video scenes. A video scene is the small snippet of film you drag from a video library, album, or collection in your editing program and add to your presentation. How do you get scenes? When you capture video, your video capturing program looks for natural divisions in the video clip, and divides it there. These divisions are determined either by sensing at what points the camera was turned on and off during filming, or just based on where the content appears to shift.

- **Movie.** A movie is your final video output—your finished production. It is what you save and share with your friends, family—even the world—when you have finished editing your project. You can output your project in several ways. For example, you might make a copy of your movie on DVD, and viewers could simply pop it into their DVD player and see your work. You could spin the same project into a Web-based movie, optimized exclusively for Web viewing.

- **Video project.** A video project is the collection of all your video and media elements in one place. You assemble, edit, and archive your video clips, scenes, and movies using your video editing program and a little imagination.

The Basic Video Editing Workspace

A common element of a video project is an editing workspace, which typically gives you two views of your video clips. These views provide the ability to add or delete video clips, text, images, sounds, and special effects. Think of the workspace as the factory floor, where all the assembly, building, and inspection of your video takes place. A workspace includes several elements:

- A preview or playback window for viewing individual video clips or project playback (Figure 5-1)

- A control panel with VCR-style controls for playing, rendering, fast-forwarding, and rewinding video playback, including "one-frame-at-a-time" controls (also shown in Figure 5-1)

- A library or resource area to display video clips, images, transitions and special effects (Figure 5-2)

- An editing area where you will sequence, trim, and combine your video clips, and build your project (Figure 5-3)

Jog buttons

Player scrubber

Figure 5-1 The Pinnacle Studio 8 player.

Figure 5-2 The Ulead VideoStudio 6 Media Library for video editing.

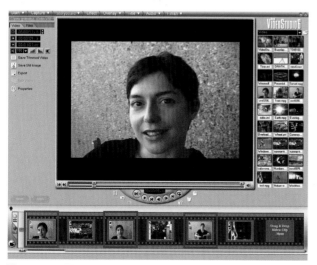

Figure 5-3 The Ulead VideoStudio 6 workspace.

 To avoid losing your work, save your projects frequently. Because video editing programs handle such large files, your computer could reach its memory limit and require an unexpected restart.

The Video Project Working Folder

Most of the files you pick to create your video project are located in what we will call a video project working folder. This folder was probably created automatically when you captured video from your camcorder. In this folder you will find the following types of files (Figure 5-4):

Figure 5-4 A folder with files for a video-editing project.

♦ **Captured video footage.** These files, produced by your camcorder, will be large. They will probably have a .AVI or .MPG file extension, depending on what type of file you created when you captured your video.

♦ **Edited video.** Most editing software will create a copy of your video and edit that copy, leaving your original footage safe.

♦ **Project file.** When you open a video editing program and develop a project, it creates a file that keeps track of all your edits, where you want the video cut, where you want music added, transitions added, etc. This is the file you click on in order to edit your project, and it's this file that you save in order to keep all your changes intact and available for further editing later.

♦ **Output file.** You will not see the output file until you are done editing, and are ready to create your movie. An output file is your completed work. It will probably have a .MPG, .AVI, or .MOV file extension. This is the file you are sharing with the world, and it will be compressed, smaller than your original video footage, perhaps much smaller depending on the options you choose.

Basic Video Editing

You will now learn basic video editing tasks using three different video editing programs: Microsoft Windows Movie Maker, Pinnacle Studio 8, and Ulead VideoStudio 6. Video editing is where you'll spend the bulk of your time developing your project, and while each program performs similar functions, each does so uniquely. By taking a look at all three, you will get a better understanding of the overall editing process, in addition to learning how to use each program's editing features.

As you go about the task of editing video, you will discover that previewing any changes you make, as quickly as possible, is an important requirement. You will also want the pieces and parts of your video project—your video clips, other images, sound or audio information—at your fingertips. Finally, you will need some space to assemble everything together so that you can preview your work, and then start the process of adding, deleting, editing, and assembling your movie all over again.

Basic Video Editing Windows Movie Maker

Windows Movie Maker is a basic video editing package. Though it doesn't offer some of the frills and thrills of programs like Pinnacle Studio 8 and Ulead VideoStudio 6, you can use Movie Maker to record both audio and video source material, import source files, then edit and arrange your video clips to create movies. Best of all, Movie Maker is

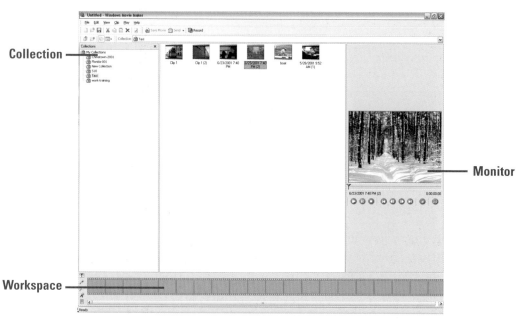

Figure 5-5 The Windows Movie Maker GUI (Graphic User Interface).

included with Windows XP, and has a stable and well-designed interface, and which is divided into three main areas (Figure 5-5):

- ✦ **Monitor.** A playback or preview screen where editing is monitored.

- ✦ **Collection/Collections area.** An album or library of videos, images, or other media such as audio, to be used in your project.

- ✦ **Workspace.** An assembly area where clips and scenes are edited, and elements such as text overlays or special effects are added.

The Monitor

The Monitor (Figure 5-6), displays a video clip as you are previewing it. After you've added a video clip, the monitor also shows where the clip appears as part of the project. Below the monitor is the Seek Bar that tells you the current playback position. To the right of the Seek Bar is a clip counter. It counts time as you play back the clip.

If you drag the Seek Bar along the length of the clip, you will see the counter change. Use the counter to note exactly where you are in a clip, down to the hundredth of a second. This is important, because you ideally want to trim or cut a video clip at a point where the subjects are not in mid-movement, so having a very accurate clip counter helps you keep your cuts precise.

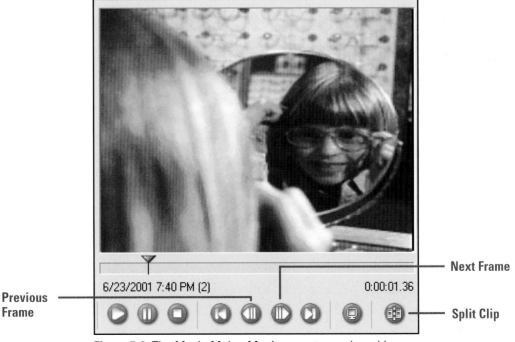

Figure 5-6 The Movie Maker Monitor use to preview video.

The Collections Area

Movie Maker organizes your video, images, and sounds into a Collection, which is a Windows Explorer-like interface including a folder view and the Collections area, which allows you to view your source media in thumbnail, list, and detail views.

To add new media to your project, right-click the folder view on the left-hand side of Movie Maker, choose Import, and locate a folder on your hard drive that contains videos, images, sounds, or any other media you want to add to your project. Alternately, you can simply drag-and-drop the media to the Collections area. To actually add a video clip or other media type to your project, just drag it to the storyboard at the bottom of the screen.

The Storyboard/Timeline View

At the bottom of the screen is where your project is assembled. In Movie Maker, this is called the Workspace. There are two project views: Storyboard and Timeline. You can switch between views by clicking the button at the upper left of the storyboard (Figure 5-7).

Switch view button

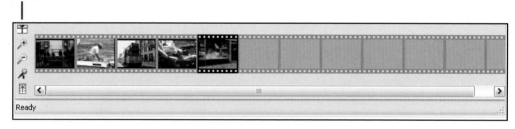

Figure 5-7 The Movie Maker Storyboard/Timeline workspace.

The Storyboard View

The Storyboard view shows you each video or still image in your project as a thumbnail. Viewing from left to right, you can see the order in which your video project's components will be played back. In Figure 5-8, you can see six media items on the Storyboard.

While in Storyboard view, you can drag a clip in between other clips. To do so, just select the clip and drag it to the space between the two clips already in the storyboard.

When you click on a thumbnail on the storyboard, it appears in the monitor. You can then drag the Seek Bar to any location in the clip for trimming or editing. Click another thumbnail on the Storyboard, and that clip will appear in the monitor.

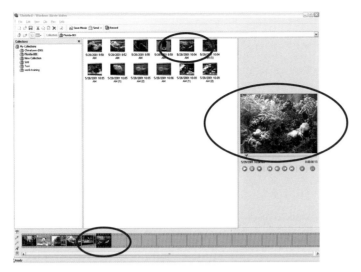

Figure 5-8 A work in progress in the Movie Maker Storyboard view.

The Timeline View

To see more of a frame-by-frame view of your project, use the Timeline view (Figure 5-9). In the Timeline view, your movie is shown right below a time ruler, so you can see exactly how long each clip is. You can then drag the clip to the right or left. Drag from the middle of the clip, and it will be repositioned on the timeline, making playback begin earlier or later. Drag from the clip's edge, and the clip's total playback time will be shortened or lengthened.

First Clip Here

Figure 5-9 The Movie Maker Timeline view.

Second Clip Here

Editing with Windows Movie Maker

The most basic video editing using the Storyboard view involves the following steps:

✦ Dragging a clip from the Collections area to the Storyboard

✦ Trimming the clip if needed

✦ Adding a second clip to the Storyboard and trimming it

✦ Adding a transition between the two clips

When you capture video in Movie Maker, it is automatically added to the collections folder on the left side of the screen. Adding videos to the Collections area makes all the videos available for your projects.

To add a video clip to your project, drag a clip onto the storyboard, at the bottom of the screen (Figure 5-10).

By default, the Storyboard view of your project is displayed. If you see the Timeline view instead (a single strip with a Time ruler across the top), then click the icon at the upper left of the timeline, and the Storybook view will appear.

Figure 5-10 Adding a video scene to a project in the Storyboard view.

Trimming Footage

To trim footage from the beginning of the video clip (to make it start later), select the video clip as it appears in the Storyboard, and click the **Play** button at the bottom left of the Monitor. When you reach the area you want to use as your new starting point, press **SHIFT + CTRL + Left Arrow** key. The video will stop playing, and the point at which you pressed the keys will be the new starting point.

Another way to trim to a new start point is to drag the Seek bar until the desired start point is reached. Select Clip from the Menu bar, then choose Set Start Trim Point.

To trim footage from the end of the video clip (this will make it end earlier), select the clip and click Play. When you reach the desired endpoint, press **SHIFT + CTRL + Right Arrow** key. Alternately, drag the **Seek Bar** to the desired endpoint and select **Clip**, then choose **Set End Trim Point**.

When you're done, you will have a nicely trimmed video clip as the opening of your video project.

Adding a Second Clip

To add a second video clip or scene to this project, just drag it in from the Collections area, positioning it on the frame just to the right of the first clip. To trim the second clip, just click on it in the Storyboard, and use the same trimming process described in the previous section.

Playing Back Your Project

To play back a single clip, select it in the Storyboard view and click the **Play** button. To play the entire project (all the media currently on the storyboard), select **Play** from the Menu bar, then choose **Play Entire Storyboard/Timeline**.

Remember to save your project. Choose **File**, then click **Save Project** or **Save Project As**.

5

Basic Video Editing with Pinnacle Studio 8

Pinnacle Studio 8 is a polished and intuitive video editing application. In fact, after just one editing session you will find editing with Studio 8 particularly easy, considering the power behind this workhorse of an application.

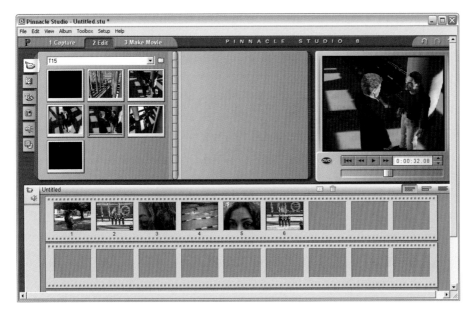

Figure 5-11 Pinnacle Studio 8's Edit mode.

Video editing using Studio 8 is accomplished by entering Edit mode. To edit a movie in Studio 8, click the Edit tab at the top of the screen. The editing workspace appears, divided into three segments (Figure 5-11). The Album, at the upper left, displays video clips and other media resources, arranged as if in a photo album. The Player is located at the top right, while the storyboard/timeline area—dubbed the Movie Window in Studio 8—is at the bottom.

Using the Album to Access Video Clips

Along the left side of the Album are six tabs, each providing access to different resources for video editing.

 In this chapter, the Show videos and Show transitions tabs are covered; subsequent chapters will discuss the other tabs.

When you click the first one, Show videos, a thumbnail view appears of your video scenes and clips. You can access other video clips and scenes by clicking the folder button at the top of the Album, to the right of the drop-down menu. When you browse to a new folder and click on a video, Studio 8 will divide that movie into scenes and display them in the album.

You can draw from more than one set of video clips, by clicking the drop-down menu and selecting a folder of videos, or using the folder icon at the right. All the folders with video clips you have recently accessed will be available in that drop-down menu.

 It is important that you do not move a movie clip to a new location on your hard drive after adding it to your project. If you do, then the next time you edit your project, the program will not be able to locate your video and add it to the project.

The Player

To the right of the Album is Studio 8's playback screen, called the Player. The VCR-like controls at the bottom allow navigation through video clips and the project in progress. To play a video clip or segment from your project, click its thumbnail, and click the **Play** button beneath the Player.

You can also use the Seek Bar—called the Player scrubber—beneath the Player for scrolling through your project or video clip. Drag it right or left, and you can move to any point in your clip or project.

For precise playback control, use the Forward one frame button or Backward one frame button—also known as Jog buttons— on the right side of the Player. To scroll through your video clip frame by frame, click and hold on either button.

The Movie Window

The bottom half of the Studio 8 editing workspace is the Movie Window, which is where you have access to both Storyboard and Timeline views.

 Studio 8 also provides a third view—the Text view. The Text view is a unique area in Studio 8 where you can see a list showing the start and end times, name, and duration of each video clip in your project. You can click on the icon to the far right side of the Movie Window to enter Text view.

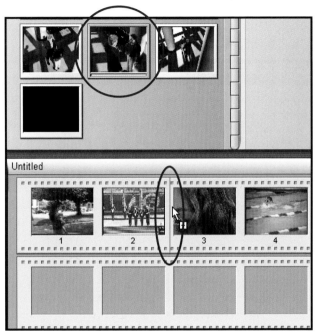

Figure 5-12 Inserting a scene between two existing scenes.

The Movie Window is where clips and other media resources are assembled into projects. To add a video clip or resource to a project, drag its thumbnail from the Album to the Movie Window. The Storyboard view appears by default, but you can switch to Timeline view by clicking the Timeline view icon at the upper right of the Movie Window. Scenes and clips from your album will appear here as slightly larger thumbnails.

You can rearrange items on the Storyboard by dragging and dropping. For example, you can insert a scene between two others by dragging and dropping on the space between the two scenes (Figure 5-12). As a result, all scenes to the right of where you dropped will move to the right one panel.

Click each frame in the storyboard, and it will appear in the Player. As you do, you will notice the Player scrubber will move to where each video appears in the project.

Trimming Video with the Clip Properties Tool

As you become more creative with your video projects, you will very often want to adjust where a clip begins playing back and where it stops. This is one of the most fundamental editing tasks, and even as your skill with the camcorder grows, you will rarely want to use an entire video clip in its raw form.

Adjusting the "in" and "out" points of a video clip to remove footage you don't need is called "trimming."

Trimming video does not actually delete any video. Studio 8 sets new trim points for the clip in the Movie Window, but does not alter the video clip. This makes it easy for you to select different in and out points, or restore a video clip to its original state.

Studios 8 has very precise trimming controls, allowing you easily view and isolate an exact frame for your start and end trimming points. Here's how to trim a video clip in the Studio 8 Storyboard view:

1 Double-click on any video as it appears in the Storyboard. The clip will appear in the Clip properties panel (Figure 5-13). Views of the beginning and ending of your clip will appear. At the bottom of the Clip properties panel are two "slicer" icons.

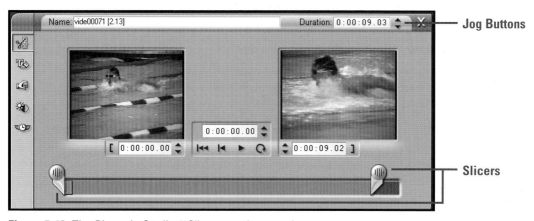

Figure 5-13 The Pinnacle Studio 8 Clip properties panel.

2 To set the starting trim point, drag the slicer icon on the left. As you drag it toward the right, the clip view advances to display your starting point. To select a point with exact precision, click the Forward one frame or Backward one frame buttons at the upper right of the panel.

3 To set an ending trim point, drag the right-most slicer icon. As you drag it in towards the left, the clip view beneath it rewinds to your new end point. To select a point with exact precision, click the **Forward one frame** or **Backward one frame** buttons, in the middle of the panel (Figure 5-13).

4 As you set starting and ending points, the Duration counter at the upper right of the panel displays the new clip duration, updated with each adjustment you make.

5 To preview the resulting trimmed clip, click the **Go to trimmed part of clip** button, found in the center of the panel. This rewinds the clip to the trimmed beginning point.

6 Finally, click the **Play trimmed clip** button (Figure 5-14). You will see the playback on the Player, not inside the Clip properties panel. The two views inside the panel are only there to navigate to your trimming points, not to display video playback.

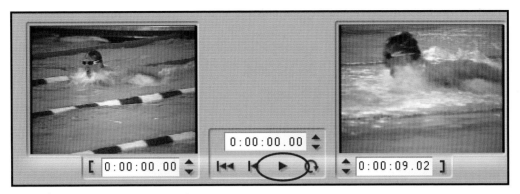

Figure 5-14 The Play Trimmed Clip button.

The changes you make to your clip are instantaneous. There is no "Apply" or "OK" button. If you make a mistake, you can use **CTL+Z** or select **Edit**, then choose **Undo Trim start** or **Undo Trim end** to undo your work. To close the Clip Properties panel, click the **X** at the upper right of the panel.

 You can edit another clip with the Clip Properties panel still open. Just click on the clip you want to edit in the Movie Window.

 To learn more on trimming scenes using Pinnacle Studio 8, go to the Web segment *Scenes: Trimming*.

Trimming Video on the Timeline

The Timeline view in Pinnacle is great for making precise video cuts. For instance, if you want to remove a segment of a scene where the subject appears awkward, use the Timeline view to zoom down right to where the unwanted segment begins, make your cuts, and then delete it. To switch from Storyboard to Timeline view, click the Timeline view icon at the upper right of the Movie Window.

Zooming in for Precise Cuts

The following steps show how to make precise cuts by adjusting the zoom level of a clip in the Timeline view:

1. Insert a video clip on the Movie Window view. You will see only the thumbnail, not a frame-by-frame view.
2. Position the mouse over the video and over the **Timescale** (yellow ruler) at the top of the Movie Window. The pointer changes to a clock with two arrows (Figure 5-15).

❸ Click and drag to the right or left. Drag to the left and the time span in view is lengthened. You will notice that, rather than viewing, for example, five seconds of video in on your timeline, you are now viewing eight seconds. The result is that when you drag your mouse over the Timeline scrubber bar on the timeline, your movements cover more territory.

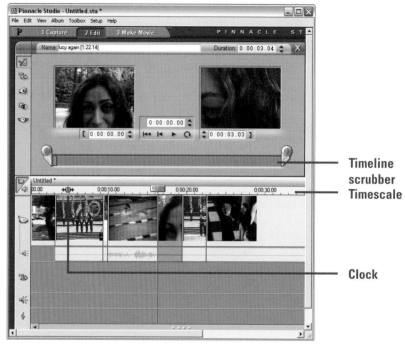

Figure 5-15 When changing time on the Timeline, the Time Ruler clock appears.

❹ Drag the **Timescale clock** button to the right, and the time span you are viewing is shortened. You will be viewing, for example, a single second of video on your timeline, rather than five.

❺ To make the cut, drag the **Timeline scrubber** bar where you want to the cut to occur, and click the **Split Clip** (the razorblade) button.

❻ You can then delete the entire video segment to the right or left of the cut by clicking either segment, then clicking the **Delete Clip** the (trashcan) button.

Isolating and Cutting a Scene Segment

To isolate a video segment and delete it, you make two cuts by performing the following steps:

❶ Make a cut at the beginning of the segment you want to delete.

❷ Use the Timeline scrubber bar or drag the Player scrubber (in the Player) to move to the end of the segment you want to cut.

❸ When you reach the end of the segment you want to delete, **Split Clip** button.

❹ Click the mid segment—the segment you want to delete, and then click the **Delete Clip** button. The segment will be deleted, and the two ends will automatically be joined.

 You can use this procedure to do the reverse: To isolate a mid-segment of video you would like to keep, simply delete the video at either end, leaving only the mid-segment on the timeline for editing.

When actually clicking a segment of video to delete it, you may want to momentarily switch to Storyboard view. It is easier to see exactly what video segment you are clicking, when only viewing thumbnails.

To learn more about splitting scenes using Pinnacle Studio 8, go to the Web segment *Scenes: Splitting*.

Basic Video Editing with Ulead VideoStudio 6

Video editing in Ulead VideoStudio 6 is a straightforward process. Using VideoStudio's Video Track in either Storyboard Mode or Timeline Mode, you can place thumbnails of video, image, color clips, and transition effects, then drag the thumbnails from location to location. This section will lead you through the basic editing process by adding two video clips to the Storyboard.

Starting a New Project

First, you will need to create a new project. This involves designating a folder for project resources, and naming and describing the project.

5

❶ Click **New Project** button at the upper left of the VideoStudio screen. When the New Project dialog box appears, note the Working folder where the project will be created; accept this location or designate a new one using the Location field.

❷ Name your project and type in a description. VideoStudio will create a folder with the same name. This folder will be where your VideoStudio project files are saved.

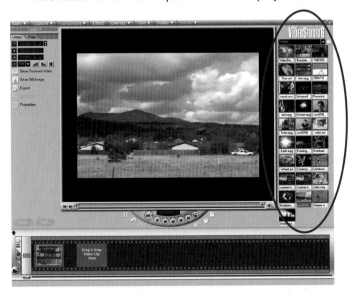

Organizing and Adding Project Media

On the right side of the screen, you will see the Library, which contains VideoStudio's tutorial videos, the video scenes you captured previously (Figure 5-16). When you create a new project, thumbnails for media files for that project appear in the Library.

Figure 5-16 The Ulead VideoStudio 6 Library.

Though this chapter deals only with trimming and basic video editing, the Library drop-down menu contains a complete library of transitions, special effects, color frames, and starter files for building your project. Here's how to access media resources in that menu, and view items in the VideoStudio Preview screen:

❶ Click the drop-down menu above the Library, and you will see five sections: **Video**, **Image**, **Color**, **Video Filter**, and **Library Manager**. The first four sections are media types. Each section contains lots of media files to get you started on your creation.

❷ To locate the folder where you've set aside videos and images for your project, click the **Load Video** button in the upper right-hand corner (Figure 5-17).

❸ Navigate to the folder that contains your videos and images

❹ Select the video, and click **Open**. When you do, the video's first frame will appear in the Preview Window. The video will also appear in the Library for this project

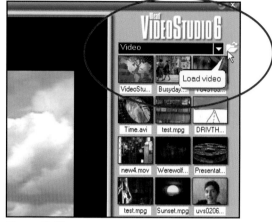

Figure 5-17 Adding Media to the Library.

❺ To make the new video clip part of your project, drag it to the Storyboard (Figure 5-18).

❻ Note the control buttons located beneath the Preview Window. After dragging your clip to the Storyboard, preview it by clicking the **Play** button.

Trimming Video Clips Using Shortcut Keys

If the video clip you inserted could use a little trimming at the beginning, here's how to fix it:

❶ Click the **Play** button. Play right past the point that you want to mark as your In point.

❷ While the video is still moving, mark your In point by pressing **F3**. Your video clip now begins at the point at which you pressed **F3**. The video will stop playing.

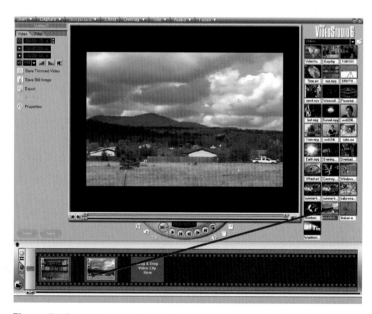

Figure 5-18 Adding a video clip or scene to a project.

③ You can now set your Out point. When the video reaches the point where you want the clip to end, press **F4**.

④ Your In and Out points have been set.

⑤ For your change to take effect click the **Apply** button on the lower left side of the screen (Figure 5-19).

If you need to finesse the In and Out points more precisely, and you want the clip to begin a few frames later or earlier than the point at which you pressed **F3**, do the following:

① Click the Control Panel's **Previous** or **Next** buttons. These buttons advance or rewind your video one frame at a time (to advance or rewind multiple frames, keep pressing the buttons).

② When you're happy with your In point, press **F3**.

Apply button

Figure 5-19 Click the Apply button to lock in your edits.

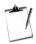 In addition to using F3, you can also use the Mark In and Mark Out buttons

③ Follow the same steps to set a new Out point, pressing **F4** when you have zeroed in on the exact position you want your clip to end.

④ Click the **Apply** button.

⑤ To view your clip with your new In and Out points in effect, press **SHIFT** while pressing the **Play** button beneath the Preview Window. If you click **Play** without pressing **SHIFT**, playback will start at the true beginning of the clip—not your designated endpoint.

To add a second video segment in your project, do the following:

① Click any video clip in the Library, and drag it to the second frame in the Storyboard area.

② To render this project and play it back, click the **Play Project** button. The two video clips will play sequentially, left to right.

Trimming Video Clips Using the Trim Bar

The following steps show how to trim the beginning of the video clip that you inserted:

① Click and drag the left side of the **Trim Bar** toward the right (Figure 5-20).

② Stop at the point at which you want this video clip to begin.

③ To make your change effective, click **Apply** on the lower left of the screen.

④ To fine-tune your video entry point, use the Control Panel's **Previous** and **Next** buttons.

 Make sure to do your fine-tuning after using the Trim Bar. Otherwise, the Previous and Next buttons are not available.

5 After each change, click **Apply**.

6 To adjust this video clip's Out point, drag the right end of the green trim bar toward the left. This shortens the video clip, moving the clip's Out point to an earlier point.

7 Click the **Apply** button.

You now have two video clips in your project, each with edited In and Out points. To play your trimmed clips, press SHIFT while pressing the Play button.

Figure 5-20 Create an In Point using the Trim Bar. **Trim Bar**

Saving the Project

Ulead VideoStudio 6 doesn't have the typical set of Windows menu items at the top of the screen. To save your Ulead VideoStudio 6 project, do the following:

1 Click the **Finish** button at the upper right of the screen.

2 Choose the **Save Project** button to the left of the Preview Window.

This action does not render your movie or create a file. It merely saves your VideoStudio project, so that if your computer crashes, you won't lose your work.

Cutting and Deleting Video Segments

While it is easy to trim a video's In and Out points, removing a segment from somewhere in the middle of a video requires more effort. The next sections show you how to:

✦ Make two cuts in your video.

✦ Isolate the segment you want to remove.

✦ Delete the middle segment and drag the two remaining ends together.

Defining the First Cut Point

To mark the first cut point of your video segment, follow these steps:

1 Click the **Storyboard** button at the top of the screen.

2 Insert a video clip into the editing area. You will be making your edits in **Timeline Mode.** To switch

to Timeline mode, click the Storyboard menu option at the top of the screen, and click the **Switch to Timeline Mode** button to the left of the Storyboard.

③ Click **Play** and proceed to the first cut point, and use the Next and Previous buttons to zero in on the point precisely.

④ Click the **Split Video** button (Figure 5-21). The movie clip will now be divided into two parts. You will see the thivk yellow boundary seperating the parts.

Figure 5-21 The Split Video button is available when a video in the project is selected.

Defining the Second Cut Point

Isolate the area to be deleted by cutting the second clip where the "good" section starts. On the second clip, everything to the left of this cut is material, which will be deleted using the following steps:

① Click inside the second video section. Play back the video to the end of the point you want to remove.

② Zero in on the exact point by using the Previous and Next buttons on the control panel.

③ Click the **Split Video** button. You will now have three video clips (Figure 5-22) divided by two yellow lines.

④ The middle clip is the one you want to delete. Right-click on the middle clip, and click **Delete** from the shortcut menu that appears.

⑤ The unwanted segment is deleted.

Adding Transitions

A transition blends one video clip into the next, using everything from a simple fade, wipe, or dissolve, to geometric shapes and patterns, special animations, and changing colors and sizes. In fact, there are some transitions which almost defy description—you will discover them for yourself as you browse through the different effects available in both Pinnacle Studio 8 and Ulead VideoStudio 6.

The duration of a transition is important. Though video editing programs apply transitions using a default length, you can edit the duration, creating an instant transition or an extra-long fade. Studio 8 and Ulead Video Studio 6 both give you the ability to setup transitions the way you want them.

Creating a Transition with Pinnacle Studio 8

Transitions are a drag-and-drop affair in Studio 8: You first display the Transition section in the Album, then choose a transition and drag it between two clips. At least one clip must be present in the Movie Window. You can drop transitions between two clips in the Timeline view, but it's a little easier to verify your placement using the Storyboard view. Here's how its done.

Clips divided by yellow border

Figure 5-22 Three video clips created by cutting.

1. Click the **Show transitions** tab on the left side of the Album. The Album now displays a page of transitions (Figure 5-23). To see additional pages, click the arrow at the upper right of the album. The drop-down menu at the upper left provides access to many transition types, including **Alpha Magic**, **HFX Wipes and Fades**, and **Hollywood FX** (discussed below).

2. You will want to preview the transition to see the type of effect it creates between clips. To do so, double-click it, and the transition alone will appear in the Player. The transition is displayed over what is known as an A/B Roll. As such, the letter "A" represents the first clip, the letter "B" represents the second.

3. To apply a transition between two clips, drag it from the Album to the space between the clips.

4. To preview your transition as it appears with the clips, just click the first clip on the Movie Window, and click **Play**.

To delete a transition from a project in Studio 8, click the clip, then click the **Delete Clips** button at the top of the Movie Window.

Studio 8 includes a large group of dramatic transitions, some with complex 3D graphics, called Hollywood FX. These effects work particularly well for opening sequences, sports footage, and music videos. Demo versions of other Hollywood FX effects are also included, and are watermarked with a Pinnacle "P." If you like the demos, you can purchase the real versions by clicking the large Pinnacle Hollywood FX button in the Album, which links to the Pinnacle Web site.

Hollywood FX transitions also include a special editor (Figure 5-24), which lets you

customize transitions by giving you control over settings like angles, direction, shadows, lighting and anti-aliasing (edge smoothing). Dubbed the Easy FX editor, you can access it by double-clicking a Hollywood FX transition in the Movie Window, then by clicking the **Edit** button in the Clip properties window.

 To learn more on adding transitions using Pinnacle Studio 8, go to the Web segment Transitions: Adding.

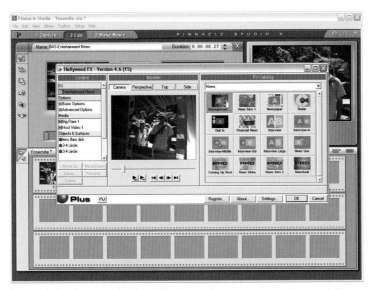

Figure 5-23 The Pinnacle Studio 8 Transition section.

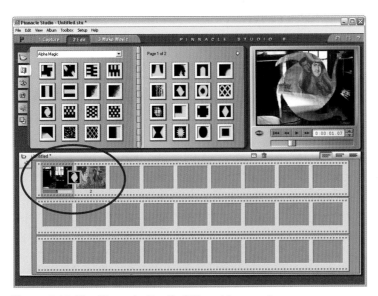

Figure 5-24 Pinnacle's EasyFX editor gives you complete control over Hollywood FX transitions.

Creating a Transition with Ulead VideoStudio 6

Ulead VideoStudio 6 provides a library of many fade types, and they're all applied in the same way, simply by dragging a Transition thumbnail down between two clips. Note that "clever" fades, such as clips that explode into boxes or shatter into glass-like shards, can be rather tiring to watch repeatedly. Keep in mind that most professional movies use simple fades, or just cut to the scene.

1 Click the **Effect** tab at the top of the screen. The Library now displays transition effects (Figure 5-25).

2 While in the Library, each transition effect is displayed in motion, which previews the transition's action. In a transition preview, the letter "A" represents the first video in the transition. The letter "B" represents the second video, the clip that begins playing after the transition has passed.

3 To select a transition, click the drop-down list to the upper right, which reveals many transition categories.

4 Select a category and a new set of transitions will appear in the Library.

5 To add a transition to your project, drag it to the space between any two clips.

6 Click **Play**, and the transition will appear. You will see the blend between the two clips take place. Until you render the project with the transition, it won't look very smooth in the Preview window.

7 Edit your transition using the controls on the left. Consider modifying the transition length if the default duration does not meet your needs.

 Transition controls will be available as long as the transition is selected in the Storyboard. If you click on the Storyboard outside the transition, select it again by clicking. The controls for the transition will appear.

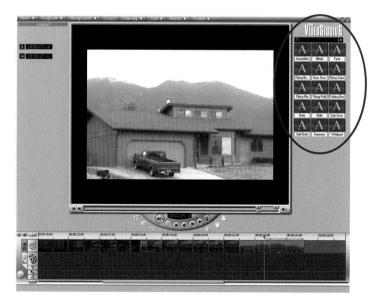

Figure 5-25 The Ulead VideoStudio 6 Transition Library

TO KEEP ON LEARNING . . .

Go to the CD-ROM and select the segment:

♦ *Change Clip Properties Tool: Using* to learn more about how to trim your video clips.

♦ *Digital Video Basics* to learn more about basic concepts of digital video.

Go online to **www.LearnwithGateway.com** and log on to select:

♦ *Capture, Create and Share Digital Movies*

♦ *Internet Links and Resources*

♦ *FAQs*

Gateway offers a hands-on training course that covers many of the topics in this chapter. Additional fees may apply. Call **888-852-4821** for enrollment information. If applicable, please have your customer ID and order number ready when you call.

5

you ar
here

Adding Text and Still Images

Creating a compelling digital movie often involves more than the video itself. Text and still images are time-honored ways to enhance your footage, put emphasis on certain segments, and invent a more informative and entertaining presentation. For example, a snappy font which announces your child's birthday party can easily achieved by adding text using both Pinnacle Studio 8 and Ulead VideoStudio 6. These programs also provide excellent support for animated text such as a scrolling credits screen as well as colorful backgrounds to put behind your text. You can also use still images, either by themselves or as backgrounds for text, to spice up documentary footage, publish scanned photographs with your movie, or build in your own custom graphics. The only limit, as they say, is your imagination!

In this chapter, you will learn how to add text, solid backgrounds and still images to your project. You will discover how to move your words across the screen from right to left, down to up, and along other trajectories. In addition, you will see how you can create a text message of any length and edit its duration to fit your video precisely. Of course, you will also learn how to choose a colorful background to go behind your text, as well as use still images either by themselves or as unique backdrops for text titles.

Adding Text to Your Movie

There are a number of reasons why you may want to add text to your video. Both Pinnacle Studio 8 and Ulead VideoStudio 6 will help get you started by providing preset titles, like "Happy New Year," and "My Birthday Party," that you can easily edit to fit your own needs. How and where you use text is then up to you. For example, you could use text overlays to:

Figure 6-1 Scrolling credits created in Ulead VideoStudio 6.

♦ Announce transitions or time jumps in your video, like "Near the End of the Game," or "The Last Day of Our Trip"

♦ Title your video project, for example: "Zion National Park Trip - 2002"

♦ Create scrolling credits and list everyone who was involved in your video production (Figure 6-1)

✦ Create thought bubbles, or exclamatory remarks, as in a comic strip

✦ Add song lyrics or quotations at key moments in your production

Creating Titles and Animations with Pinnacle Studio 8

In Pinnacle Studio 8, you can work with text in Storyboard or Timeline view. In either view, Studio 8 processes animation results very quickly and provides 36 editable presets at the click of your mouse. To add text or titles to your video in Pinnacle Studio 8, perform the following steps:

1 Open Studio 8.

2 Make sure you are in **Edit** mode, by clicking the Edit tab.

3 If necessary, click the **Show videos** tab in the Album, and add at least one video clip to your project. In Studio 8, the duration for most text animations is set, by default, to four seconds. You may want to add a video clip of at least four seconds in length.

4 Click the Album's **Show titles** tab (the third tab down on the left, as shown in Figure 6-2). Animated text titles will appear and first eighteen preset titles are shown. To view more, turn the "page" by clicking the arrow on the upper right of the Album.

6

Shows titles tab

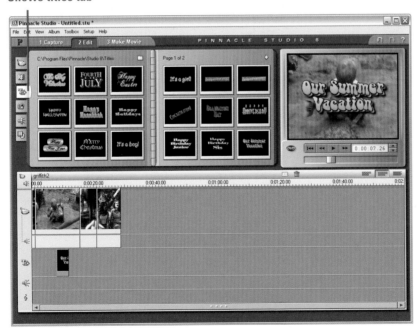

Figure 6-2 The Show titles tab displays Text animations.

5 To add a title, drag it from the **Album** to the **Movie Window**. Drop it on a video clip, and the title will appear superimposed over the video (Figure 6-3).

 You can also drop the title icon on a blank frame in the Movie Window, or insert the title between two frames. In both of these cases, Studio 8 will automatically create a new clip for the text title.

6 Click the Play button under the Player to see the results of your new text title.

 To learn more about adding text to your movie, go to the web segment Text: Adding to Movies

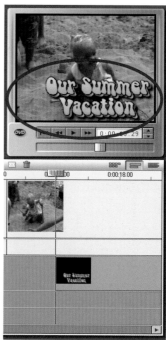

Figure 6-3 A new text title appears superimposed over a video clip.

Editing Text with the Title Editor

Studio 8 provides a number of text-editing options. Using Studio 8's Title Editor, you can change the text message, font, font size, and color. You can also animate your text, scrolling it either from bottom to top or from right to left, and add shadow, edge, and gradient color effects.

Here's how to edit a title:

1 In either Storyboard or Timeline view, right-click on the video clip for which you have created a title and select **Go to Title/Menu Editor**. The text animation appears in Studio 8's Title Editor, ready for editing (Figure 6-4).

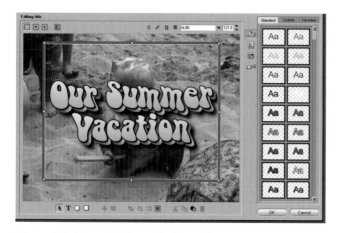

Figure 6-4 A text title is ready for editing.

 You can also open Studio 8's Title Editor by clicking on the Video Toolbox button in the upper left of the Movie Window. When the Video Toolbox window appears, simply click the Edit Title button. If you are in Timeline view, double-clicking the title thumbnail will also open the Title Editor.

② To edit the text, highlight the text you want to edit (Figure 6-5).

Figure 6-5 Selected text will appear bounded in a semi-transparent blue box.

Font drop-down box

③ To change the font, highlight the text you want to change, then click the Font drop-down menu on the top right side of the Title Editor (Figure 6-6). Scroll to find your new font, and click it.

 Studio 8 lets you change fonts for individual letters in any title. If you want to change the font for text you have already typed, you must highlight the text first. If you don't highlight the text you want to change, you will not see any changes on-screen, though you will have set the font for any new text you will add.

④ To change the font size, click inside the Font size field, to right of the Font drop-down menu, and type a new font size. Alternately, you can use the small arrows next to Font size field to increase or decrease the size.

 To learn more about editing your text, go to the Web segment Title/Menu Editor User Interface.

Figure 6-6 You can change fonts using any font installed on your computer.

Animating Text

Pinnacle Studio 8 provides two types of text animation. If you click on and enable the **Roll** button, text will start off-screen, then move from bottom to top—just like credits scrolling at the end of a movie. If you click on the **Crawl** button, text will start off-screen, moving from right to left, much like bulletins on a news show. Clicking on the first button—the **Title** button—will disable animation.

To apply animation to text, click any of the first three Title-type buttons at the upper left of the Title Editor. (Figure 6-7).

Title Roll Crawl

 The fourth of the Title-type buttons, the Menu button, is for creating interactive menus for use in DVD movies, and is discussed in Chapter 10, "Create DVD and DVD-Compatible Movies."

Figure 6-7 Pinnacle Studio 8 offers a choice of two animations.

Once you've got your animation the way you want it, you will probably want to edit its length. If you are using either the Roll or Crawl animation, Studio 8 will automatically alter the speed of the animation so that text doesn't finish scrolling too soon or too late. If you're using no animation, setting the duration will simply determine how long the text will be up on the screen in same spot. To set text animation duration, do one of the following:

◆ Type a new duration amount in the **Duration** field, at the upper right of the screen (Figure 6-8). You can also use the small scroll arrows to the right of the field.

◆ In Timeline view, locate the "T" icon on the left side. The track to the right of this icon is aptly called the title track. Drag the edge of the thumbnail to the right or left using the double arrow (Figure 6-9) which appears when you mouse over either edge.

Figure 6-8 Text animation Duration can be adjusted.

 To control the animation more precisely, use the Timescale (the yellow ruler at the top in Timeline view) to see the starting and ending times of your title track in more detail. When the mouse pointer changes to a clock hand, drag it to the right to zoom in, to the left to zoom out.

The longer you make a title animation, the slower the text moves across the screen. If you want to speed up the scrolling, you can do so by selecting the title's thumbnail in the title track and moving its "Start" point forward along the timeline. Then, move the "End" point back using the double-arrow.

Creating Titles and Animations using Ulead VideoStudio 6

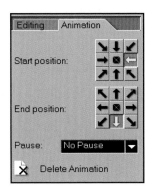

With Ulead VideoStudio 6, you can edit and customize preset text animations or create one from scratch. VideoStudio 6 provides many preset motion-text options. You can combine "In" and "Out" points to animate your text messages in dozens of ways (Figure 6-13).

Figure 6-13 Creating Start and End points sets the direction of your text animation.

Let's start by working with VideoStudio's preset text animations, then describe how to edit and create your own. Follow these steps:

❶ Add a video clip to the Storyboard. Since a line of text requires time to read, make sure the video is at least six seconds in length.

❷ Click **Title** at the top of the screen. You will notice that your view of the video changes to Timeline since editing text involves adjusting how long text will appear on the screen.

❸ In the drop-down menu on the right side of the Title workspace are two libraries: Title and Animation (Figure 6-14).

❹ To preview a Title, click it, and it appears in the Preview window. You will not see it animated at this point, nor will you see it added to your project yet.

6

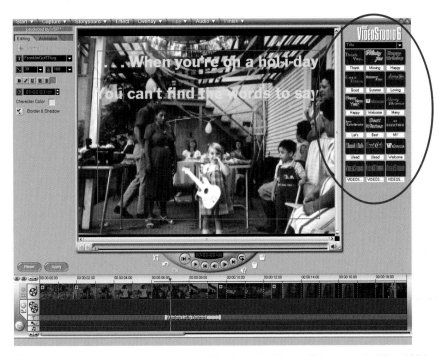

Figure 6-14 The Libraries are accessible from the Title editing area in Ulead VideoStudio 6.

 Although the titles are displayed against a black background, only the lettering will appear in your video.

⑤ To add a Title to your project, drag it down to the T track in the Timeline (Figure 6-15). When the title is in position to be added, the mouse pointer changes to a plus sign. By default, each title displays for three seconds.

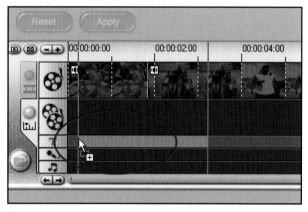

Figure 6-15 Adding a title to a project in the Timeline view.

More About... Working with the Timeline

There are two navigational features which will be helpful if you add lengthy text to your video—perhaps 10 or 15 seconds at a time—and want to move between text segments for editing. On the far left of the Timeline, the Zoom To button lets you select a magnification level for viewing your video. You can set it so the entire project fits onto your screen, or zoom up so you are staring right at a single frame, and all points in between. In the same area, the Plus and Minus buttons are for zooming in and out. Note that if you click any of these buttons, the digits on the Time Ruler change accordingly. In addition, at the bottom of the Timeline are two scroll buttons and a scroll bar. These are useful if your project requires scrolling beyond the right edge of the screen.

At this point, you have one stationary title superimposed on your video. To preview the title and your video, click the title as it appears on the Timeline, and click the Instant Clip button, just below the Preview Window. The video segment with the title on it will play back. This playback method will not preview segments that precede or follow your title.

 If you click on the video clip, then click **Play Clip**, your title will not be included in the playback, even though you see it on the timeline. Because VideoStudio 6 must render part of your movie segment in order to play the title and movie together, it provides two different views, Instant Preview and Play Clip. Instant Preview shows you the rendered version of you video, while Play Clip only shows you the currently selected video clip.

Now that you know how to add a simple text overlay to your VideoStudio 6 project and preview it, you are ready to animate it, edit it, and add even more text to your project. In fact, editing an existing preset is faster than building text animation from the ground up.

Changing Text Position and Duration

To shorten or lengthen the Title you added, click Title at the top of the screen, and on the "T" row of the Timeline, drag either yellow end of the **Title**. This action shortens or lengthens the end you drag. To move your Title so that it starts earlier or later in your clip, hold the mouse over the title until the pointer becomes a four-arrow pointer, then drag the **Title clip** to its new location.

Animating Text

It's time to learn how to animate your text! VideoStudio 6 comes with plenty of preset animations to give your title a little pizzazz. To see them, click the drop-down menu arrow on the right side of the Library, and choose **Animation**. Rows of animation thumbnails will appear (Figure 6-17). Each thumbnail contains an animation sequence, indicating the type of motion each would apply to the Title.

To apply animation to a title, simply click it. To preview the Animation effect, click the **"T"** row of the Timeline, and then click the **Play Clip** button.

Figure 6-17 Ulead VideoStudio 6 provides a Library of text animations.

Adding More Text to Your Project

You can add another Title and Animation to other points in the Timeline (Figure 6-18). To do so, drag a title to the "T" row of the Timeline, noting its position along the video clip. Then click on that new title, and choose **Animation** from the Library. To apply the Animation, just click on it once.

Figure 6-18 Adding multiple text animations to a project.

To preview the second title, click it as it appears along the "T" row, and then click the **Play Clip** button. To play the entire movie including both titles, use the green Trim Bar to select the area around the titles, then press **SHIFT + Preview** button. Next, the video will render, which make take some time, and once that is completed the video will play back.

Editing Existing Titles

Up until now, you have worked with positioning and animating one of VideoStudio 6's preset messages. You can also edit your presets at will. Rather than create a title and animation from scratch, you can edit an existing one, change the message, font type and style, and animation type by performing the following steps:

❶ **Delete** the title animation or animations currently on the "T" row of the timeline. To do so, right-click on the title and choose Delete.

❷ Choose a title and add it to the Timeline.

❸ As the timeline appears in the Preview Window with the video behind it, double-click on the movie. It will appear in a bounding box, ready for editing (Figure 6-19).

❹ On the left side of the screen are editing tools for text (these will only be present when Title is selected at the top of the screen). There are two tabs, Editing and Animation. Options on the Editing tab will be available only if the text on your screen is selected. To select the text, double-click it.

❺ To create a new text message, select the text inside the bounding box and begin typing a new message.

Figure 6-19 The Text bounding box, ready for editing.

As you type, your message is not constrained inside the box, meaning there is no auto text-wrap. To fit all your text on the screen, use the ENTER key to create line breaks where needed.

If you do not press **ENTER** for line breaks, the program will allow text to extend beyond the edge of the screen. VideoStudio 6 makes text that scrolls from one end of the page to the other, which would include "ticker tape" animated text, as well as scrolling credits.

Of course, editing the words is only one kind of editing. You can also use the Editing tab (Figure 6-20) to edit the appearance and behavior of your text.

The Editing tab allows you to edit the following parameters:

Figure 6-20 The Ulead VideoStudio 6 Editing Tab.

+ **Font Attributes.** These include font, font size, line spacing, as well as typical type formatting such as Bold text and Alignment.

- **Text animation duration.** You can digitally set animation duration with one-hundredth of a second accuracy, although it may be easier to drag the text animation in the timeline itself, matching the text to video content rather than a specific digit.

- **Character Color.** Click the **Character Color** square to set text color for the selected text.

- **Border & Shadow.** Click the **Border & Shadow** button to add a shadow to your text and trace a line around it. The Border & Shadow dialog box has two tabs, one for each feature:

Figure 6-21 Animation Start and End positions provide many text animation options.

Designing a Custom Text Animation

To set your own animation rather than use a preset animation, click the **Animation** tab on the left side of the screen (only available when Title is selected on top). There are three settings available. You can choose an Animation Start position, End position, and Pause (Figure 6-21). Now you can customize exactly where and how your text will animate. You can have text scroll from right to left, top to bottom, diagonally, or even start or end in a stationary spot in the center of the screen.

Scrolling movie credits are a great example of a custom animation. Never underestimate the helpfulness of including even a small credit in your movie. Of course, you may have several people to thank, which is why the "scroll" in "scrolling" comes in very handy. You can create scrolling text in VideoStudio 6 by performing the following steps:

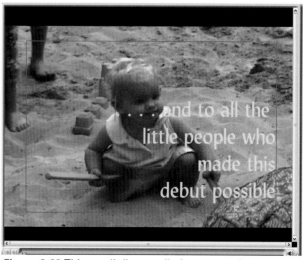

Figure 6-22 This credit list scrolls from top to bottom.

1. Make sure there is a video on the Timeline.
2. Click **Title** at the top of the screen and the screen will display text editing options.
3. On the left side of the screen, click the **Editing** tab, and then click the "T" next to Create Title. A rectangular bounding box will appear in the preview screen.
4. Click inside the bounding box and begin typing text. Text will appear with the formatting options shown in the Editing tab. You are making a list of credits that will scroll from top to bottom (Figure 6-22). Therefore, the first item you type will actually appear last on the screen.
5. As you type entries in your list, press **ENTER** to move to the next line, continuing to add credits as necessary. You can include as many credits as you like, since they will eventually scroll into view from their off-screen position.
6. When you are happy with your text, click the **Add** button at the bottom of the Editing Tab.

To change the text formatting, select the text and apply the new formatting. This is similar to the process of formatting text in a word processing program. You may also want to increase the duration of the animation above the default three seconds shown on the digital Duration counter. For example, click the **3** and type in a **6** instead. To set animation for scrolling credits, do the following:

1. Click the **Animation** tab on the left side of the screen.
2. Next to Start Position, click the top center arrow to scroll from the top of the screen.
3. Next to End Position, click the bottom center button to scroll down past the bottom of the screen.
4. When you've clicked both a **Start** and **End** animation position (Figure 6-23), click the **Apply** button at the bottom. Your animation is ready to be tested.
5. To preview your animation quickly, click the **Play Clip** button at the bottom of the Preview screen. To render your movie to include the animation, use the green Trim Bar to select the segment of movie you want to render, then press **SHIFT + Preview**. The movie will begin rendering and shortly you can view it.

Figure 6-23 An animation is set by clicking both a Start and End position.

Adding Color Backgrounds to Your Movie

A color background applies frames of single color to your movie. The color will display for a set number of seconds. Color backgrounds can be positioned and inserted in between clips (Figure 6-24), or used to open or close a movie.

There are many uses for color backgrounds. For example, you can apply text to color frames, allowing the text animation to play against the backdrop of a single color, rather than against the video. This can be helpful since reading text against a background with moving video content can be difficult.

You can also use color backdrops to display a video overlay, which is a video superimposed on another media. For example, a color background can be used as a backdrop while a video clip moves across the screen from one end to the other (Figure 6-25).

Figure 6-24 Adding a color background to a movie

Figure 6-25 Color backgrounds can be used with video overlays.

Adding Color Backgrounds with Pinnacle Studio 8

In Pinnacle Studio 8, color backgrounds are added using the Title Editor. To add a color background to your project with Pinnacle Studio 8, do the following:

1. In either Storyboard or Timeline view, right-click on any video clip and select **Go to Title/Menu Editor**.
2. Click the **Backgrounds** button.
3. Click the **Change color** or **Change gradient** option buton at the top right of the Title Editor.
4. To change the selected color, click the color rectangle next to the option button. If you are changing the gradient, click each corner color box that you want to change. The color-picker dialog box will appear.
5. Use the color-picker to select or create any color you like. Click **OK** to close the color-picker, and your new color will be applied to the video. If you are creating a gradient, the gradient will not be applied until you click the **X** button in the Change gradient box.

Adding Color Backgrounds with Ulead VideoStudio 6

To add a color background in Ulead VideoStudio 6, do the following steps:

1. Select Storyboard at the top of the screen.
2. On the Library drop-down menu at the upper right of the screen, click the arrow and choose Color. Color thumbnails appear. Beneath each thumbnail is its numeric RGB (Red-Green-Blue) color value. This is not an issue for you unless you are asked to produce a color background that specifically matches another RGB color.
3. Click a color thumbnail once, and the editable color values appear (Figure 6-26).
4. Note the Duration counter at the top left. You can see that by default, a color background appears on the screen for three seconds. Dial in a new duration, if desired.
5. Make your new color choice, either by clicking the color rectangle and launching the color-picker, or by specifying a new color using the RGB settings that appear right below the color rectangle.

Figure 6-26 A color background's color values can be edited.

6. Add a color to the project by dragging the thumbnail down to the Storyboard or Timeline area.
7. Once your color is in place, you can add text animation over it, leave it as is, or use the Overlay feature to add a video that will interact with the color background .

 In Timeline view, you can drag the color background to the right or left, adjusting its duration to match some other element in your project, like music or text animation duration.

Adding Still Images to Your Movie

Still images can add a new dimension to you movie, and you can add as many still images as you like. You can use images from your digital camera or scanner that have been saved to your hard drive, or images from a commercial photo collection. Images in your project can serve as backgrounds to text messages or as still shots displaying content described by a voiceover. Still images can also serve as slide shows, giving your audience a break from the constant motion of video content.

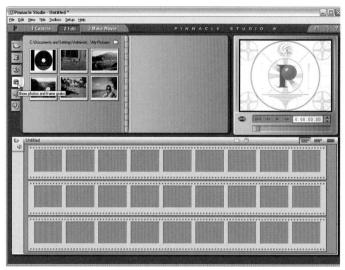

Figure 6-27 To add images to your Pinnacle project, use the Show photos and frame grabs tab.

Adding Still Images with Pinnacle Studio 8

To add photos to your project, do the following steps:

1. Click **the Show photos and frame grabs** tab in the Album (Figure 6-27). All images in the designated image folder will appear in the Album.
2. To view images from a different folder, click the **Folder** button at the top of the Album and browse to any image you want to add.
3. To add an image to your project, drag it from the **Album** to the **Movie Window**.
4. By default, each image appears in your project for four seconds. To edit duration, double-click on the image and it will appear in the Title Editor (Figure 6-28). The duration is displayed in digits at the upper right of the screen. Dial or type a new duration amount in the Duration field.
5. To play back your image, close the Title Editor and click the **Play** button beneath the Player.

Figure 6-28 Edit Image Duration from the Title Editor.

 To learn more about this utility in Pinnacle Studio 8, go to the Web segment *Frame Grabber Utility: Using.*

Adding a Still Image with Ulead VideoStudio 6

In Ulead VideoStudio 6, a still image is added to your project in the same way as a color background. Like color backgrounds, still images can be used as text backdrops, or for video Overlays, displaying a still image while a video moves across the screen or fades.

The Library provides an Image Library (Figure 6-29) with available images displayed as thumbnails. Click an image once to view it in the preview screen. When you do so, image information such as file name, size, and image type appears on the left side of the screen. To add an image to your project, drag its thumbnail either to the storyboard or timeline view of your project.

Just as with color backgrounds, the image appears in your project for three seconds by default. Adjust image duration by dragging the image in the Timeline mode, or indicate the duration using the image tab that appears when you click on an image in your project.

Figure 6-29 The Ulead VideoStudio 6 Image Library.

Note that images of many formats can be used for your video projects. You can import images from your digital camera, image editing program, or still shots from your digital camcorder. When you add an image to a project, you're given several resizing options (Figure 6-30), allowing you to display your image at its true size or resize it to fit the project.

Figure 6-30 You can resize an image to fit your project, or maintain its current dimensions.

6

Adding Music, Voiceover and Sound Effects

B eginning videographers tend to focus on the visual, but in reality, what the viewer sees is only half of the story. Well-executed audio tracks can make a huge difference to the impact of your project. Digital video includes digital sound, so music can sound just as clear as the day it was recorded and the voices just as crisp. Just like digital video, you can easily edit, build, and develop digital audio tracks long after you've put your camcorder away.

Audio is an amazingly important component, playing a number of different roles. Background music can set the tone and add drama to your video; voiceover and narrative can guide viewers towards areas of special emphasis; sound effects can both punctuate comical moments and make what is real seem even more real; songs can inject emotional depth. In this chapter, we'll cover how to add these types of audio to your project.

Working with Audio Tracks

The audio components of the programs discussed in this chapter work in similar ways. You can record a song directly from an audio CD, save that song in your project, and edit it to fit your needs. In the case of Ulead VideoStudio 6, when you add a selection from a CD to your music project, you can also add it to the Audio Library, where that song becomes available to all VideoStudio projects. Both Ulead VideoStudio 6 and Pinnacle Studio 8 allow you to add sound effects, voiceover, and audio files (like MP3s) to your project, with two tracks of audio per project.

 Before using another's audio, always obtain permission from the property rights owner.

Both programs provide one timeline "line" for CD music, and another for voiceover, sound effects, and other audio files (Figure 7-1). However, any sound file, be it music, voice, or sound effect, can be added to either "line" of the timeline.

Figure 7-1 You can insert audio in the two Timeline slots in VideoStudio 6.

 When audio is introduced into a project, it can be edited like other components. Feel free to experiment with sound effects, songs, and music to determine if the addition really enhances the project. If not, you can always edit and finesse the results until it matches what you had in mind.

The audio components you add to your project fall roughly into five categories: Original audio footage, CD music, sound effects, MP3s, and voiceovers.

Original Audio Footage

You will, of course, have the audio you recorded with your original video footage. Street noise, conversation, music, and whatever else the microphone picked up when you pressed that record button. These sounds are now part of your project. In Pinnacle Studio 8 in particular, the original audio is treated just like any other audio track. You can mute it, trim and edit it, and delete it.

CD Music

These are music tracks you record from an audio CD directly into your video editing program, for use in a specific project. Some programs actually record the CD music onto your hard drive, allowing you to put away the CD after the initial recording. Other programs need to access the CD in the drive each time you edit the movie. You are only done with the CD after you export the movie for final output.

More About. . . Pinnacle SmartSound®

Studio 8 includes a feature called SmartSound, which assigns music clips from hundreds of sources to each individual scene in your project. The SmartSound Library is quite large and you can purchase even more "smart sounds" if you want.

7

Sound Effects

These are quick sounds you add for dramatic or comic effect. Examples are crowds applauding, airplanes taking off, buzzers, boinks, etc. Both Pinnacle Studio 8 and Ulead VideoStudio 6 provide an audio library filled with folders containing sound effects.

MP3s

Working with MP3s is very similar to sound effects. You can search for them by browsing your programs' audio library. You can also edit and trim these as well (Figure 7-2).

Figure 7-2 Adding an MP3 to your project.

Voiceovers

A voiceover is a narrative presence that describes or explains the video content to the audience. A Voiceover is recorded by plugging a microphone into your computer and recording your voice while the video is playing back.

Adding CD Music to Your Project

Let's discuss adding music from a CD to your movie using Pinnacle Studio 8 and Ulead VideoStudio 6. You can add music and sound clips to your projects, editing and positioning clips to match your video content exactly. When creating your project, however, make sure that you do not infringe on the rights of the copyright owners.

Adding CD Music to a Pinnacle Studio 8 Project

You can add CD music easily to your project. First, locate the song you want to use, edit and trim it to your liking, then set in and out points to match the project's video content. Studio 8 splits audio clips in your project, so music segments can be repositioned, copied, and deleted as your project requires.

 While Studio 8 does not create automatic crossfades (fading in one sound while another fades out), you can create an audio cross fade by placing two audio tracks on separate lines in Timeline view and adjusting the volume.

To add CD music to your Studio 8 project, do the following:

1. Place a music CD in your CD-ROM drive.
2. If you are prompted by Windows to play the CD, click Cancel.

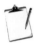 You do not need to have a video present in your project in order to work with audio, although having the video in place certainly helps for synchronizing audio and visual playback.

3. Start Pinnacle Studio 8.
4. Click the Audio Toolbox button in the upper left of the Timeline (Figure 7-3). The Audio Toolbox appears.

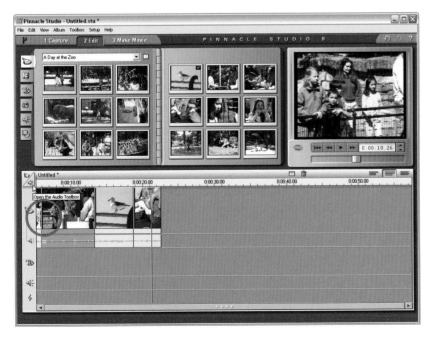

Figure 7-3 The Audio Toolbox button accesses all kinds of audio controls.

⑤ On the left are five buttons; the four lower buttons access audio features. If it is not already selected, click the **Add background music from an audio CD** button. The Toolbox changes to display a CD selection and trimming menu (Figure 7-4). The CD Title, names and number of tracks will appear in the drop-down menus. If the program does not recognize the CD or music track, a dialog box appears prompting you to type a name for this CD. This warning only means that Studio 8 cannot automatically name the music. You can, however, still use it.

Figure 7-4 Editing and trimming CD Music in Pinnacle Studio 8.

⑥ Choose a track from the **Audio Toolbox** Track list and click **Add to Movie**. The program then processes the entire song for video use, and places it on the background music track of the timeline without further prompting. If the song is long, drag your mouse along the Timescale to zoom in on the project.

⑦ Once the track appears on the timeline, click the Play button located under the Player. The music track and any video on the timeline will play.

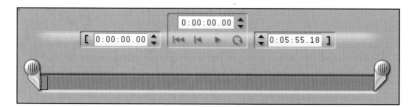

Figure 7-5 Use the Slicer buttons to trim audio tracks.

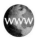 To learn more about adding music using Pinnacle Studio 8, go to the Web segment *Music: Adding to Movies.*

Editing Your CD Track

At this point, the track is putty in your hands. You can trim the audio track by dragging the Slicer icons at either end of the Audio Toolbox (Figure 7-5). The Left Slicer trims the beginning of the audio track and the Right Slicer trims the ending.

Alternately, you can click on and enter a value into the in and out fields right above the slicers. These inform you of the audio track's current in and out points, down to a one-hundredth of a second accuracy.

There are other ways to trim and rearrange your track as well. You can do one of two things:

✦ Drag the track itself as it appears in the Movie Window. To trim from the beginning, drag to the right from the beginning of the track. To trim the ending, drag from the end of the track towards the left.

Figure 7-6 You can split audio tracks and isolate segments for special actions.

✦ Make splits in your audio track to cut away song segments, either setting them aside for special use, or deleting them as unwanted for the project. To do so, drag the **Timeline scrubber** to the spot where the first cut should be.

This makes the razorblade available—click on it to make your first cut. Drag the **Timeline scrubber** again to and make your second cut. You can then move that audio track segment to another part of your project, based on video content, or delete it (Figure 7-6).

Note that with Pinnacle Studio 8, there are no special steps before playback. Just click **Play**, and the audio and video presently in the Movie Window will play back.

Relocating a Track

To move a sound clip of any type (either sound effect, CD Music or MP3), click the clip once with the mouse as it appears in Timeline view, then when the pointer changes to a hand, drag the clip to the right or left. You can also drag the clip to the other track on the timeline. Though you have two tracks—sound effect/voiceover and background music—they are completely interchangeable.

Adjusting the Volume Wave

Studio 8 lets you adjust volume at any point along the track. Each audio clip displays a single audio waveform representing track volume. If this wave, represented by a single line, is near the top of your track, then the clip volume is about as loud as it can be. If the line is exactly in the middle of the track, then the sound is half as loud. If the line is at the very bottom, you've effectively muted that portion of the audio track.

To adjust track volume at any point, do the following:

1 Click on the volume wave of that track with the mouse. The mouse pointer changes to a "mini-speaker" icon, indicating you are adjusting volume (Figure 7-7).

Figure 7-7 Editing volume on the Timeline by setting points and dragging.

2 Press and hold once on the line to create a point for volume adjustment.
3 Drag up or down on that point to change the volume at that exact point in the track.

The trick to adjusting volume using this method is to actually make two points. If you just make a single point somewhere in your track, then raise the volume at that point, you are telling the program to gradually increase the volume from the beginning of the song, and finish increasing it at that point. That's probably not what you meant to do. You probably meant to boost the music at that certain point, or perhaps mute an unwanted sound or some other on-the-fly adjustment. The solution is to use more than one point; using multiple points will allow you to create very precise volume adjustments at any point in your audio track.

For example, if you wanted to mute three seconds of music, you would do as follows:

1 Click and make one point where the mute should start.
2 Click where you want the sound completely gone and drag the volume to zero.
3 Click where you want the volume back up again, and drag that volume to the previous level (Figure 7-8).

Conversely, if some important phrase keeps getting lost in your track, and you want to make sure it is heard loud and clear, then follow these steps:

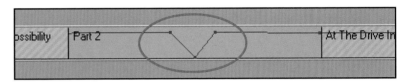

Figure 7-8 Set a mute point by creating three points.

1 Create a point where you want the volume increase to start.
2 Create another point where you want the peak volume. Raise the volume here.
3 Create another point where you want the volume to be back to normal again. Lower the volume to the original level here.

 To learn more on the audio tool in Pinnacle Studio 8, go to the Web segment *Trim Audio Tool: Using*.

Adding CD Music to a Ulead VideoStudio 6 Project

To extract a music track from a CD and add it to your Ulead VideoStudio 6 project, follow these steps:

1 Insert an music CD into your CD-ROM drive.
2 If you are prompted by Windows to play the CD, click Cancel.
3 Start Ulead VideoStudio 6.

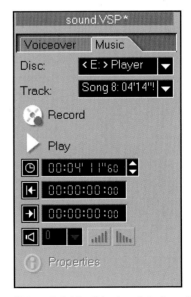

Figure 7-9 The Music tab is for adding CD Audio tracks to your project.

④ Click the **Audio** button at the top of the screen. Two tabs appear on the left, Voiceover and Music.

⑤ Click the **Music** tab (Figure 7-9) to access the controls for previewing and recording music tracks. Note that your view of the project changes to Timeline view.

⑥ To choose which drive to record from, click the **Disc** drop-down menu arrow, and select the drive where your audio CD is located. This step is essential if you have a CD-ROM burner and a standard CD-ROM drive. VideoStudio 6 will detect the audio CD and its music tracks.

 Clicking Audio at the top of the screen opens the VideoStudio 6 Audio Library. The Audio Library is on the right side of the screen. TheLibrary contains sound effects that can be applied to your video by dragging a sound thumbnail to the Music track of the timeline.

⑦ To locate a track to record, click the Track drop-down menu arrow, and select a track.

⑧ To preview your track before recording, press the **Play** button (the Play button under the Music tab, as shown in Figure 7-9). The track you selected will begin playing back.

⑨ f you do not intend to record the entire track, pay special attention to where the segment you want to record will begin. Note the CD Track Playback Position Counter digit. Use this number to pinpoint your audio In mark. If such precision is desired, click inside the CD Track Playback Position Counter, and type where you want recording to begin.

⑩ Click the **Record** button and VideoStudio 6 will begin recording your track. You will see an indicator that recording is occurring other than the advancing Play counter.

⑪ Click the **Record** button, located under the Music tab, to stop recording.

After a little processing time, you will see the track displayed on the Music line of the Timeline view. Note that if you save your project now, the track you recorded will be saved as part of your project. Ulead provides automatically a numerical name for this track and it will be saved in the same folder as your current project. This track is yours to edit, or simply save the original in the VideoStudio 6 Audio Library. You can also position this track at any place along the timeline, synchronizing it with video content (Figure 7-10). To do so, click and drag the audio track to the right or left along the timeline.

Figure 7-10 You can synchronize audio and video content on the Timeline..

 As you record music, voiceover, and acquire sounds from other sources, these can be stored in the Audio Library and applied to all your projects. As soon as you save a clip to the Library, it will be available for future projects; you need not save the current project in order to make a clip available in the Library

Adding the CD Track to the Library

If you want this track easily accessible for other VideoStudio 6 projects, click the track as it appears in the Timeline, and drag it to the Audio Library located on the right side of the screen. The track's icon will appear with all the other audio tracks.

 In order to name the track something more memorable than the numeric title assigned by VideoStudio, locate the folder where the track is saved, and rename the file. To do this, right-click on the track's thumbnail as it appears in the Audio Library and choose Properties. You will see its folder there. Open the folder, click on the track, press F2, and rename the audio file.

Editing Your Audio Track

If you want to further trim down this track, so that it plays back only the segment you intend, with no "dead" space, do the following:

① Click the CD track as it appears on the on the timeline, and click the Play Clip button under the Preview Window. Only the music clip will play back.

② As with video, the F3 key is the in button and F4 is the out button. As the track plays back, press these keys to mark in and out points.

③ The Trim Bar beneath the Preview Window will display your in and out points (Figure 7-11). You can use this trimmed version of the track in your existing project, or drag it to the Library for future use. Unfortunately, it will have the same name as the track you trimmed it from, and the only way you will tell the difference

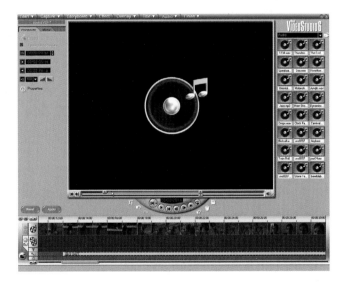

Figure 7-11 You can use the Trim Bar to trim audio tracks.

between your trimmed and non-trimmed track is by dragging it to the timeline and playing it back.

④ To render your music track as part of the project, use the Trim bar to trim down to the segment you want to preview, then press SHIFT + Play, which is the Play button under the big Preview Window. The movie segment will render and your music track will be part of it.

 Remember to save your project frequently, especially after making changes that required lots of time and effort. To do so, click Finish, and choose Save Project.

You can always change your music track's in and out points, either by dragging the clip in the timeline, using the Trim bar, or typing a number into the Mark in and Mark out fields on the Music tab.

Editing Track Volume

To change the overall volume for this music track, click the **Clip Volume** arrow, or just type a number in the provided field. You can increase as well as decrease the track volume. Even though the digit reads "100," you can exceed that value. This can be very helpful if you find your music getting buried behind the video's audio track.

You can also fade your music track in or out. To do so, click the **Fade In** and **Fade Out** buttons to the right of the Volume field (Figure 7-12). Note that you cannot control fade speed. You must accept the default fade amounts.

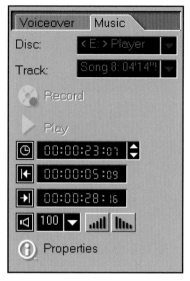

Figure 7-12 You can adjust audio track volume and set fades.

 Changes you make to your music track will not be evident until you render that portion of the movie. For example, if you change the overall volume of your track, and want to preview the impact this will have on your movie, you must press **SHIFT + PREVIEW**, which re-renders the segment, including your change. After doing this, each time you press **Preview**, that video segment with audio will play.

Adding Voiceover to Your Project

In order to add voiceover narration to your video, you will need to make sure that you have a microphone plugged into the microphone input jack of your sound card. You will also need to make sure your mic is working properly. Using Windows Sound Recorder, set microphone playback volume so you can hear your voice through your computer speakers, and set the mic input level so that the voice does not distort, but can be heard. Spend some time getting this level just right, so that when you speak into the mic, the voice occasionally goes into "the red" but does not stay in the red the whole time thus causing distortion.

You may also have to turn up your speakers perhaps 30% louder than normal to actually hear your voice, but you should not have to turn them up more than that. If you do, your mic input (through your sound card) is too low. If this quality is unsatisfactory, and you find yourself producing lots of voiceovers for your video projects, you may need to invest in a better sound card.

 Microphone quality makes a difference in voiceover quality. The use of at least a uni-directional, semi-professional microphone will result in a more natural-sounding and accurate voice quality in your video.

Recording Voiceover with Pinnacle Studio 8

In Studio 8, recording a voiceover is quick, easy, and intuitive. You narrate as you watch the movie play in real-time, matching your words with action in the video. To record voiceover in Studio 8, do the following:

1. Open the video project to which you will add voiceover.
2. Click the button located on the upper left of the Movie Window.
3. When the Toolbox appears, click the **Record a voice-over narration** button located on the left.
4. A microphone icon will appear (Figure 7-13) with a fader for adjusting volume levels. In order to set levels, speak into the mic just as you would while recording, and adjust volume with the fader. You want to occasionally hit "the red," while speaking, but most often, your voice should stay in the green and yellow.

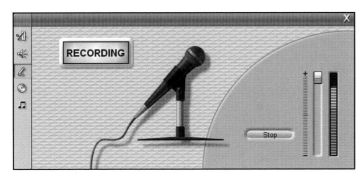

Figure 7-13 Recording a Voiceover in Pinnacle Studio 8.

5. When ready to record, click the **Record** button and begin speaking.
6. When finished, click the **Record** button again to stop recording.

 To learn more on creating a voiceover using Pinnacle Studio 8, go to the Web segment *Voiceover: Creating.*

Recording Voiceover with Ulead VideoStudio 6

Here's how to record voiceover using Ulead VideoStudio 6:

1 Open VideoStudio 6, click the **Audio** button.

2 Click the **Voiceover** tab, if neccessary. Note that the option to record a voiceover will not be available if you have other tracks on the Voiceover track (the track with a microphone button next to it).

3 Click the **Record** button in the Voiceover tab. The Adjust Volume level indicator will appear (Figure 7-14), allowing you to adjust your microphone's input volume or speaking voice.

4 When you are satisfied with your level, click the **Start** button.

Figure 7-14 You can adjust your vocal input volume just before recording.

5 Record your voiceover while watching the video, taking care to speak clearly in an unhurried tone. Space out your phrases so that the timing of your comments matches the video content's own pacing. You will not see an onscreen indication that you are recording, but just keep talking until you have reached the end of your voiceover segment.

6 Stop speaking, and press the **Record** button located on the Voiceover tab.

7 After a bit of computer churning and crunching, the Voice Track line of the Timeline will display your track.

8 You may want to save your project immediately, since you have gone to all this trouble to create a good recording.

Just as with music tracks, the voiceover you just recorded is part of this project, but is not yet part of the Library. Just drag the track to the Library to add it. The voiceover will then be available for other projects.

Editing Your Voiceover Track

You may want to reuse a portion of your voiceover in other projects, but not necessarily the entire thing. Keep in mind that a voice track is just as editable as any video track. It can be cut, pasted, spliced, and you can repeat segments without having to record again.

Editing Voiceover with Pinnacle Studio 8

Your voiceover is one long audio track, and just like other tracks, can be trimmed and split using the usual Studio 8 tools. Take the time to tighten your narration, trimming or muting the "umms" and "ahhs" (Studio 8 lets you adjust volume levels throughout your track), and you will be happier with the overall results.

Editing Voiceover with Ulead VideoStudio 6

To make segments of your voiceover available to projects without having to import the entire thing, just use the trim bars to isolate the voiceover you want to save. Then add that new segmented clip to the Audio Library by dragging it. The new clip will be available, as well as the larger "source" clip previously added.

Once you have recorded your track, there are some changes you can make.

✦ In the Voiceover tab, use the Clip Volume field to change the volume for the entire voiceover.

✦ In the Voiceover tab, use the Fade In and Fade Out buttons, next to the Clip Volume field, to create in and out fades for your voiceover.

✦ Trim the voiceover using the Trim Bar, or F3/F4 buttons.

Adding Sound Effects and MP3s to Your Project

Sound effects are not a special type of audio file, and are not recorded using any particular technology, but they do serve a special purpose in your video. They punctuate and enhance what the viewers are watching, making them laugh, building suspense, and engaging them even more.

Most sound effects are very short—for example, the sound of an airplane taking off, a car revving, glass shattering, explosions, or a ball bouncing. Sound effects can also be longer, such as single violin glissando or a snare drum hit. To be effective, sound effects must be synchronized with video content.

In this section, you will also work with MP3s. You can use MP3s as both background music and sound effects, and the process of adding an MP3 is much same as adding a sound effect.

Adding a Sound Effect or MP3 to Your Pinnacle Studio 8 Project

Sound effect files are usually quite short, and when added to your video project, the trick is to position them "just so" for maximum impact. After adding and positioning your sound effect, zoom in. Zooming is accomplished by dragging the clock icon along the top of the Player scrubber to the right. When your view is close enough to align the sound effect and video track, drag your sound effect to the intended video action point.

To add a sound effect to your project, do the following steps:

❶ Open Studio 8 and click the **Show sound effects** tab located on the left side of the Album. You will see icons representing Pinnacle's library of sound effects (Figure 7-15).

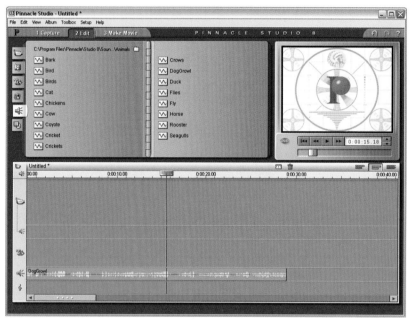

Figure 7-15 The Pinnacle Studio 8 Sound Effect library.

❷ Drag an effect to the **sound effect** and **voiceover track** on the timeline.
❸ Position and trim the sound effect as you wish. You can drag either end of the sound effect to shorten it or use the razorblade tool to split it.
❹ To edit the effect further, double-click on it. The effect will open in the Audio Toolbox where you can create more precise cuts, based on the digital counters provided.

Adding an MP3 or other audio file follows similar steps. Although the tab reads "Show Sound Effects," this segment of the Album is essentially an audio library. This library can be used to access any folder of audio files, either MP3s, .WAV file, or any other compatible audio file types. When you open a folder this way, all the compatible audio files in that folder will appear in the Album. Any sound file can then be dragged down and used in your project. To add an MP3 to your project, do the following steps:

1. Click the **Show sound effects** tab on the Album. A folder of sound effects will appear, ready for you to drag down to the timeline for use in your project.

2. Click the **folder** button, at the upper middle of the Album, and browse to a folder that contains the MP3s you want to access. After doing so, all the MP3s and other compatible audio files will be displayed in that folder.

3. Drag an MP3 or other audio file down to the timeline. It will now be included in your project, and is available for editing.

Using Pinnacle Studio 8 SmartSound

SmartSound is a Studio 8 feature that allows you to add music of all types to every clip in your project with a click of a mouse. Because SmartSound adds more than 200 MB to the program's install size, SmartSound requires you to choose **Custom Installation** when installing Pinnacle Studio 8. If you don't have SmartSound installed, locate the Studio 8 CD and install this extra feature.

To use SmartSound with your project, do the following:

1. With several video clips assembled on the timeline, click the **Audio Toolbox** button at the upper left of the Movie Window.

2. When the Audio Toolbox appears, click the **Create background music automatically** button, on the lower left.

3. All the available SmartSound song libraries will appear. SmartSound is displayed in three columns.

4. On your Timeline, click which video clip you would like to add a SmartSound song selection to.

5. Choose a Style to browse by clicking a music style, displayed on the left.

6. Songs representing your chosen style will appear in the Song list. Click one.

7. Versions of your chosen song will appear on the right in a list. Click one as well.

8. To preview your selection , click the **Preview** button.

9. To add the chosen song to your project, click **Add to Movie.**

10. The song will begin playing as that clip appears, and stop as the clip leaves the screen.

 To learn more on creating background music using Pinnacle Studio 8, go to the Web segment *Background Music: Creating.*

Adding a Sound Effect or MP3 to Your Ulead VideoStudio 6 Project

When you click the **Audio** button at the top of the VideoStudio 6 screen, the Audio work area appears. The Audio Library is displayed on the right. The Audio Library consists of mostly sound effects (Figure 7-16). To add one of these sounds to your project, drag a thumbnail from the Library to the Music Track line in Timeline Mode. Position the sound effect to where it best punctuates the video content. Since sound effects are usually very short, dragging the sound effect to a specific location may be difficult unless you zoom in. To get a closer view of your track, make sure you are in Timeline view, and then click the **Plus** sign at the upper left of the Timeline. You can add as many sound effects as you like, but keep in mind their overall effect on the project's impact.

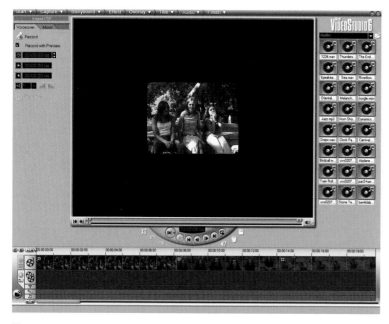

Figure 7-16 The Ulead VideoStudio 6 Audio Library contains mostly sound effects, until you add your own material.

Adding an MP3 or other audio file follows similar steps. The Library can access any folder of audio files, either MP3s, .WAVs or other compatible audio file types. When you click the folder next to the Audio Library and browse to another folder, all the compatible audio files inside it will appear in the Library ready for use.

Go to the CD-ROM and select the segment:

✦ *Nature of Sound* to review the basics of sound.

✦ *Sound Elements in Video* to learn the primary elements of video sound.

✦ *Microphones* for an overview of the different types of micro phones and their uses.

Go online to **www.LearnwithGateway.com** and log on to select:

✦ *Capture, Create and Share Digital Movies*

✦ *Internet links and resources*

✦ *FAQs*

Gateway offers a hands-on training course that covers many of the topics in this chapter. Additional fees may apply. Call **888-852-4821** for enrollment information. If applicable, please have your customer ID and order number ready when you call.

7

Adding Special Effects

In the motion picture industry, special effects are a billion-dollar business. The Star Wars® series of films, for example, rely as much, if not more, on digital special effects as they do on real settings and human actors. Though you may not be planning to open your own special effects studio any time soon, you can employ basic, professional-quality special effects for a variety of editing tasks. Used creatively, special effects will make your movie more interesting to watch and more useful to your audience.

At their core, special effects are really video filters that alter what your video displays frame-by-frame. You will find different filters useful for different tasks. For example, some filters can practically turn back time, by allowing you correct problems present in otherwise valuable footage. Other filters—though they are not too useful for fixing mistakes—can enable you to creatively entertain your audience, and enhance the impact of individual frames in your movies.

 Unlike single image effects, video effects are rendered across many frames—a process that increases memory requirements for effect rendering. Also, a video effect does not stay the same on all frames. It changes in intensity, color spread, and other aspects over time. When you play back a video effect, expect some pauses while the program renders the effect. Once rendered, the affected video will play back at top speed.

This chapter covers three groups of special effects filters: color correction, deformation effects, and motion effects. Each of these are powerful additions to your video editing palette, however, you will find that they are easy to apply—usually with just the click of a mouse.

Video Color Correction

Sometimes, the video you've recorded isn't as bright and vibrant as you like. Subjects can be lost in the shadows, facial features a little unclear and too dark. Video color correction can make a difference, adding a little brightness or stronger hue to underexposed or dull video. Video color correction changes the hue, color mode, or intensity of colors in your video. You can make subtle color changes, or create moonscapes or other radical departures from the norm. Color correction can, for example, restore color to dull footage (Figure 8-1), or render your video in a single tone for an artistic "historical" effect (Figure 8-2).

Applying brightness and/or contrast or increased Saturation can also make your footage more vibrant and alive with color. Whether filming conditions are predictable, such as moving from outdoor to indoor filming, or unpredictable, such as a beautiful spring day suddenly changing into a dark thunderstorm, you will find color correction helpful. For example, you may need to remove an unwanted tint to your video that went unnoticed during the shoot.

Before	**After**

Figure 8-1 Color-corrected video footage.

Figure 8-2 Sepia-toned video footage.

Creating Color Correction with Pinnacle Studio 8

Pinnacle Studio 8 provides very simple color correction tools. Using a slider, you can vary Hue, Saturation, Brightness or Contrast. Color correction is applied uniformly to an entire clip. The same setting is applied from beginning to end. Here's how to color correct or vary the colors in a clip using Pinnacle Studio 8:

1. With a video clip loaded and displayed in either Storyboard or Timeline view, click the Video Toolbox button, then click the **Adjust color or add visual effects** tab. The Adjust color/Visual effects tool panel appears. The dialog box includes eight sliders. The four on the left provide color correction.

2. Drag any slider to the right or left and you will instantly see the effects of your edit in the Player. Dragging a slider to the right increases the effect; dragging to the left decreases it.

Now look at each slider, from top to bottom.

✦ To alter your video clip's hue, drag the Hue slider to the right or left. This will advance the color range along the RGB color wheel either clockwise or counter-clockwise. All the colors in your video clip will be affected by the use of this slider (Figure 8-3).

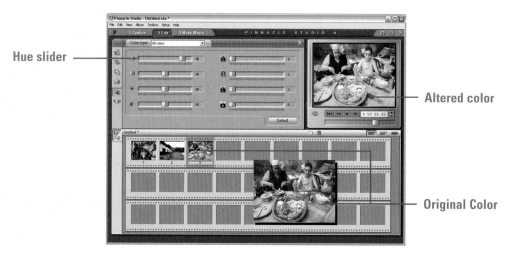

Figure 8-3 Altering a clip's Hue changes all colors in the video.

✦ To add or remove color saturation, drag the Saturation slider to the right or left. Adding saturation increases the amount of color in each pixel in your video. All the colors in your video will be affected by the use of this slider. If you drag the Saturation slider all the way to the left, your clip will become a black-and-white movie. Note that adding too much saturation can introduce a layer of "electrical noise" that looks pretty bad.

✦ To brighten up your video clip, drag the Brightness slider to the right or left. Brightness will help brighten video that was shot a bit too dark. Adding too much Brightness will wash out colors, so don't over do it. You can also darken video that was shot a little on the bright side, but the effect is very easy to over do. Proceed with caution.

✦ To increase the range between the dark and light colors in your video, use the Contrast slider. This effect can help if your video content looks a little muddy.

Another color-based effect provided by Studio 8 is Posterize. The Posterize slider is on the bottom right. The effect creates block images from the video content, narrowing the color range (Figure 8-4). The video resembles a high-contrast lithography print. A typical use of this technique is to posterize the background while displaying the main subject in a separate, normal video layer.

Studio 8 lets you easily tint your video, change it to a black-and-white or Sepia tone movie. Adding some color variety into your project can be a nice touch, if not overdone. To select a tint color for your video clip, do the following:

1 Click the **Color** type dropdown menu at the top of the Adjust color/Visual effects tool panel.

2 From this menu, you can choose **All colors**, **Black and white**, **Single hue** or **Sepia**. (Figure 8-5). The Single Hue option tints the video using the color range currently in the Hue slider.

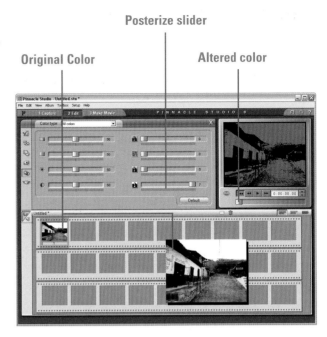

Figure 8-4 Applying the Posterize effect to a video clip.

 You don't necessarily need to use the slider to add an effect. To the right of each slider is a digital indicator. When no effect is added, the digital indicator reads 50. To adjust precisely any effect rather than use the slider, type digit into the indicator field.

After adding an effect, it is automatically applied. To play or preview your video with the effect, click the Play button beneath the Player.

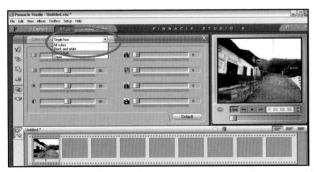

Figure 8-5 Applying a Color Type effect to a video clip.

Creating Color Correction with Ulead VideoStudio 6

VideoStudio 6 has many special effects, which are easily applied by clicking a target clip, selecting an effect, then modifying it if necessary. When working with these effects, take a tip from Hollywood. Effects are used to make a particular point, as part of the story line. So as you view all the effects available in the VideoStudio Library, remember to use them judiciously.

 Special effects, or video filters, are applied to the currently selected clip, not the entire project. To render a filter to an entire project, you would have to click and apply it to each clip.

As with most effects in VideoStudio 6, color correction is applied in varying degrees at the beginning, then at the ending of a video. Like the video itself, the effect changes over time. For example, you can apply a filter that shades the beginning of the video red, gradually fading to green. However, with video that requires correction due to poor lighting, you don't want to apply a different correction at the video's beginning and ending. So in this segment, you'll learn how to edit filter settings at the video clip's start and end points.

With video added to your project, click the **Storyboard** button at the top of the screen. Then, click the Filter tab on the left side of the screen. Alternately, click **Video Filter** on the **Storyboard** sub-menu. The Filter Library will appear on the right, containing 30 filters (Figure 8-6).

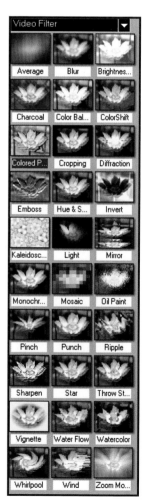

Figure 8-6 The Ulead VideoStudio Filter Library.

Filters are applied by clicking an icon on the right, then clicking the **Apply** button. This applies the filter to the video currently in the Preview window. Then you edit the filter using the parameters on the left. Out of those 30 filters, five can be called color correction effects:

✦ Brightness/Contrast

✦ Color Balance

✦ Hue & Saturation

✦ Monochrome

✦ Sharpen

For this example, let's choose the Color Balance filter, which lets you add or remove shades of Red, Green and Blue from your video. This is helpful if your video as a tint that you want to get rid of, or if you want to experiment with colorizing your footage. Here's how to apply a color correction filter to your video clip:

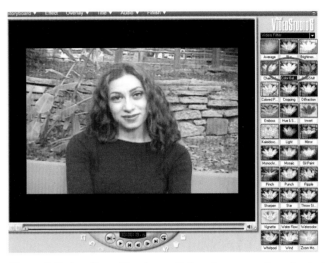

Figure 8-7 An effect filter is applied to the currently selected video clip by clicking its icon.

❶ Click the Color Balance filter button, on the right side of the screen.

❷ After clicking the filter icon, you will see the effect of the filter applied to the video in the Preview Window (Figure 8-7). You are actually seeing one of about a dozen presets for that filter. To see the effects of other presets, click a **Preset** button, on the left side of the screen (Figure 8-8).

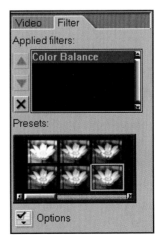

Figure 8-8 Effect filter variations are applied using Presets.

③ You are previewing your filter as applied to one frame. However, the filter will affect all frames in the clip. To see the full effect of the filter, press the **Play** button, just beneath the Preview Window. The clip will play back, showing the filter's effects in motion (Figure 8-9).

 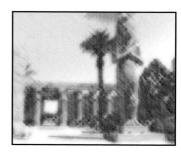

Figure 8-9 A video effect is rendered across an entire clip during playback.

In this example, you can apply an effect that does not vary while the clip plays back. However, every VideoStudio 6 effect is animated. By looking at the moving icons on the right side of the screen in the Filter Library, none of the effects are stationary. Our example requires a stationary effect. To remove the motion aspect, access the Options dialog box to edit the effect in other ways. For example:

① Click the **Options** button on the left side of the screen. The Color Balance dialog box will appear (Figure 8-10), providing three sliders for either increasing or diminishing the amount of Red, Green or Blue in your video.

② To specify the filter amount for the beginning of your clip, drag one or more of the sliders to the right or left, and you will see the results in the Preview Window located on the right side of the dialog box.

In order to adjust the color level at the end of your clip, record the settings you made by adjusting the sliders, then move to the end of the clip, and indicate those same settings. You want the same color adjustment to be in effect - both at the beginning and at the end of the clip. To apply a filter setting at the end of your video clip do the following steps:

① Click the **Position slider** right beneath the Preview Window of the effect dialog box and drag it all the way to the right (Figure 8-11). The next edit you create will be applied at the end of the clip.

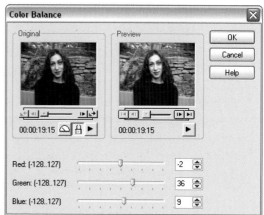

Figure 8-10 Edit effect parameters using the effect's dialog box.

❷ Use the Red, Green, and Blue sliders to recreate the settings you had at the beginning of the clip.

❸ When you are happy with your effect, click **OK** to close the Color Balance dialog box, and click the **Apply** button on the left side of the screen. Your effect will be applied.

❹ To quickly preview the effect, click the **Play** button at the bottom of the Preview Window.

❺ To render the movie segment that includes the effect, use the trim bars to select the desired segment of video, and press **SHIFT + PREVIEW** (the Preview button is also under the Preview window, on the left side).

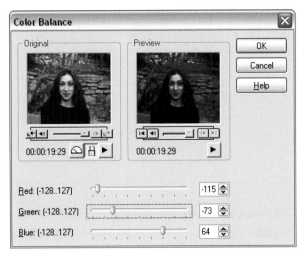

Figure 8-11 To change how an effect appears at the end of a clip, drag the Position slider to the right.

This process will not change the clip's filter settings from beginning to end. If you want a special color tint at the end of the clip, then use the faders.

If a green tint is applied at the end of the clip, it will gradually fade towards green. The program fades the effect in or out across the entire video clip. The sliders control how much of each effect you want to apply, at the clip beginning, and the clip ending. Figure 8-12 shows a more dramatic example of how an effect can change from clip beginning to ending.

Figure 8-12 By the time the video clip reaches its end, the applied Effect is very dramatic.

 Your Filter will appear in the list of Applied Filters, at the top of the Filter tab on the left side of the screen. To delete a Filter, click it, and then click the X.

You can add more than one Filter effect to a video clip. For example, it's perfectly fine to add a color correction filter as well as a deformation. Both filters will appear in the Applied Filter list. To edit a filter, click its name in the list, then click the Options button located on the left side of the Filter tab. This provides access to editing options for that specific filter.

Adding Deformation Effects

Deformation effects make portions of your video appear to bulge, become spherical, pinched, cropped, or otherwise deformed. The "painterly" effect, shown in Figure 8-13, is an example of a deformation effect.

Deformation effects do not add pixels to your video. Rather, they distort the pixels that are already present. When applying deformation effects, timing and duration are very important. A quick "pebble-in-a-pond" effect rippling through your video momentarily is nice, but you wouldn't want it to stay there. In fact, you will generally want to apply deformations to short video sequences, just for a change of pace, rather than to an entire project.

Figure 8-13 A deformation effect applied to video.

 Keep your friends. Be careful with applying effects like Pinch and Bulge to human subjects in your video. People can be very touchy about liberties taken with their likenesses.

Adding Deformation Effects Using Pinnacle Studio 8

Pinnacle Studio 8 has three effects that could be placed in this category of Deformation Effects. With the Blur effect, you can temporarily blur your footage before bringing it back into focus; with the Mosaic effect, a video clip can look like it was drawn in thick chalk; finally, with the Emboss effect, you can accent the edges of subjects in the video (obviously, this is an effect you'd want to apply sparingly).

Here's how to access and apply them:

① With a video clip loaded and displayed in either Storyboard or Timeline view, click the **Video Toolbox** button.

② Click the **Adjust color or add visual effects** tab. The Adjust color/Visual effects tool appears. There are four effects controlled by the sliders on the upper right: Blur, Emboss, Mosaic, and Posterize.

 The Posterize effect is mentioned here because of its close proximity to the other deformation effects. It is, however, a color correction effect, and is covered in the section, "Creating Color Correction with Pinnacle Studio 8," earlier in this chapter.

③ To apply one of these effects, drag its slider towards the right, or type a digit into the digital indicator field to the right of the slider.

The effects are as follows:

✦ Blur considerably softens the focus of the entire video clip (Figure 8-14).

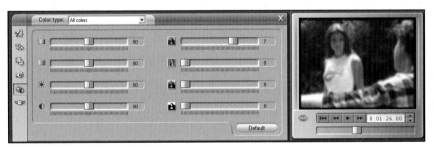

Figure 8-14 The Pinnacle Studio 8 Blur Effect.

✦ Emboss changes the video color to shades of gray. The shapes and objects in the video become raised outlines in black and dark gray (Figure 8-15).

8

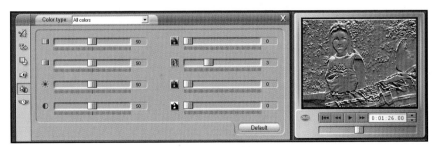

Figure 8-15 The Pinnacle Studio 8 Emboss effect.

✦ Mosaic transforms the video into blocks of like-colored pixels.

Adding Deformation Effects Using Ulead VideoStudio 6

Ulead VideoStudio 6 offers a large selection of deformation effects. VideoStudio also lets you control each effect's intensity and other attributes, allowing you more creativity and more ways to tailor the effects to your particular needs.

In order to add an effect, a VideoStudio project must have at least one video clip or still image present. To add a deformation effect, do the following:

1. Click the **Storyboard** button at the top of the screen, and click on a video clip or still image in your project.

2. On the left side of the screen, click the **Filter** tab. The Video Filter Library appears on the right, each effect represented by an icon.

3. Choose an effect. A good example of a deformation effect would be Kaleidoscope, Ripple, or Pinch. Choose an effect by clicking its icon and the video clip in the preview screen will display the effects of that effect (Figure 8-16).

4. To apply the effect in a variety of ways, choose an effect preset from the left side of the screen.

5. To edit effect start and ending intensity, or other effect control, click the **Options** button on the left side of the screen, and the dialog box for that effect's options will appear (Figure 8-17).

6. To view the effect across the entire duration of the clip, drag the **Play slider** on the Preview side of the Options dialog box, or press the **Play** button which is located on the Preview side too. Note that you can adjust effect amount at both the beginning and ending of the clip.

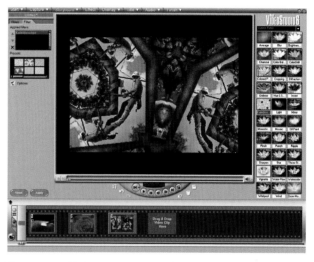

Figure 8-16 Deformation effects can be found in the VideoStudio 6 Video Filter library.

Figure 8-17 A deformation effect's Options dialog box.

7 When you are satisfied with your effect, click **Apply**.

8 To view the effect on the main screen, rather than in the tiny Options preview area, click the **Play** button at the bottom of the Preview Window.

9 To render the segment of video that you have applied the effect to, use the Trim bars to select only the video segment you want to render, and then press **SHIFT + Preview**, right beneath the Preview Window.

Adding Motion Effects

Motion effects move segments of your movie around the screen. Your video shrinks, filling only a portion of your video background, or can grow, zooming in on a particular detail. Other examples are whirlpool, ripple or wind effects (Figure 8-18). These are

Figure 8-18 A motion effect applied to video .

effects you should sparingly; what can be a creative novelty in small doses can quickly turn tedious.

Motion effects add objects that move across the video, such as stars and sunbeams. Examples are Star and Color Shift. With a video loaded into a project, click **Storyboard** at the top of the screen, and click the **Filter** tab on the left. When the Video

Filter Library appears, click an effect. For our example, let's use Star.

1 Click the **Star** effect icon. A Star effect will appear in the screen over your selected video clip.

2 To browse through various preset star effects, click the **Preset** button on the left (Figure 8-19).

3 To preview the star motion of these presets, click the **Play** button, just beneath the Preview screen. This type of effect takes a few seconds

Figure 8-19 Applying the Star effect to a video clip.

8

to process, so be patient while the star movement makes its way across the screen. In a true playback situation, the movement will be much more fluid.

④ To edit the Star effect, click the **Option** button on the left. The Star dialog box opens. You can add additional stars, change star size, brightness, and color.

⑤ To reposition a star's location at the beginning of the clip, hold your mouse over the crosshairs and drag it (Figure 8-20). The crosshairs are shown on the Original preview screen located on the left side of the Star dialog box.

⑥ To reposition a star's location at the end of the clip, drag the **Location slider** beneath the clip and under the Original preview screen. Make sure you drag that slider all the way to the very end. The crosshair will again appear. Drag the crosshair to a desirable location. This is where the star will appear at the clip's ending.

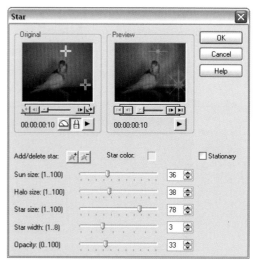

Figure 8-20 Repositioning the beginning and ending points of the Star Effect.

When the video clip is played back, the program will gradually move the star from its Begin point to its End point.

Go online to **www.LearnwithGateway.com** and log on to select:

◆ *Internet Links and Resources*

◆ *FAQs*

Gateway offers a hands-on training course that covers many of the topics in this chapter. Additional fees may apply. Call **888-852-4821** for enrollment information. If applicable, please have your customer ID and order number ready when you call.

8

Saving and Sharing Your Movie

When it comes to video, the medium really is the message. For example, if you post a large, uncompressed video file on the Web and expect users to download it over a 56 Kbps modem, your movie will probably never be seen. After a few minutes of waiting and frustration, your potential viewer will be gone and probably won't be back. Likewise, if your movie is headed for DVD playback, no one will suffer through it if you render it as a tiny, postage stamp-sized movie with maximum compression.

In this chapter, you will learn how to chose the right format for the right audience, as well as what your file format and compression options are. You will also learn various techniques and options for optimizing video performance. For instance, while most video editing programs provide presets for different viewing environments, there are times when you may want to make some additional choices, like selecting a larger frame size or a slower data rate. This chapter will arm you with a variety of output choices, and show you when and why to use them.

File Saving Options

No matter who your audience is, your ultimate goal is to save your movie in a format optimized for your target playback environment. For example, Figure 9-1 shows four video frames, each optimized for a different audience.

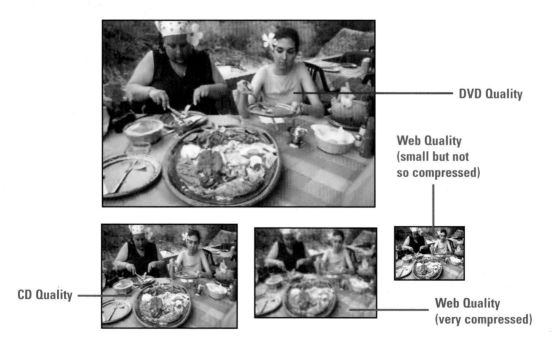

DVD Quality

Web Quality
(small but not
so compressed)

CD Quality

Web Quality
(very compressed)

Figure 9-1 Four video frames showing various degrees of compression and frame size.

The first frame is very high quality and large, suitable for DVD playback, MiniDV tape or hard disk playback. The second is mid-sized and decent quality, and would work well on a CD or high-speed Internet connection. The third is mid-sized, but the video is highly compressed, which makes it ideal for lower-bandwidth Internet connections. The fourth serves the same audience as the third—low-bandwidth—with a nod toward quality over size.

Achieving these radically different frame sizes and compression rates is accomplished by using different video file formats. As first discussed in Chapter 4, "Video Hard Drive Transfer," there are number of different formats you can use. Let's focus on practical choices for a variety of playback situations. The video output options listed below are found in both Pinnacle Studio 8, Ulead VideoStudio 6, or both.

Export to Web Page. Creates a Web page with a link to a video clip. By uploading both the page and the clip, viewers can visit that page and play back your clip whenever they like.

Export to E-mail. Opens your e-mail program, attaches the selected clip, and includes the video file name in the subject field.

Greeting Card. Lets you position a video clip against a background image of your choice and add a greeting message. Click on this video clip file and play back will begin. This greeting card file can be played back on almost any PC (Figure 9-2).

DVD. Saves your movie for playback on most DVD players. You can divide your movie into chapters and create a menu. Viewers access this menu, fast forward to any chapter and view from there. Saving to DVD requires a computer with a recordable DVD drive.

Figure 9-2 A Ulead VideoStudio 6 video Greeting Card.

9

 Chapter 10, "Creating DVD and DVD-Compatible Movies," is dedicated to creating DVDs.

SVCD. Creates movies for saving on recordable CDs for playback in a DVD player. Note that many standalone DVD players are not compatible with SVCDs. More than likely, your viewers will need a PC-based DVD player.

VCD. Creates movies for saving on recordable CDs for playback in any 8X or higher CD-ROM drive.

Tape/Project Playback. With your camcorder attached to your computer via FireWire, the movie is played back while the camcorder records it. You can also record your movie directly to VHS using this method.

NTSC DV. Renders your movie in high-quality .AVI format, compatible with saving onto MiniDV tape for playback on TV according to NTSC broadcast standards, as used in North America.

NTSC DVD/SVCD/VCD. Renders your movie in North American TV-compatible format for DVD, SVCD or VCD, whichever you choose.

PAL DV. Renders your movie in high-quality .AVI format, compatible with saving onto MiniDV tape for playback on TV according to PAL broadcast standards, as used in most of Europe.

PAL DVD/SVCD/VCD. Renders your movie in European TV-compatible format for DVD, SVCD or VCD.

MPEG-1. Renders your movie for Web or CD-based playback. Creates compressed movies that provides options for balancing multiple output requirements.

MPEG-2. Renders your movie for DVD, broadcast, or PC playback. Creates compressed movies that provide options for balancing multiple output requirements.

QuickTime (.MOV). You can view these files in PC and Mac environments. This is a Web-friendly

Figure 9-3 A QuickTime movie.

format that provides many quality vs. compression options. QuickTime movies are highly customizable. You can create multiple video layers; add interactivity and links to Web sites. QuickTime is a natural choice for videographers who want to develop video-based applications (Figure 9-3).

Video For Windows (.AVI). Universal video format for PCs running some form of the Windows operating system. .AVI movies maintain high quality even when compressed and they are a preferred format for tape transfer, PC-based viewing, and high-speed Internet and intranet viewing.

Streaming RealVideo (.RM)/Streaming Windows Media (.WMV). Renders your movie in the most Web-efficient format. Unlike other formats, the movie will begin playback before download is complete. This means your viewers are less likely to lose patience and go on to something else before they've enjoyed your show. Allows you to select several playback speeds, for example, one for slower Internet connections and one for faster. Figure 9-4 shows a RealVideo movie.

Figure 9-4 A RealVideo movie.

Customizing Video Output Options

While all video programs provide video export presets that will work fine for most uses, you will eventually find a reason to do a little customization on you own. For example, you can choose a larger frame size, slightly lower data rate, or lower quality audio. You will make these choices to find the right balance between movie quality on one hand, and portability and smooth playback on the other. The list below describes the most common customizable output options.

Frame Type. The options are Frame based, Field order A, or Field order B. Choose Frame-based for computer monitor or Digital TV viewing, and choose Field Order A or B (check broadcast specification for which one) for broadcast TV viewing.

Video/Audio or Video Only. To discard all audio, choose Video Only. The results will be a silent movie, and you will save a little on file size. Note that discarding audio during rendering does not affect the project itself. Rendering a silent movie leaves the audio of your project untouched.

Frame Rate. Higher frames per second (fps) means higher quality video. However, higher frames per second requires more CPU power and bandwidth. Choose 29 fps for NTSC broadcast video, or video for TV, or choose 25 for PAL European broadcast standard TV. For CD-based playback choose 15 fps. For Web-based playback, choose 12, or even as low as six, for lower bandwidth requirements. For DVD playback, you can choose 30 fps. Note that your video editing program provides presets for these output environments, and you are not likely to encounter a need to choose a fps setting yourself.

Figure 9-5 A menu of compression options.

Frame Size. Be careful choosing a new frame size for your project, as you are likely to alter dimensions as well. This can be bad, as no one wants to look fat on TV. Increasing frame size makes the picture bigger, and thus, more fun to watch. However, file size and bandwidth requirements are increased as well.

Compression Type. Some video formats allow you to choose a compression type (Figure 9-5). Each compression type has a special use, so this feature can be helpful. For example, when saving your movie as a QuickTime file, you can choose Cinepak compression for playback on older computers.

Video Data Rate. Your video can be optimized for the rate at which the playback device is likely to ask for data. High data rates, such as above 2000 Kbps, are good for high-speed Internet connections or intranet. Low data rates such as 800 or below are good for 56 Kbps modems or viewing your movie during times of heavy Internet traffic. A variable data rate is good for situations where Internet traffic can affect movie viewing. For example, if you expect viewers to be accessing your movie online at all hours, you would choose a variable data rate. However, a constant data rate promotes smooth viewing in more optimal conditions.

Keyframes. When choosing a compression type, you are often given the option to set keyframes (Figure 9-6). Keyframes are the frames of video that the in-between-frames use as their baseline, reproducing only the data that changes in between keyframes. A higher number of keyframes means better-quality video but larger file size. A good range is setting keyframes every 8 to 24 frames. Keyframes every eight would be a fairly high-quality video.

Hinted Streaming. Hinted Streaming is a QuickTime Web video option that lets you specify which segments should be allowed more CPU power for smoother downloading.

Pad frames for CD-ROM. Select this option for more efficient CD-based video playback. This option is usually found under Advanced Compression Options.

Interleave Audio and Video. You can specify how many packets of video information should be stacked together in the video stream before an audio packet is added. If audio playback is particularly important, specify a high audio-to-video ratio.

Audio Bit Rate. A high audio bit rate (in Kbps) results in better audio quality. 128 to 256 Kbps supports high-quality audio, but you will need a high-speed Internet connection to deliver it reliably. Video in which music is important should provide at least 96 Kbps bit rate.

Figure 9-6 Saving a VideoStudio project as a .rm streaming movie.

Figure 9-7 Selecting an Internet connection type for a target audience.

Target Audience. When creating RealVideo or Windows Media movies for the Web, you can specify the type of Internet connection that your audience will have, for example dial-up modem or Dual ISDN (Figure 9-7). If you choose a server-based streaming type, you can choose more than one type of connection as your target.

Movie Output Options

As mentioned earlier, several video editing programs have presets that select the best compression, frames size, data rate, and other options for each output situation. The process involves selecting the project you want to export, choosing a format, and noting the location of the resulting files, so you can easily access it. Beyond this, the other requirement is patience, since rendering and exporting a movie can take a while. Let's move through the exporting process for various formats using both Pinnacle Studio 8 and Ulead VideoStudio 6.

Pinnacle Studio 8 Output Choices

Pinnacle Studio 8 provides a single interface for exporting movies. To export a movie, click the **Make Movie** tab at the top of the Studio 8 screen. On the left side of the screen, there are tabs for accessing six format types: Tape, AVI, MPEG, Stream, Share, and Disc.

Tape

To output your movie to MiniDV tape using your camcorder, do the following:

1 Make sure your camcorder is connected via FireWire to your computer. It should be powered on and set to **Play/VCR** mode. Make sure the MiniDV tape currently loaded has enough tape to record your project.

2 Click the **Tape** tab at the top left.

3 Click the **Settings** tab. Make sure DV Camcorder is the selected option.

 To allow Studio 8 to start and stop recording without requiring manual handling of the camcorder, click the **Automatically Stop and Start Recording** check box.

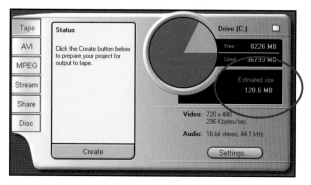

Figure 9-8 The AVI file size for saving a movie to tape should be quite large.

4 Click **OK** to close the dialog box. In the Estimated Size field of the Make Movie screen, note the size of your .AVI file (Figure 9-8). After verifying that the settings are correct, you are ready to record to tape.

5 Click the green **Create** button (Figure 9-9). If you have not already output your project as an .AVI file, Studio 8 will immediately begin rendering the movie first.

 If you intend to return later and output this movie to tape rather than output it now, note the folder where the video is saved. By default, Studio 8 will save .AVI files for Tape output in C:\...\My Documents\Pinnacle Studio\Auxiliary Files.

6 Once your movie is saved as an AVI movie, it can be saved immediately to tape. To do this, just click the **Play** button on the Player. The REC indicator will appear in your camcorder's LCD screen, and you will hear the camcorder's tape transport motor kick in, indicating that tape is moving

7 To stop recording, use the **Stop** control beneath the Player.

8 After you have played back your project, the camcorder's LCD reads STOP. You're done!

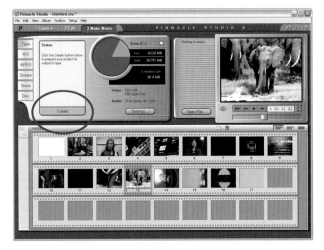

Figure 9-9 Click the Create button to start the process of saving your movie to tape.

 To learn more about using Pinnacle Studio 8 to output to videotape, go to the Web segment *Movies: Outputting to Videotape.*

AVI

If you want to create a movie for hard drive playback on a PC-based computer, .AVI is a natural choice. The format is well-supported on most Windows platforms, and Studio 8 provides many .AVI compression options so you can create an .AVI movie for various environments and requirements. In addition, if you create your .AVI file first, it will be pre-rendered and

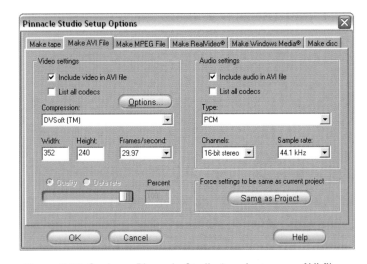

Figure 9-10 Saving a Pinnacle Studio 8 project as an .AVI file.

ready to copy your movie to tape, if you so desire, as discussed in the last section.

To render your movie as an .AVI file, do the following:

① From the Pinnacle 8 Make Movie screen, click the **AVI** tab on the far left.

② To specify options for your movie, click the **Settings** button. The Pinnacle Studio Setup Options dialog box appears with the Make AVI File tab selected (Figure 9-10).

③ Choose a compression option. If you choose DV Video Encoder or Indeo Video 5.10, your movie will be quite large. If this is not your intention, choose one of the other compression options, such as Cinepak. To create a movie for MiniDV tape, you choose DV Video Encoder.

 By default, the Compression drop-down menu does not display all of the available codecs. To see all the codecs installed on you computer, select the **List all codecs** check box.

④ After making any adjustments to your .AVI settings, click **OK**. You are now ready to create an .AVI movie.

⑤ Click the **Create AVI file** button. A Save As dialog appears, allowing you to specify where your movie will be saved. Note this location; this is your finished product you will be sharing with the world.

⑥ After clicking **OK**, the .AVI file will begin rendering. Status messages will appear on the screen, indicating when the movie is completed or errors in rendering. You can monitor the rendering progress by watching the progress bar at the bottom of the Player.

⑦ When the bar has moved across the final scene, rendering is complete.

 To learn more about using Pinnacle Studio 8 to save .AVI files, go to the Web segment *Movies: Saving as AVI files*.

MPEG

MPEG movies are popular because of their small file size, good quality, and flexible playability. MPEG-2 is used for DVD and HDTV broadcast, and MPEG-1 is popular for the Web and for creating video CDs. To render your movie as an MPEG, do the following:

① With a video project loaded, click the **Make Movie** tab located at the top of the Studio 8 screen.

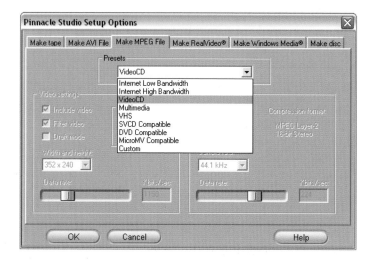

Figure 9-11 The MPEG Options dialog box.

➋ Click the **MPEG** tab on the far left.

➌ Click **Settings** to choose one of the presets or customize your compression and movie output choices. The presets, ranging from Internet Low Bandwidth to DVD output, will suit most needs (Figure 9-11).

➍ If you click **Custom** in the Preset list, you can select which MPEG format to use, choose a video dimension, data rate, as well as audio sampling and data rate.

➎ When you are happy with your Settings, click **OK** to close the dialog box, and click the **Create MPEG file** button. A Save As menu appears, prompting you to name your movie.

➏ Monitor rendering progress by noting the progress bar.

➐ When rendering is finished, you can play your movie in any MPEG player, or preview it in Studio 8 by clicking the **Open a file for playback** button.

Ulead VideoStudio 6 Output Choices

Ulead VideoStudio 6 provides output options as the final step in the movie creating process. You'll see them when you click **Finish** at the top of the screen. The exception are options where you generate output from a single movie clip, such as e-mail, Greeting Card, and Web page. These are accessed from the Storyboard screen. We'll now discuss how to save your movie in various formats using Ulead VideoStudio 6. We'll cover saving your movie to tape, as well as creating an Greeting Card, an MPEG movie, and a QuickTime movie.

Tape

Ulead VideoStudio 6 converts your movie to an .AVI format as part of the process of saving your movie to tape. However, movies that have already been strongly compressed may not be compatible with saving to tape, and the program may prompt you to select another movie. Movies based on footage that you've transferred from your camcorder and edited will convert just fine. VideoStudio 6 provides an easy step-by-step set of screens for saving to tape.

To save your movie to tape using Ulead VideoStudio 6, do the following:

➊ Make sure your digital camcorder is connected to your computer via FireWire. The MiniDV tape should have enough remaining tape to comfortably record the entire project.

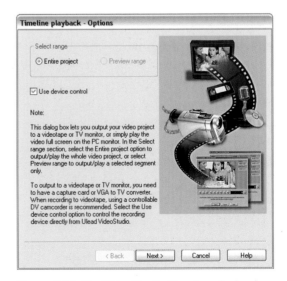

Figure 9-12 The VideoStudio Timeline playback Options dialog box

❷ Set the camcorder to **Play/VCR** mode.

❸ In VideoStudio 6, click the **Finish** button at the top of the screen. Verify the project is present.

❹ Click the **Project Playback** button on the right. The Timeline playback - Options dialog box appears (Figure 9-12).

❺ To allow VideoStudio's controls to control your camcorder, click the **Use device controls** check box.

❻ Specify if you want to record the entire project or just the currently selected preview range.

❼ Click **Next**, and the Timeline playback - Device Control screen appears (Figure 9-13). The screen reports the camcorder brand, current timecode (the current tape position), and format.

❽ If you start recording at a specific timecode position, use the digital counter at the right to indicate and then move to that position. For example, if you know where the video on your MiniDV tape ends and you want recording to begin exactly at that point, then use the digital counter.

❾ The Preview Window will not display video until you press the red **Record** button, and your camcorder will start recording it.

❿ You can monitor the progress by watching your camcorder's LCD or watching the VideoStudio Preview Window. The Timeline Playback screen will only display the message "Video Frame are

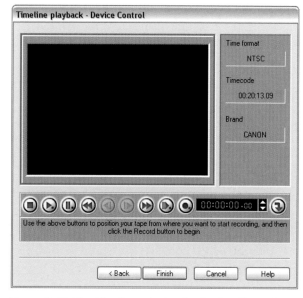

Figure 9-13 The Timeline playback - Device Control screen

Outputting to DV Camcorder." You can manually stop recording, rewind, or do any other VCR-like function using the controls in the Timeline Playback dialog box.

⑪ When the project has reached the end, recording will automatically stop. You can use VideoStudio's VCR controls to rewind your camcorder and play back the project or just play it back on your camcorder.

⑫ Click the **Finish** button. The project has now been saved to tape.

Greeting Card

Ulead VideoStudio 6 lets you save a movie clip against a background image of your choice. You position the video clip any way you like against the background image. Both image and video clip are saved together as a single file. You can then send this file to anyone who has a PC. When they click the file, the video plays back against the background image.

To share your movie as a greeting card, do the following.

① With a video clip open, click **Storyboard**.

② Click one video clip as it appears in the storyboard. You can also click a video clip in the Video Library.

③ Click the **Export** drop-down menu on the far left and choose Greeting Card. The Multimedia **Greeting Card** dialog box appears (Figure 9-14).

④ Select the Background template **Browse** button to locate an image you'd like to use for your background. The video clip you clicked will appear against the background.

⑤ To make this background image available for other greeting card projects, click the Add button.

Figure 9-14 The Multimedia Greeting Card dialog box.

⑥ If you wish, resize and move the video clip so that it works well with the background image. To maintain video dimensions, click the Keep video aspect ratio button so that your video clip is resized proportionally.

⑦ To maintain video dimensions click the **Keep video aspect ratio** check box so that your video clip is resized proportionally.

⑧ To preview the video, click the **Play** button.

⑨ When you are happy with the greeting card, click the **Browse** button next to the Greeting Card file field, and type in a name. This will be the name and location for your greeting card. Make note of both.

⑩ Click **OK** and the greeting card will be created immediately.

⑪ When the process is completed, browse to the folder where your card was saved. You will see an .exe file with the name you chose. Click that file, and the greeting card will play back.

MPEG

9

MPEG movies are a favorite multi-purpose format, compatible with output for the Web, CDs, DVD, and PC-based playback. You are provided many compression and frame size choices, and even high-quality MPEG movies don't require nearly the same amount of disk space as many other formats. To create an MPEG movie with Ulead VideoStudio 6, do the following:

① At the top of the VideoStudio 6 screen, click **Finish**.

② Click **Create Video File**. A drop-down menu will appear.

③ Choose **MPEG-1** or **MPEG-2**, depending on your requirements.

④ A Save As dialog box appears, prompting you to type a file name and choose a location for your movie.

⑤ If a portion of your project is selected, you can choose to render only that portion or render the entire project.

⑥ Click **OK**. The movie will be rendered. A blue progress bar indicates the progress.

⑦ When the movie has finished rendering, it will appear in the Video Library with the other videos. The rendering and saving process has completed. You can now distribute that MPEG movie any way you wish.

To create an MPEG movie with customized options, go to the Create Video File drop-down menu and choose **Custom**. Then do the following:

① In the **Save as** type drop-down menu, choose a file type. In this case, choose **MPEG files**.

② Click the **Options** button. Since you selected MPEG, you will only see MPEG-specific export options. Typical options you may like to modify are Video Data Rate, Audio Frequency and Bit Rate, Media Type, and Frame Size.

③ Click **Save** and your movie will begin rendering.

Sharing Your Movie Online

Movies destined for the Web have special requirements. Before the viewer can watch your movie, they are required to download it (or at least a portion of it), which takes time. Even if you are reasonably certain that the viewer will have a high-speed Internet connection, download speeds will still often vary depending on Internet traffic. This means that your Web-based movie should be as small and compact as possible. In this section, you will learn what makes a good Web-based movie, and how to format and save your movies for viewing on the Web, or send as an e-mail attachment. We'll also touch on Internet Streaming technology, and how you can create Web movies that play optimally in a number of different online environments.

 Before using another's audio in your movie, always obtain permission from the property rights owner."

Making a Good Web Movie

A good Web movie will be short and to the point. You may need to return to the editing screens and remove content that is not essential to your project, for example scenes where the camera lingers on a single subject for more than a few seconds. You will show mostly close-ups of main subjects. Keep in mind that subtleties tend to get lost in Web-based movies due to the smaller frame size (Figure 9-15 displays a movie in both the Windows Media and RealMovie players, which are both typical Web viewing environments). Also, note that transitions and special effects greatly increase movie download time. So, if you are making a point to edit your project for the Web, consider removing them.

Figure 9-15 A movie clip shown in both RealMovie and Windows Media players.

Let's begin with some general tips for creating Web-based videos:

✦ Before posting your video online, take the time to reduce file size, frame rate, color, and audio depth. Movies designed for 56 Kbps modem download should not be larger than 250 Kb. Movies designed for ISDN, DSL or cable modems should not be more than about 1.5 MB.

✦ Movies with fewer colors transmit faster than films with detailed, complex images. An ideal Web-based movie shows people talking against a single-color background.

✦ Avoid using transitions. If a movie is destined for the Web, eliminate fades and just use straight cuts.

✦ Use a frame rate somewhere between six and 15 frames per second.

✦ Edit your movie ruthlessly. The Web version of your project will be much shorter in length than movies distributed through other media.

✦ Take time to experiment with audio settings. Unless music plays a huge roll in your project, make your tracks mono, 12-bit at 22Hz.

 Video dimensions do not affect download times as negatively as the other factors mentioned. If you have a video at 320 x 240 pixels that you really want to post, but the file size is too large, reducing the dimensions to, say 160 x 180 won't make much difference.

Both Pinnacle Studio 8 and Ulead VideoStudio 6 let you create a Web-formatted movie with a Web page ready for viewing. Pinnacle Studio 8 provides a Web site, allowing each Studio 8 owner 10 MB of video space for personal videos. All you must do is provide an e-mail address, and choose a username and password. This registers you for your free Web space. Use Pinnacle Studio 8 to create your Web movie using the Share feature; choose a Web page template for your video, allow the program to upload your video, and you are done. You can e-mail the link to your online movie to anyone you wish and it can be viewed at any time.

Ulead VideoStudio 6 will create a Web-formatted movie and Web page, all ready for you to upload at once to your own Web space, and share with the world as you see fit. VideoStudio 6 also provides a single-step process for creating a movie that you can e-mail. The program will open your e-mail program and attach the movie to an empty e-mail message.

The steps for creating a Web-based movie in Pinnacle Studio 8 and Ulead VideoStudio 6 are fairly unique, so we'll now take a close look at both programs.

Creating a Web-based Movie with Pinnacle Studio 8

The following describes how to share your movie online using Pinnacle Studio 8:

1 With a video project load in Studio 8, click the **Make Movie** button at the top of the screen.

2 Click the **Share** button on the left.

3 Click the **Share** button that appears in the Status window on the left. Pinnacle will begin creating a Web-formatted movie from your project.

4 When the movie is completed, Pinnacle will open your browser and visit the Pinnacle Studio Online Web site (You will need an open Internet connection to do this). You will be prompted to register for the site, with no fee. Studio 8 customers are provided 10 MB (about five minutes) of free storage space for movies.

5 After registering, a screen appears prompting you to choose a template for your video, after you chose a template you then see the following screen (Figure 9-16). Here, you can indicate an e-mail recipient. The recipient will get an e-mail providing a link to the movie.

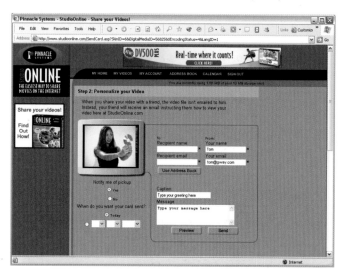

Figure 9-16 Sharing your movie online with Pinnacle Studio 8.

⑥ Personalize the template by adding a message.

⑦ Click **OK** and the movie will be uploaded to the site. The e-mail will be sent. You can send that same link to others as well, notifying as many people as you wish about your online movie.

 To learn more about using Pinnacle Studio 8 to share your movies online, go to the Web segment *Movies: Sharing through the Internet.*

Creating a Web-based Movie with Ulead VideoStudio 6

Ulead VideoStudio 6 provides three avenues for sharing your movie online. You can create a Web page that automatically plays back your movie, attach your movie as an e-mail, or create a streaming movie optimized for Web viewing. To create an online movie using Ulead VideoStudio 6, do the following:

① Add video clips to the VideoStudio 6 Storyboard or Timeline Mode.

② Click **Storyboard**.

③ Click a video clip as it appears at the bottom of the screen. This selects that video clip for online viewing. You can also click a video clip in the Video Library.

④ Click **Export** on the left, and when the Export drop-down menu appears, choose **Web Page**. Ulead will prompt you to specify whether it should create a Web page that uses Microsoft ActiveX controls, or a page with a standard HTML link.

 Some people surf the Web with ActiveX controls disabled, so you may or may not want to use the more advanced ActiveX feature for your page.

⑤ Click **OK** and a Browse menu appears, prompting you to type a name for your page and select a folder location. Note the location, as you will have to visit this folder to access both the video and the Web page created along with it.

⑥ Click **OK** and VideoStudio will render the movie clip and create a Web page for it.

⑦ After rendering, the Web page will appear in your browser (Figure 9-17). In the page, VCR controls will appear at the bottom of the video clip, so your viewers can control the video.

Figure 9-17 VideoStudio 6 creates a Web-based movie and a Web page, all ready to upload.

9

8 You can now upload both the video and the HTML document to your own Web space, and share the link to your movie with anyone you wish.

E-mailing Your Movie using Pinnacle Studio 8

In Pinnacle Studio 8, you have the option to e-mail your movie from both the MPEG and Stream tabs under the Make Movie tab. The process is quick and easy:

1 Once your movie has been rendered, you will see a new button to the right of the **Open a file for playback** button—the **Send file by e-mail** button. Clicking it will open a dialog where you can select your new movie, or any other MPEG movie, to send via e-mail.

2 Studio 8 will launch your computer's default e-mail program—Outlook Express, for example—and attach the video to an e-mail, ready to send to whomever you wish.

3 Check the files size of the movie to make it is not too large for the person to whom you are sending it, then select the recipient's e-mail address and send the e-mail like you would any other e-mail.

E-mailing Your Movie using Ulead VideoStudio 6

To render your movie to an e-mail message using Ulead VideoStudio 6, do the following:

1 Add video clips to the VideoStudio 6 Storyboard or Timeline Mode.

2 Click **Storyboard**.

3 Click a video clip as it appears at the bottom of the screen. This selects that video clip for online viewing. You can also click a video clip in the Video Library.

4 Click **Export** on the left, and when the Export drop-down menu appears, choose E-mail. Ulead will open your e-mail program and attach the currently selected clip to an e-mail. The subject line will contain the video file name.

 Make sure you choose a movie clip that is compressed, and not too large for a viewer to reasonably have the patience to download. A good choice for an e-mail movie would be MPEG-1 or QuickTime.

Streaming Video

An important technology for viewing movies online is known as video streaming. Streaming allows your online movie to begin playback before it has completely downloaded. Since a movie can take a while to download, giving your viewers something to watch before download is finished is a great advantage.

There are two types of streaming technology. The most common and least expensive streaming technology allows a viewer to begin watching your movie as soon as a portion has been downloaded. Then, as data is transferred according to the connection quality

and modem speed, more video will be displayed. This method is called Web Server-based, or Single-Rate streaming. It is also sometimes referred to as HTTP streaming.

More advanced streaming requires the Web host provide a Streaming server, also known as Multi-rate streaming. The company hosting your Web site may very well offer a streaming server solution if you inquire. With Multi-rate streaming, playback begins as soon as the visitor clicks on the page or clicks the Play button. Streaming servers provide an "intelligent" connection for your movie that not only begins playback as soon as the visitor views the page, but adjusts transmission of video data according to Web traffic. The server will always download your movie as fast as the connection will allow, and is capable of delivering smooth playback in bad Internet traffic. If you want Multi-rate streaming, you will pay an extra monthly fee to your Web host, and follow specific setup instructions.

Both Pinnacle Studio 8 and Ulead VideoStudio 6 will format your project as a streaming movie. There are two types, RealNetwork's RealVideo (.RM) movies, and Microsoft's Windows Media Video (.WMV). Both streaming technologies allow you to create Single-Rate streaming and Multi-Rate streaming.

How will you know which type of streaming movie you are creating? When you choose your streaming movie options, you will be prompted to choose a target audience, for example, 56 Kbps Modem, or Dual-ISDN. Now, the dialog boxes allowing you to make this choice will let you choose more than one, and that is when you have crossed the line. If you choose more than one target audience, the program will format your movie for Multi-rate streaming. If this is your intention, you will have to get with your Web host and set up this technology. If not, then just choose one target audience for your streaming movie.

Creating a Streaming Movie with Pinnacle Studio 8

To create a RealVideo or Windows Media movie using Pinnacle Studio 8, do the following:

1. With a video project loaded, click the **Make Movie** button at the top of the Studio 8 screen.
2. Click the **Stream** tab on the left.
3. Click the **Windows Media** or **RealVideo** button (above and to the left of the Settings button), whichever format you'd prefer for your Web movie.
4. After choosing which movie type to use, click the **Settings** tab.
5. Choose playback options for your video. You can choose frame dimensions, target audience, playback and audio quality, and many other options.

9

6 If you choose Windows Media Player, you can opt to have File Markers that allow viewers to move between clips in your project (Figure 9-18). Your audience can preview segments of your video, rather than sit through the whole thing.

7 If you choose RealVideo, you can select several target audiences for your movie by selecting the RealServer option. As mentioned above, you will have to work with your Web host to set up the details of how to deploy movies with Multi-rate streaming.

8 After choosing your options, click **OK** to close the Settings dialog box.

Figure 9-18 In a Windows Media movie, your movie clips can be saved as File Markers.

9 Click the **Create Web** file button. A Browse dialog box appears, prompting you to choose a file name and location. After doing so, click **OK**. The video will be created.

10 When finished rendering, you can view the movie by browsing to its folder and clicking it.

Creating a Streaming Movie with Ulead VideoStudio 6

To create a RealVideo or Windows Media movie using Ulead VideoStudio 6, do the following:

1 With a video project loaded, click the **Finish** button at the top of the screen.

2 Click **Create Video File**, and on the drop-down menu, click Streaming RealVideo or Streaming Windows Media.

3 On he drop-down menu, click **Streaming RealVideo Streaming WindowsMedia**.

4 To customize your options, click **Customize** on the drop-down menu, and when the Save As dialog box appears, choose one of the streaming file types as the saved video format.

5 To access options for your saved movie, click **Options**. You can choose frame dimensions, target audience, playback and audio quality, and many other options. If you select more than one target audience, you will need to work with your Web host to iron out the details.

6 After choosing options, click **OK** to close the dialog box, and on the Save As dialog, click **OK**. The movie will begin rendering.

7 When rendering is complete, your new movie will appear in the Video Library located on the right side of the screen.

TO KEEP ON LEARNING . . .

Go to the CD-ROM and select the segment:
- ✦ *E-mailing your Movie* to learn more about e-mailing your movie.

Go online to **www.LearnwithGateway.com** and log on to select:
- ✦ *Capture, Create and Share Digital Movies*
- ✦ *Internet Links and Resources*
- ✦ *FAQs*

Gateway offers a hands-on training course that covers many of the topics in this chapter. Additional fees may apply. Call **888-852-4821** for enrollment information. If applicable, please have your customer ID and order number ready when you call.

9

Creating DVD and DVD-Compatible Movies

D VDs are the optimal digital video media. You will not have to shorten your movie, or render it as a thumbnail. The quality is compatible with digital TV. Most DVDs can play back on any commercial DVD player, which moves your potential audience away from the computer screen and into the TV room, a more relaxed viewing environment. DVDs present your video in chapters. Insert the DVD and a menu appears, allowing viewers to click around and view the segments that interest them. Additionally, DVDs are roomy enough (more than four gigabytes of data) to facilitate sharing several video projects, not just one.

In this chapter, you will learn DVD creation as well as video CDs. Both options allow you to create a menu system, bringing a degree of professionalism to your presentation. Note that creating DVDs requires a recordable DVD drive, but even if you don't own one, you can still create DVD-quality video for playback on DVD players through the use of a video CD.

Video-to-Disc Specifications

There are different movie specifications and file types used for portable-disc-based movies. The variety of formats makes it possible for those with and without standalone DVD players to still enjoy DVD-quality movies, as well as viewers who still primarily work with CD-ROM discs.

Before we walk through the process of creating your DVD or video CD, you should be aware of some of the similarities and differences between the three disc formats: DVD, SVCD, and VCD. In fact, creating any of these formats involves three steps:

❶ An existing movie is rendered into a compatible format. Some programs render the video into the appropriate format for you, as part of the disc creation process. Other programs require you to have previously saved your video into the right format before disc creation can begin.

❷ The movie is prepared for disc transfer and marked with clickable "Scenes" that viewers can use to navigate your movie via remote control (Figure 10-1). You may also incorporate an introduction video (a clip used to introduce the movie project), or a background image behind the clickable interface.

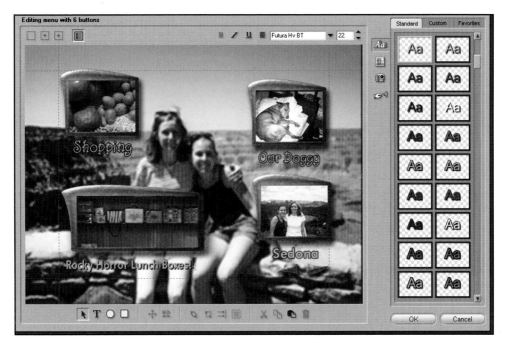

Figure 10-1 The scenes in your movie can be used for DVD chapters.

❸ The movie and support files are burned onto a CD or DVD using your DVD-burning or Video editing software and hardware. Most programs, including the two we'll look at in detail in this chapter, provide a step-by-step wizard for disc creation. You've already done the hard work. At this phase, you'll have to do little else besides select menu options and click Next.

DVD

To record a DVD (Digital Video Disc), you must have a DVD recorder in your computer. Your digital video software will provide options for creating DVD menus and saving your final movie onto your DVD recorder. DVD movies are stored in MPEG-2 format. Standard DVD output settings are as follows:

✦ **Frame Rate:** 29.97 frames per second (fps) for NTSC and 25 fps for PAL

✦ **Frame Size:** 720 x 480 for NTSC and 720 x 576 for PAL

✦ **Video Data Rate:** Between 4 to 8 Mbps (depending if a constant or variable bit rate is used)

✦ **Audio Settings:** 48 kHz

10

Movies saved onto DVD can be played back on most of today's standalone DVD players and computer-based DVD-ROM drives.

 Before purchasing a DVD player, check to see what kinds of formats it can play (the manufacturer's Web site is usually an excellent place to find this information). If you are going to be using SVCD or VCD formats, double-check to make sure that your standalone player will play those formats. Even if your DVD player will play these formats, some players may also require a specific brand of CD media.

SVCD

SVCD (Super Video Compact Disc). This format lets you record high quality video for playback on some standalone DVD players and almost all computer DVD and CD-ROM with playback software. An SVCD can hold around 40 minutes of video, and are stored in MPEG-2 format. SVCD output settings are as follows:

✦ **Frame Rate:** 29.97 frames per second (fps) for NTSC, and 25 fps for PAL

✦ **Frame Size:** 720 x 480 for NTSC and 720 x 576 for PAL

✦ **Video Data Rate:** Up to 2600 kbps variable.

✦ **Audio:** Layer 2 audio bit rate 32 to 384 kbps variable.

 To maximize the amount of video on an SVCD, use a lower data rate. For highest quality, use a higher data rate.

VCD

VCD (Video Compact Disc). This is the format for sharing video projects on CD. They'll be playable on almost any computer CD-ROM drive, providing the viewer has standard video playback software. A typical VCD can hold about 74 minutes of video. The standard VCD format is MPEG-1. The picture is smaller than SVCD or DVD, and quality will decrease. But using this format, you can share your video with almost anyone that has a modern computer. VCD output settings are as follows:

✦ **Frame Rate:** 29.97 frames per second (fps) for NTSC, and 25 fps for PAL

✦ **Frame Size:** 352 x 240 for NTSC and 352 x 576 for PAL

✦ **Video Data Rate:** 1152 kbps

✦ **Audio Settings:** CD-quality, 44.1kHz stereo.

For the rest of this chapter, we'll step through the disc creation process for Pinnacle Studio 8 and Ulead VideoStudio 6. Both programs convert an existing project to the disc format of your choice, provide tools for menu building, create the necessary image files, then burn to disc. The image files can be saved for burning more discs at a later date. We'll start with Pinnacle Studio 8, then walk through similar steps with Ulead VideoStudio 6.

Creating a Video Disc with Pinnacle Studio 8

Pinnacle Studio 8 lets you create menu systems for your DVD/SVCD/DVD. There are 27 menus to choose from, accessible by clicking the **Show Menus** button on the Album (Figure 10-2). A menu automatically creates a clickable thumbnail for each scene in your movie.

When the viewer inserts the DVD or CD into their drive, the first thing they see is the menu. They can jump to any scene by clicking its thumbnail. If your movie contains many scenes, Pinnacle Studio 8 creates multiple pages to accommodate the required thumbnails. Viewers are provided a Next button for jumping to additional pages.

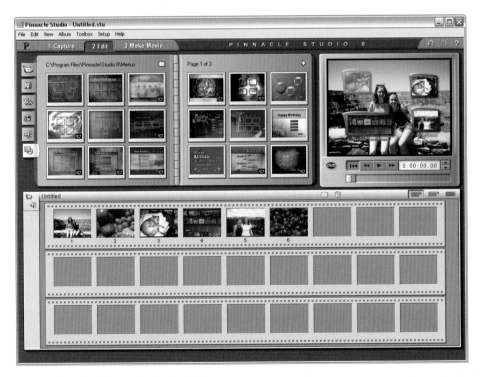

Figure 10-2 The Pinnacle Studio 8 disc menus.

Creating the Menu Backdrop

A menu backdrop is a special "first scene" for use as the background behind your menu. To create a menu backdrop, take a look at your project's scenes for adequate chapter breaks, and locate a suitable scene. You will want to add this scene to the beginning of your movie, so that it plays while the menu appears on the screen. This is the menu that viewers will first see when they insert your DVD into their drive and begin playing it back.

 You may want to choose a scene that is six to ten seconds long, giving viewers plenty of time to view your menu and make a choice. The menu will leave the screen at the end of this special introductory scene. If viewers click no menu option, the movie simply plays.

Now that the introductory scene is in place, the menu can be created. To add a menu to your movie, click the **Show menu** tab, then select any thumbnail from the Menu Album and drag it over your special first scene in the Movie Window. The preview screen will show the menu superimposed on the scene (Figure 10-3), and the Album will change to the Menu Editor. Before you can do the information in step 2, you must click the Show menu tab.

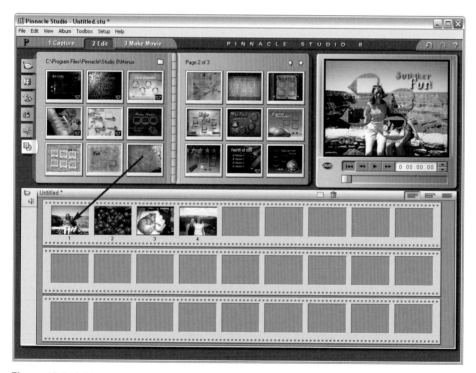

Figure 10-3 Add a menu to a movie by dragging it over a scene.

 With your project in Storyboard view so you can see each scene's thumbnail, now is a good time to ensure that your scenes are of a reasonable, if not somewhat equal, length for viewing. If you see opportunities for cutting lengthy scenes in half or combining some smaller ones together, this will provide an easier and more pleasant experience for viewers.

Creating Chapters from Scenes

Once you've added a menu, Studio 8 prompts for permission to sequentially add scenes to the menu thumbnails (Figure 10-4). Scene 1 becomes Chapter 1, Scene 2 becomes Chapter 2, and etc.

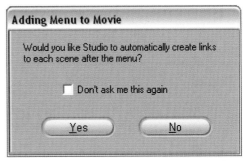

Figure 10-4 Studio 8 will automatically generate DVD chapters from scenes.

If you want to rearrange your scenes rather than have Pinnacle automatically add scenes sequentially, you will need to add each scene manually. To manually add a scene to the menu do the following:

❶ Drag the thumbnail of each video clip you want to include in your menu from the Movie Window to a thumbnail slot as it appears in the Menu Editor (Figure 10-5).

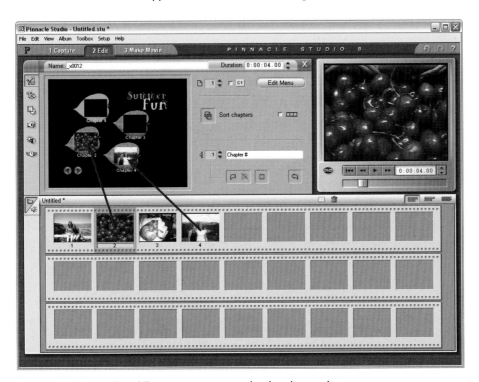

Figure 10-5 Manually adding a scene as a navigational menu item.

❷ Switch to Timeline view, so you can view the chapter markers and keep better track of your chapters and sequences.

❸ A chapter marker appears over each scene (Figure 10-6). Click a chapter marker, and that scene appears in the Menu Editor.

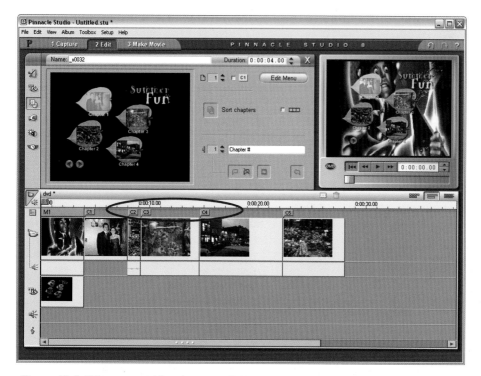

Figure 10-6 When a menu has been applied, chapter markers appear over each scene in Timeline view.

❹ The left side of the screen displays a menu for renaming the Chapter titles. Click the menu thumbnail you want to rename, and in the Text field, add a new name (Figure 10-7). Press **ENTER** to finalize your name change. You can do this for each scene name.

Figure 10-7 Changing a chapter title.

 If your menu has more than one page, you can name the scenes in the other pages by clicking the **Next Page** arrow near the top of the menu.

Editing the Menu and Testing your Movie

To edit a menu, click on its thumbnail located in the **Title Track** in Timeline view, then click the **Edit Menu** button, near the top of the screen. The menu appears in the Menu Editor (Figure 10-8). Use this view to move around thumbnail positioning, choose different button and thumbnail frame appearances, and change the font used by each chapter's title text.

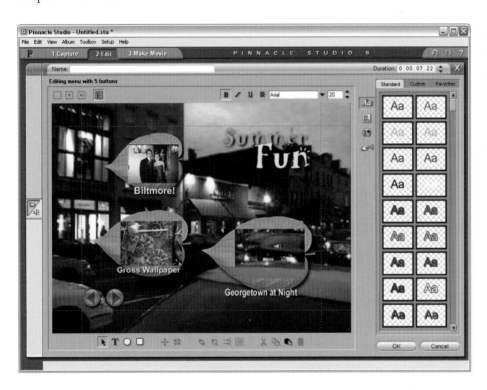

Figure 10-8 The Menu Editing window.

From the Editing screen, you can click on a button or frame to drag it elsewhere on the screen, thus making more room for video elements that should not be covered. Repositioning the menu items is helpful if the thumbnails appear over an important element in the video. After making your changes, click the **X** in the upper right of the screen, and your modified menu will appear on the Timeline or Storyboard.

10

To test the menu as it would appear and operate on a TV screen, click the DVD button at the lower left of the Player (See Figure 10-9). This button is only operational when working with disc menus. A set of VCR controls will appear. Use these to navigate to the chapters in your video, as well as "home" and "end," simulating the experience of users watching your movie using a remote control.

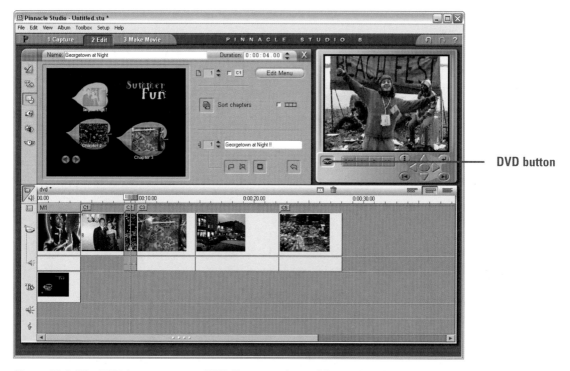

Figure 10-9 The DVD button opens a VCR-like control panel for testing the menu.

After setting up your project for disc distribution, you may want to save your work. To do so, choose **File**, then select **Save Project** or **Save Project As**.

Rendering the Movie to Disc

After creating and editing your menu, you can choose an output disc type, and select parameters for your chosen media. To render your project, and save to DVD or CD, do the following:

1 Click the **Make Movie** button, at the top of the screen.

2 Click the **Disc** button, at the bottom of the Output menu, on the left.

3 Click the **Settings** button to choose output options. The Make Disc dialog box will appear (Figure 10-10). After setting these options, Pinnacle Studio 8 will create your disc.

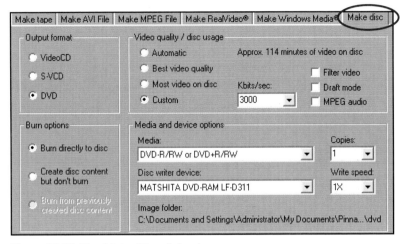

4 Use this dialog box to choose output type, for example, VCD, SVCD or DVD.

Figure 10-10 The Make Disc dialog box.

 If you do not have a recordable DVD drive, then the drop-down menus under Media and device options will be grayed out.

5 After choosing Output format, you can select quality settings from the options on the right side of the Make Disc dialog box. Note that when you select an Output type, the dialog box reports how much video can be saved to that particular disc type.

6 On the right side of the Make Disc dialog box are options for rendering smoother, less jerky video at the expense of some clarity. Choose **Filter video** and/or **Draft mode** if you are creating a Video CD that you suspect will be played back on older, low-speed CD drives.

7 The **Burn options** section, on the lower left, allows you to save your video directly to disc, create video data that can be burned to disc later, or both. Chose one of these options if you will be creating discs at a later date.

8 After choosing your target drive and inserting the proper media into your recordable drive, click **OK** and the Make Movie screen will reappear.

9 When you are ready to create your disc, click the green **Create Disc** button on the left side of the screen. Your movie will be rendered, and then saved to the specified media. A blue progress bar appears under the Player. When rendering is finished, you can remove the disc and play it back on any device suitable for your media.

Creating a Video Disc with Ulead VideoStudio 6

When creating a Video disc in VideoStudio 6, you create the menu first then choose output specifications for you disc media. So, whether you are making a DVD, SVCD or VCD in VideoStudio, your steps will be identical until the final screen, where those output settings are selected. As mentioned previously, for DVD, you'd create an MPEG-2 movie. For VCD, you'd create an MPEG-1.

Choosing and Converting the Project

To begin, choose a project you want converted to a portable disc, DVD, SVCD, or VCD, and load it into VideoStudio 6. If you are creating a DVD or SVCD, note that the final output will look just about as good as your original MiniDV tape footage. You will not have to make quality compromises, as you would with many other output formats. After choosing a project, perform the following steps:

❶ After loading the movie, click the **Finish** button, at the top of the screen.

❷ Click the button for the disc type to create, either a DVD, SVCD or VCD. The Create Video browse menu will appear (Figure 10-11).

❸ Name your movie, and note the save location, should you have to manually browse to this video. You will save the current movie as a new file.

❹ Click **OK**. The movie will be rendered as an SVCD-compatible video file. The blue progress bar at the bottom of the Preview screen will display your progress.

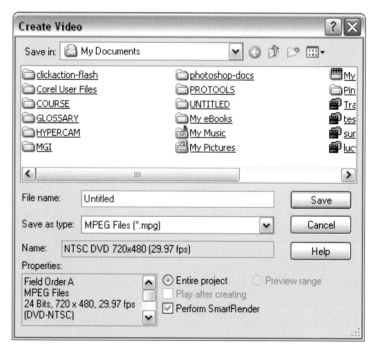

Figure 10-11 Saving an MPEG movie with NTSC SVCD compression.

Adding Scenes and Formatting Your Movie

As soon as the movie is finished rendering, the Ulead DVD Plug-in screen appears. This opening screen displays three movie creation options: DVD, SVCD and VCD (Figure 10-12). Whatever option you choose, will be pre-selected on this screen. Perform the following steps:

❶ The DVD Plug-in screen provides valuable information about file size, frame size, audio quality, and video duration. Is the length correct? Is the audio quality what you had in mind? If you are not happy with these choices, you can go back and choose Custom, rather than SVCD, and create an SVCD movie with the options you had in mind. If you are happy with the preset choices, then click **Next**.

❷ Place a CD in your recorder.

❸ After clicking Next, the Add Scene dialog box appears (Figure 10-13). Add thumbnails that represent starting-point movie Scenes.

❹ On the right is a thumbnail list displaying the opening screens of the scenes you will select for the DVD project. Select your chapter beginning-points, allowing viewers to click to any place you designate as a starting point of a chapter in your movie.

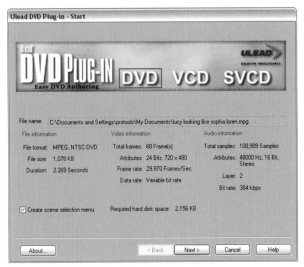

Figure 10-12 The Ulead DVD Plug-in Start screen.

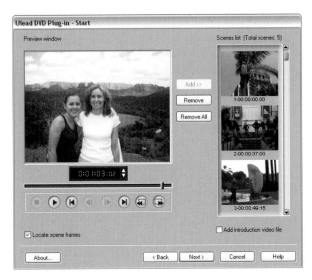

Figure 10-13 The Add Scene dialog box.

10

 Later, when the DVD is viewed in the user's DVD player, the same opening screen thumbnail view appears. However, they will see an attractive interface and not a list. The user will click any thumbnail, which will transport the movie to that particular scene, and start playback.

The Add Scene dialog box will now load the beginning of the movie. This is scene one, appearing alone at the upper right of the screen. To add other scenes, do the following:

1 Use the **Next Scene** arrow at the lower right of the control panel below the movie preview, or use the location indicator to move forward and locate the beginning of a scene you want to add.

2 When the Preview Window displays the frames that you want at the beginning of your new scene, click the **Add** button. That scene is added to the thumbnail list on the right.

When the user views the DVD opening screen, they will click a scene via remote control. The movie will begin playback from that point.

3 Continue adding as many scenes as you like. The DVD Plug-in will continue to add thumbnails for Scenes. Using the remote control, the user can select double, or even triple-digit numbers to choose Scenes that are far into your movie.

4 When you are finished adding scenes, click **Next**. The Select Menu Template dialog box will appear, which just so happens to be the subject of the next section!

Selecting a Backdrop and Adding Text Labels

In the Select Menu Template dialog box, you can choose a backdrop for the movie scene thumbnails. You can use one of VideoStudio's presets, or an image of your own (Figure 10-14). You can also add a line or two of text describing each scene, which will appear below the thumbnails.

The left side of the screen displays your thumbnails as they would appear in a template. This backdrop is what the DVD viewer will see when the DVD (or CD) is inserted into the drive. Note that if you have added more than six scenes, the plug-in adds additional pages to accommodate all your scenes. If you have more than six scenes, the "forward" arrow near the bottom of the preview moves you through those pages. The right side of the screen

Figure 10-14 The Select Menu Template dialog box.

allows you to choose templates from a dropdown menu. The dropdown menu has six menu types, each type offering several menus to choose from.

You can add a text label to each thumbnail, indicating to the viewer the content each Scene. To do so, click the text with the cursor. The Input Scene Text dialog box appears. Type any text you like. Since pressing Enter will close the dialog box, you can create a hard line break by pressing **CTRL + ENTER.** Click **OK** to close the dialog box and apply your text. Repeat these steps for each scene where you want to add text.

You can also choose a background image as a backdrop for your menu. To do so, click the **Background** button. A Browse menu appears, allowing you to search your hard drive for an image. The image you choose will appear behind the menu chapter thumbnails.

Testing the Menu's Operation

After making changes to the menu, click Next, and the Playback Simulation dialog box appears (Figure 10- 15). This simulates the navigation experience of your audience as they use their remote control or mouse to move through the chapters of your video.

The left screen displays the DVD scene selection screen as the viewer would see it. The right screen shows a typical DVD remote control. Click the digits and buttons to simulate the user's experience of navigating your movie.

Figure 10-15 The Playback Simulation dialog box.

 If you want to make adjustments to your Scenes, labels or sequence, use the Back arrows to return to any of the previous screens.

When you are happy with the layout, click **Next** to confirm your CD-ROM or DVD burning options. The Determine Output Options Settings dialog box appears.

10

Burning the Disc

Use the Determine Output Options Settings dialog box to specify where the working files should be created, and confirm drive choice for your recordable device (Figure 10-16).

To choose the type of SVCD format for your disc, click the **Advanced SVCD** button. You can choose to create an SVCD that will accommodate the newest, most up-to-date hardware, or create a disc for "legacy" (older) systems, or allow Ulead to strike the balance and create both.

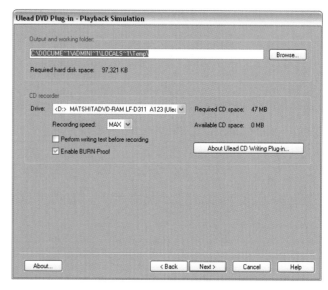

Figure 10-16 The Determine Output Options Settings dialog box.

 This screen offers different options, depending on whether you are creating a VCD, SVCD, or DVD. One main difference, of course, is in the length of your project, since a DVD has more than six times the capacity of a CD.

When you are ready to begin creating the CD, click **Next**. The Finish screen will appear, displaying a pair of progress bars. The top progress bar indicates remaining time until all SVC-related tasks are completed. The bottom bar indicates CD burning progress.

If you think you will be creating more than one disc, click the **Create Disc Image File** check box. Doing so means that next time you want to burn a copy of this same project, you can browse to this Disk Image. The program will then only have to copy the Disc Image to the disc, rather than again create a disc file, then copy it over.

 If you receive a "buffer underrun" warning, select the **Enable BURN-Proof** option the next time you try. Not all CD burners have this technology, and this option will be present in a selection even if your CD burner does not have it. Check your CD manufacturer's documentation for more information.

After recording is completed, you can remove the CD from the CD recorder. It is ready for viewing on a DVD player.

Go online to **www.LearnwithGateway.com** and log on to select:

✦ *Movies: Saving to Disc*

✦ *Internet Links and Resources*

✦ *FAQs*

Gateway offers a hands-on training course that covers many of the topics in this chapter. Additional fees may apply. Call **888-852-4821** for enrollment information. If applicable, please have your customer ID and order number ready when you call.

10

Troubleshooting Issues

You may occasionally encounter difficulties with your digital video equipment and software. The source of these problems could be as simple as a cable disconnection or camcorder adjustment, or could require detailed intervention from technical support. This chapter provides tips and advice for solving common issues with video camcorders and software, including shooting tips, video capture concerns, editing, and output issues. These tips and suggestions are general recommendations, and will not apply to every specific indication of trouble. They will, at the very least, point you in the right direction towards a solution.

We'll start out by discussing camcorder-related concerns, such as the camcorder not being detected by the computer, problems with the MiniDV cassettes, and batteries.

Camcorder Troubles

This section deals with camcorder issues, such as problems getting good footage, or getting the computer to detect your camcorder when capturing video. While it's true that shooting and editing video involves lots of buttons, knobs and cables, the solution to most problems you'll encounter are usually very simple. For getting good footage, you'll want to spend time learning your camcorder's autoexposure menu, shooting options, and get to know how to finger that zoom lens with ease. You'll then be prepared for the host of filming conditions you're likely to encounter with your camcorder. Regarding camcorder detection by your computer, often, its just a matter of resetting something, either restarting the program, or disconnecting, then connecting the FireWire cable. More on that in a moment.

Detecting Your Camcorder

Most of the time, detection of you camcorder by your video capture program happens without problems. Your camcorder includes a special chip that identifies the camcorder type, model, and features. When your video capture program attempts to detect your camcorder, this chip usually tells it all it needs to know. The computer and FireWire cable act as a gateway, allowing this detection to happen.

If your video capture program does not detect your camcorder, the problem could be because you have too many other processes running at

the same time on your computer, or your FireWire cables have become disconnected. In order to fix these common problems, do the following:

1. Close your video capture program.
2. Make sure your camcorder is powered on, and is set to the VCR/Play (not Record) position.
3. Close all other open programs on your computer.
4. Unplug the FireWire cable from the camcorder and plug it back in again.
5. Re-start your video capture program.

 If plugging in the camcorder causes another program to automatically start, close that program.

If your video capture program still does not detect your camcorder, you should:

1. Shut down your computer.
2. Disconnect and reconnect your FireWire cable, ensuring that the connector is firmly inserted.
3. Restart your computer.

If none of the above work, you may need to obtain and install the newest set of drivers for your FireWire card. This may especially apply if you've upgraded from Windows 98 to Windows XP. A new driver may be needed.

Fixing MiniDV Cassette Problems

Most of the time, MiniDV cassettes work flawlessly. However, you may encounter a problem with your camcorder rejecting the cassette. Whenever you insert a cassette, after the door closes, it opens again, and you see a message saying that the cassette cannot be used.

In order to function, your camcorder and cassette must be in perfect alignment, and the cassette must roll smoothly at an exact speed. This requires optimum temperature and humidity conditions. If the camcorder detects moisture or temperature out of range, it won't let you play or record your cassette. The solution, most often, is just to wait. The humidity will dry, and the temperature should even out soon. While waiting, keep the cassette area open (don't close the door after removing the cassette), since this will speed de-humidification.

Don't wait too long, however. If, after a day or so of drying out, the cassette won't play, you may have a faulty tape. Try a different tape at that point to determine that it is the tape and not a much bigger problem with the camcorder itself.

Reducing Battery Problems

Keeping your camera on and running is a critical part of any video shoot. When you get halfway through filming, the last thing you want to see is that your camcorder's battery is running low.

There are two main battery types. First is Lithium-ion, which recharge relatively quickly and can hold a charge fairly long. There's also Nickel-Cadmium, or Ni-Cad batteries. These are an older technology, and do not hold a charge as long as Lithium-ion. With Ni-Cad, you are more likely to have to totally deplete the battery power before being able to fully recharge. This requirement is not as critical in Lithium-ion batteries. In any event, follow manufacturer's recommendations for charging, recharging, and storing your battery.

In practice, the number one step you can take to increase battery life is to use the viewfinder rather than the LCD. Also, remember to turn off the camcorder between takes. If you find, however, that your sessions are more than a couple hours of straight filming, you may need to purchase a second battery, perhaps one with a longer charge. For example, batteries for the Canon ZR-45 camcorder come in three sizes, 2.75 hour, six hour, and nine hour. You may also want to consider the purchase of a car charger.

Video Shoot Issues

Some problems are solved just by improving video shooting technique. It's helpful to know a little about your camcorder's focus, lighting, and aperture controls, and how to optimize your shooting environment to obtain the best footage possible.

Keeping Objects in Focus

Sometimes when you are focusing on a faraway object, it keeps moving in and out of focus. You may be able to focus on close objects just fine, but objects farther away persist in coming in a bit too soft.

Figure 11-1 Because a zoom was used, only the foreground of this image is in focus.

When you film faraway objects, the field of focus is narrow. The distance between the lens and the shutter has to be very precise. That means that the "sweet point" where your lens can focus perfectly on that faraway object is much narrower than, say, focusing on something 15 feet away. The results are that, with only one tiny movement of the lens and boom, you're out of focus (Figure 11-1). The solution is to physically move closer to the subject, or use a tripod, which will make it easier for you to manipulate focus with more precision.

Stopping Shaky Video

One of the most common problems with shooting good video is keeping the camera still. For example, your video looks a bit too shaky, or it always looks as if what you are filming is bobbing up and down. This is especially true when you film distant objects. To keep your video from moving and shaking too much, try using image stabilization. This feature reduces the effects of an unsteady hand when filming.

Avoid using zoom—particularly a digital zoom if your camera has one. Zooming always tends to exaggerate hand motion. You can also move closer to the object. You'll find that the closer you are to what you're filming, the more forgiving the camcorder is regarding inadvertent hand movements. Finally, if the problem persists, try using a tripod.

Dealing with Low Light Problems

You may find that when you film in the evening, the camcorder automatically applies the "Evening" exposure settings, which can change the color tone of your video changes. If you've like to avoid this, you can manually adjust exposure and aperture settings.

Similarly, when filming at night, the automatic "Night Filming" setting leaves the lens open for a long time, so even slight movements can blur across several frames of video. This can leave "trails" across the screen when subjects move. To avoid this, try manually adjust exposure and aperture settings, minimizing movement, or just moving the shoot to a location where you can apply more lighting.

When shooting indoors in mid-level lighting, you may find your video is dark and shadowy, and the colors dull. To fix this, try adding more lighting. Digital video responds dramatically to increases and decreases in available light. Also, adjust the "white balance"—as specified in your camcorder's user manual[em]specifically for that environment. Adjusting "white balance" is usually a very simple process, and will reset your camcorder's color range to make better use of the colors in that specific room.

Video Capture and Editing Concerns

This section helps solve problems with video capture and editing. You'll find solutions to some common problems that occur when moving video from camcorder to computer, and learn how to ensure a smooth editing experience.

The solutions to these problems are often software-specific. When solving these types of problems, especially the persistent ones, you are encouraged to keep track of the steps you have tried, and if need be, write down what happens, for example on-screen warnings, error messages, and so forth. Once a problem is accurately described, it is often very easy to figure out what to do about it.

Enabling Onscreen Controls

Your video capture or editing program has onscreen controls for controlling your camcorder. If the program appears to recognize your camcorder, but these buttons seem to have no effect, this could be due to a variety of problems:

- ✦ Unplug the camcorder from the FireWire cable, and plug it in again.

- ✦ Close the program and open it again.

- ✦ Manually select your camcorder from the list of camcorders provided by the video capture program's setup menu. If your camcorder make and model is not shown, choose the model closest to yours.

- ✦ Visit the video capture program's Web site for a product update. These may include an expanded list of supported camcorders, and improved auto-start support.

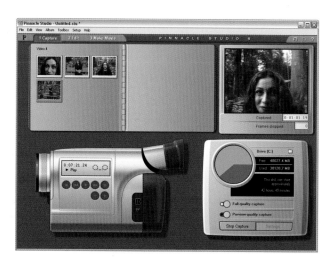

Allocating System Resources

If you cannot capture more than a couple minutes of video, you software or computer may be having problems with allocating the proper resources. If recording stops, or begins to move very slowly, or you get lots of dropped frames, this is most likely the problem.

Just like with other CPU-intensive activities such as printing huge images or editing sound, video editing software must work with your computer to allocate enough memory and CPU-time to get the job done. Yes, your computer has lots of memory and lots of hard drive space, but you'd be amazed how quickly it all goes. If your computer doesn't have enough resources to allocate, you'll have to help it out. That means closing programs that don't need to be open, cleaning up your hard drive, and just get your computer up to speed to complete the task at hand. Here are some tips:

✦ Close all other programs except your video capture software. You may even need to close your anti-virus program and Office Toolbar while capturing video. Look on your taskbar for other software that sits in the background taking up memory. These programs appear as an icon in your toolbar notification area on the right bottom of the screen.

✦ You may have run out of hard drive space during the video capture process. To see if this is the case, open **My Computer**, and right-click on the drive that contains your video files. Choose **Properties** and click the **General** tab. If you see that you have very little or no hard drive space, click the **Disk Cleanup** button (on the same tab) for more options.

✦ You may have enough hard drive space, but it may be too fragmented to use. This is sometimes the case, since video files are so large, and contiguous (all-in-one-row) computer space is required to capture such large files. To defragment your hard drive, choose **start**, then **All Programs**, then select **Accessories**, then **System Tools**, then click **Disk Defragmenter**.

✦ Video capture is often hindered by too little RAM. To find out how much physical RAM you have, right-click on the **My Computer** icon and choose **Properties**. Video typically requires at least 128 MB of RAM.

✦ Consider recording two or thee minutes of video at a time, then joining the segments in the project-editing phase.

✦ Your chosen video capture quality may be above the capabilities of your computer. Try capturing video at a different setting, such as MPEG-2. Don't try to capture at DV quality.

11

Another problem you may experience is your video capture program suddenly stopping during capture. If you never seem to be able to get beyond capturing a small amount of footage, the culprit could be the amount of hard drive space you have left. It could also be some problem with a portion of the tape itself. The following are the most common solutions to sudden stops during capturing:

✦ Make sure your camcorder is running from AC power, not battery. It's quite possible that the battery could have run out of power during video capture.

✦ Ensure you have adequate hard drive space.

✦ It could be that recording has not stopped and you are capturing blank frames. This could be the case if there was a segment of unrecorded space in between your movie clips. This could account for the "dead" space with no video content. Upon hitting this dead space in your video, you may think that you have no more tape left, but in reality, you just have to play on a bit farther.

✦ Try recording again. If the capture program always stops recording at the same place on the tape, try rewinding the tape all the way to the beginning. Then play towards that segment (without recording), then record again.

Clearing Up File Problems

Sometimes it's the little things that can cause you the biggest headache. For example, you would think that adding a standalone video file that you like to a new project would be a no-brainer. Unfortunately, sometimes it just doesn't work. You try to drag and drop it into the library, or open it through the library, and it just won't appear as "added."

Most often, video clips you add have to be the same format and compression type as the project you are adding them to. To check if formatting is different, right-click on the video and choose **Properties**. You may have to create a new project including only this video clip, and save it using the formatting of the target project.

Similarly, sometimes when you add an image to your video project, the image might appear on the screen much larger than the video. The video is one size, but the image is much larger than everything else (Figure 11-2).

When you add an image to a project, you typically have the option of resizing it to fit the presentation. Either choose that option or resize the image by hand in another paint program, such as Microsoft Paint. You can then resize the image to something closer to the dimensions of your video project.

Figure 11-2 The image (on the left) is of larger dimensions than the video clip next to it.

Another common problem occurs when you are trying to edit video, and the program reports that the link to your video clips and audio files has been lost. Being an intelligent program, it may also ask you if you want it to "relink" them for you.

If this happens, you may have moved your files and forgotten where you put them. Most video editing programs let you add clips from anywhere on your computer, or even from a local network source, such as a computer down the hall. Trouble is, if that video gets moved, or the connection to the networked computer is lost, the program can't use that video. Rather than just reporting an error, a good video editing program will ask you to browse and "point" to the video clip's new location.

Problems with Video Formatting and Settings

Making even small adjustments to the video capture settings in your program can sometimes create big problems. For example, your video editing program may show that you can capture hours and hours of video, but simply changing the output format shortens the available space by several hours or more.

Many factors affect video capture disk space requirements—for example, frame rate, quality, and video type. Whenever you adjust a factor, the capture software updates its disk space usage prediction accordingly. You'll find that when you choose an option with high frames per second, such as DV format, the amount of video you can capture will decrease substantially. Of course, the resulting movie will be much larger as well (Figure 11-3).

11

Changing Video Modes

If you are trying to edit video, and receive an error message that says you need to change video modes or use a higher screen resolution, you computer may not be set to 24-bit color mode.

Video editing requires at least a 24-bit color display. Make sure your computer is set to at least 24-bit color mode, with a screen resolution of at least 800x600 (preferably higher). To adjust this setting, right-click on the **Desktop**, choose **Properties**, and click the **Settings** tab. Increase the Screen Resolution and Color Quality as needed.

Preventing Too Many Dropped Frames

One of the most frustrating problems you can encounter is too many dropped frames during video capture.

Figure 11-3 The amount of video your hard drive can capture changes with video type.

If you notice—during the capturing uptake, for example—that the Dropped Frames number is increasing rapidly, your capture settings may need adjusting.

Your computer must work overtime to capture the highest quality video frames. First, check to see if you are capturing video at DV quality. If so, try capturing video at a different setting, such as MPEG-2.

 If you capture video as MPEG-2, sometimes it takes a while to save the video as MPEG-2. Because of the advanced compression scheme which MPEG-2 uses, this is not unusual. Go make some coffee or start a load of laundry; it could take twenty minutes or more to complete this process.

Be careful which settings you choose, however, and don't be afraid to experiment a little. For example, if you have no dropped frames and you are able to capture the entire video session in one take, but your video playback is not much bigger than a postage stamp, you've captured video at an MPEG-1quality setting. This option captures small video frames for playback on CD-ROM or other low-capacity output media. Try capturing at a higher setting.

Audio Problems

Some audio problems can be a bit tricky; others are very simple, but happen time and time again. Remembering to do the following can solve the most common problems with audio:

✦ Check your speaker connections.

✦ If your speakers have a separate audio volume knob, make sure it's turned up.

✦ Ensure that your computer's audio volume is up.

✦ When choosing video capture settings, make sure you include audio as well. The audio you hear while capturing video may be coming from the camcorder speaker itself.

 To adjust your computer's audio volume, select Control Panel from the start menu, then click Sounds and Audio Devices. Move the Device volume slider bar to the right. Also, make sure the Mute check box is not selected.

Remember that capturing audio is part of the video formatting process. When you choose a video setting, you're choosing audio as well. Most often, the default capture settings will include the best audio settings to match, but if these get changed, you may have to open a dialog box that controls audio setup for video capture (Figure 11-4), and make adjustments there.

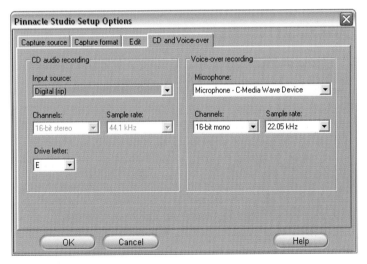

Figure 11-4 Altering audio settings for captured video.

Getting Rid of Audio Distortion

Audio distortion can sometimes occur and can be hard to track down. If you play back your video capture, and the audio sounds distorted, a number of possible causes exist:

✦ Your speakers may not be up to the task of playing back digital audio except at very soft volume. Try reducing the volume on the speakers.

11

- You may have turned your computer's audio output volume up too high. Go to **start**, **Control Panel**, **Sounds**, **Speech and Audio Devices**, **Sounds and Audio Devices**, and move the Device volume slider bar to the left.

- Your source audio may be distorted to begin with. Listen to audio on the camcorder speaker with the volume on the camcorder set at half-way to see if the audio is still distorted.

Reading Music from a CD

If you want to use music of your own that you've recorded onto a music CD, but you can't seem to get your video editing program to read the files, you will need to use a third-party program.

A third-party "decoding" program can extract audio CD content into MP3 format. Then, just note where your MP3 file is saved. When you open your video editing program, go to the audio editing screen and browse to the folder that has your MP3 files. You can now easily add them to your video.

Problems with Viewing and Output

Some problems only pertain to how your video looks onscreen, how your video clip plays back outside of an editor, and how to gain access to your entire captured footage. Other issues can arise when you finalize your movie output into a format to suit your intended audience.

Finding Your Captured Video File

In reality, once you've captured video, it exists on your computer as one big, captured video file. However, a good video capture program is going to show you what it believes are natural breaks in your footage, based on what's happening in your video. Displaying the video as individual clips helps you to organize your video project based on content.

If you would like to view your entire video onscreen just as you captured it—not all cut up into clips—you'll need to locate the captured video file itself. Usually you'll find it the My Videos folder. So where is this folder? If you created a special name for yourself when you set up Windows XP, you need to know that name. If so, the folder is here:

C:\Documents and Settings\the-name-you-picked\My Documents\My Videos

For example, if your Windows XP account name is Tom, the path would be:

C:\Documents and Settings\Tom\My Documents\My Video

It's also possible that the captured file will wind up in:

C:\Documents and Settings\the-name-you-picked\My Documents

For example, if your Windows XP account name is Tom, the path would be:

C:\Documents and Settings\Tom\My Documents

Eliminating the "Comb Effect"

An interesting problem that may occur during playback on a television set or monitor can be appropriately dubbed the "Comb Effect." When objects move, it will look as if someone is dragging a comb through the picture.

You are seeing the effects of "field" video formatting. In order to work on television, your video must be filmed with two interlacing fields per frame. If you've intentionally filmed with two interlacing fields per frame, you can ignore the onscreen interlacing effect you are seeing. It won't look that way on the TV. However, for movies that will remain in the digital domain, shoot your footage again using a frame rather than field setting. If your video includes fast-moving subjects, choose a Progressive Scan or a "Sports" (Figure 11-5) setting.

Figure 11-5 Select a Sports setting for filming fast-moving action

Sharing Your Videos Online

If you use your video editing program's "E-mail Video" option, but it says you don't have an e-mail program installed, you need to configure your e-mail program to open whenever you access an e-mail feature in other applications. Most commercial e-mail clients give you this option. For example, in Outlook Express, do the following:

❶ Start Outlook Express.
❷ Select **Tools** from the Menu bar, then choose **Options**, and click on the **General** tab.

11

3 Under Default Messaging Programs, click the **Make Default** button to the right of the text, "This application is the default Mail handler."

4 Click **OK**.

 If you use the America Online service for sending e-mail, you'll need to attach your video manually to your e-mail.

Whether you send your video via e-mail or post it on a Web page, your 56 Kbps-challenged friends and family members may not like the time it takes to download and watch your creation. Even after you've made your video small and used Web-friendly settings, it will typically still be much larger than still images and even audio files.

For 56 Kbps modems, you may have to make your video even smaller. Here's how to optimize for the Web:

+ Choose six frames per second, rather than 12 or 15, and decrease the number of key frames.

+ Delete all footage that does not totally enhance your presentation.

+ Consider getting rid of any geometric transitions and fades.

+ Try setting the audio for 22,000 kHz rather than 44.1.

+ Consider using a streaming video technology, as discussed in Chapter 9, and create a link for visitors to download the necessary player.

To Keep on Learning . . .

 Go to the CD-ROM and select the segment:
✦ *Troubleshooting* to review more on troubleshooting.

 Go online to **www.LearnwithGateway.com** and log on to select:
✦ *Internet links and resources*
✦ *FAQs*

 Gateway offers a hands-on training course that covers many of the topics in this chapter. Additional fees may apply. Call **888-852-4821** for enrollment information. If applicable, please have your customer ID and order number ready when you call.

11

Glossary

A/B-roll editing Editing from two video sources (such as two video tracks) for output to a destination track in order to achieve a variety of transition effects.

Amplitude The maximum distance a wave travels above and below a point designated as "zero." The amount of oscillation between two points on a wave.

Analog A continuously variable electrical signal.

Aperture The opening of a lens which exposes each frame of film or video. It's also the light-gathering area of a lens.

Artifact Distortion in digital video, caused by signal overloading or excessive or improper compression .

Aspect ratio The ratio of width to height in image dimension, specific for various video types (The ratio of horizontal to vertical in image size). The frame aspect ratio of NTSC video is 4:3. Standard motion-picture frame sizes are 16:9.

AVI (Audio-Video Interleaved) The file format used by Windows for video. AVI is the video format created by Microsoft for digitizing and compressing video and audio signals. AVI movies employ a number of codecs and compression schemes that support the Windows operation system.

Bandwidth Measured in MHz, the range of signal frequencies that a video recording or playback device can encode or decode. Also, the amount of information that can be carried by a signal path, such as downloaded content via telephone lines over the Internet.

Bit The smallest unit of data in a computer system.

Blue Book The Sony & Phillips specification for Enhanced Music CDs for audio and video data.

Broadcast quality A standard for video signals set by the National Television Standards Committee, ensuring uniformity in video signal broadcast quality.

Byte A unit of data that is 8 bits long, the most fundamental unit of computer data. A byte usually represents a single text character or the red, green, or blue component of an image pixel.

CCD (Charged Coupled Device) A light-sensitive microprocessor that converts an image to electrical voltage which is used in scanners and video cameras.

Camcorder A device combining camera, tape or DVD recorder and playback monitoring screen into one unit.

Chapter The subdivision of video scenes in a DVD, SVCD or VCD movie.

Cinepak A popular QuickTime Codec for compression of video onto CD-ROM.

Clip A digitized or captured portion of video, sometimes further defined by setting In and Out points.

Codec Contraction for Compression/Decompression. Represents the combining of COmpression and DECcompression technologies, allowing compressed video to be played back in real time, rather than waiting for an entire video to decompress before playback can begin.

Component video A video recording method that records and transfers video brightness (luminance) and color signals along separate paths. Component video maintains the original video elements separately, rather than encoding them into a single signal. This produces high-quality video signal compatible with HDTV. Contrast to composite video.

Composite video A video signal in which the luminance and color (RGB) elements have been combined, which is a requirement for NTSC and PAL broadcast standards.

Compression The conversion of media data to a more compact form for efficient storage or transmission, requiring less storage space than the original data.

Data rate The amount of data moved through a pathway over a specified period of time, used to describe the efficiency of data transmission in a given situation using a given technology.

Deinterlace To properly align two frame fields in a single frame of video.

Depth of field When focusing a camera, the depth of the area in which all objects are in focus, dependent on the distance of the camera to the subject, focal length of the lens, and f-stop.

Digital The storage of information about analog events in an efficient, non-destructive binary form.

Digital zoom Magnifying an image by electronically enlarging selected pixels, rather than changing lens focal point and length. Digital zoom introduces distortion into an image, or video, and should be used with caution.

Disc at once The ability of a CD recorder to record a disc in one continuous operation, which helps prevent playback problems on some CD playback devices.

Dot pitch On a color monitor, the distance in millimeters between a dot of a specific RGB color and the closest dot of the same color.

Dropped frames Frames lost during the process of digitizing or capturing video, usually caused by a hard drive incapable of maintaining the transfer rate required by the transfer devices, such as a camcorder.

DV (Digital Video) A video signal made of binary information, it can also denote the compression used by digital video systems. It can also refer to the type of tape cartridge used in DV camcorders.

DVD Abbreviation for digital versatile disc, a storage medium that can contain seven times as much data as a compact disc.

DVD-R A recordable write-once DVD, with a capacity of 4.7GB per side.

DVD-RAM/DVD-RW A re-writable DVD, with capacities of 4.7 GB (second generation) per side.

Field In television and broadcast video, one complete vertical scan of a picture or one half of a television or video frame. A television frame comprises two fields: The lines of field 1 is vertically interlaced with the lines of field 2, to produce a specific number of lines of resolution.

Fade One video clip fades from view as another fades into view. Fades are of a specified duration. For example, the time where the first clip begins to fade down and the second clip has faded up might be for a three-second duration.

FireWire Data transfer technology that facilities high-speed transfer of large data amounts, e.g. video. FireWire data transfer requires devices with FireWire connections, a FireWire cable, and a computer with a FireWire card.

Frame A complete television or video picture made up of two fields. Progressive scan or "sports" mode video shoots one full picture of video per frame.

Frame rate The number of frames per second displayed during playback. Frequency in which video frames are displayed, described in frames per second (fps). Higher frame rates provide higher quality video.

Generation loss The reduction in image and sound quality due to making copies of copies of analog media. Generation loss does not occur in digital reproduction unless lossy compression is employed.

HDTV (High Definition Television) The latest improvement to standard broadcast television, HDTV provides 1125 lines, 2:1 interlace, 60 Hz field (30 fps), a 16:9 aspect ratio and 30 MHz RGB and luminance bandwidth. Uses MPEG-2 quality video.

Hue The differentiation between RGB colors. In video editing, the adjusting of video color along the RGB color wheel, usually by use of a slider that moves the entire spectrum of colors used in the video to a new location along the RGB color wheel.

Interlaced Video produced by capturing every other line of an image, or every other frame of the video. Video frames are played back quickly enough to produce the illusion of a complete image per frame.

KB (Kilobyte) In digital video, used when calculating storage or transmission requirements. 1 KB = 1024 bytes.

Kbps (Kilobits per second) In digital video, used when calculating data transmission speed. 1 Kbps = 1024 bits per second, or 128 bytes per second.

I-frame In compression schemes such as MPEG, the I-frame is the reference video frame that contains non-compressed data, and is used to determine the color data that neighboring frames can compress and still maintain quality video. I-frames are used to reconstruct neighboring video frames and are not reconstructed from another frame.

LCD (Liquid Crystal Display) A screen on an electronic device such as a camcorder that uses liquid crystal technology, which facilitates clear, full-color, high-definition images. Used for previewing and monitoring video filming.

Lossless Compression A data compression process that allows for recovery of data exactly as it was encoded.

Lossy Compression A data compression process which results in some data loss.

Mbps (Megabits per second) Stands for one million bits per second, or 125,000 bytes per second. Used to measure data transfer speed.

MP3 A level of MPEG audio encoding for compressing audio on CD-ROMs and Internet downloads.

MPEG (Motion Pictures Experts Group) A working group of the International Organization for Standardization (ISO) that has defined several video and audio standards for digital technologies. MPEG also refers to an efficient and popular compression scheme developed by the same organization.

NTSC (National Television Standards Committee) An organization that standardized the color broadcasting system currently used in the United States. Also denotes the video specifications that must be adhered to for television broadcast.

PAL (Phase Alternating Line) The television standard used in most European and South American countries. Generally known as the European TV standard for television signals. Also denotes the video specification that must be adhered to when broadcasting throughout the PAL system.

Pan Filming while moving the camcorder on its horizontal axis (sweeping to the left or right). To turn the camcorder towards the left or right (not tilting) in order to include more of the view in your scene.

PCI slot Connection slot to a type of expansion bus found in most personal computers. Most video capture cards require this connection type.

Pixel Combines the words pixel and element, representing the smallest point of a single specified color on a computer monitor. One pixel represents a single byte, combining 8 bits of information to create a single color dot.

Progressive Scan The ability of the camcorder to record all lines of an image to tape for each frame of video, as opposed to recording two fields to create one frame.

QuickTime Video software from Apple Computer that can be downloaded from the Apple Web site and used for digital video playback. Considered to be one of the better multi-platform, industry-standard, multimedia software architectures, and it is very popular in the professional and semi-professional digital video community. It is also compatible with most Windows-based computers. QuickTime also provides a complete video-editing and audio media environment on a computer.

RealMedia Video and audio format designed specifically for the Web, providing media streaming and variable data rate compression options.

RGB (Red, Green, Blue) The three primary colors used to display color on a computer monitor or television screen.

Roll An effect used with text or graphics where they move vertically on the screen, like the credits that "roll" at the end of a movie. Also used in a general sense to mean filming, or recording video, i.e. to "roll tape."

Rule of thirds While previewing a scene before recording, the division of the scene into nine imaginary segments (like a tic-tac-toe board) to facilitate a natural-looking arrangement of subjects.

Sampling The recording of analog information at regular intervals and storing them digitally. The digitally encoded samples combine to provide a digital representation of the analog source.

Streaming The process of sending video over the Web or other networks to allow playback on the desktop as the video is received rather than requiring the entire file to be downloaded prior to playback.

Storyboard In video editing programs, the layout of video clips as thumbnails, facilitating easy re-sequencing of the clips, by repositioning the thumbnails.

Sustained Transfer Rate The rate that a hard drive can transfer data continuously. For digital video transmission from a camcorder, the sustained transfer rate has to be greater than 3.6 megabytes per second.

Timecode A frame-by-frame address code time system that assigns a number to each frame of video. The digits assigned to each video frame indicate hours, minutes, seconds and frames, usually as an eight-digit number.

Timeline In video editing programs, the layout of video clips as filmstrips, showing the length of time each video clip is on the screen. Facilitates cutting and pasting video segments by using time markers for making cuts.

Track at once A CD recording method where a track is written in one action, but then waits before the next track is written. Since the laser is actually stopped in between tracks, glitches can be caused when playing audio CDs recorded with this method.

USB (Universal Serial Bus) Technology for data transfer between electronic devices such as scanners and digital cameras and PCs. USB data transfer speeds are suitable for transferring images, photos from digital cameras, and with USB 2.0, digital video.

Video Capture To transfer video from camcorder to computer, storing the video on hard drive. After capture, the video is available for digital editing.

Viewfinder On a video camcorder, a single-eye eyepiece for previewing and monitoring video recording.

WAV file A digital file of sound data. The .WAV format is native to Windows-based PCs, and is thus, very widespread and popular.

White balance A calibration technology for achieving good color range in any given environment. Pointing the camcorder towards a white object in the target environment and pressing the White Balance button on the camcorder sets White Balance.

Wipe A transition between two video clips. The second video clip moves in by wiping the first video clip off the screen.

Zoom Magnifying an area of a video scene by centering that area into view and increasing the lens length (or digitally increasing image detail of that area). This is carried out by pressing the camcorder's Zoom button.

Index

GATEWAY, INC. END-USER LICENSE AGREEMENT

IMPORTANT - READ CAREFULLY: This End-User License Agreement (EULA) is a legal agreement between you (either an individual or an entity), the End-User, and Gateway, Inc. ("Gateway") governing your use of any non-Microsoft software you acquired from Gateway collectively, the "**SOFTWARE PRODUCT**".

The **SOFTWARE PRODUCT** includes computer software, the associated media, any printed materials, and any "online" or electronic documentation. By turning on the system, opening the shrinkwrapped packaging, copying or otherwise using the **SOFTWARE PRODUCT**, you agree to be bound by the terms of this EULA. If you do not agree to the terms of this EULA, Gateway is unwilling to license the **SOFTWARE PRODUCT** to you. In such event, you may not use or copy the **SOFTWARE PRODUCT**, and you should promptly contact Gateway for instructions on returning it.

SOFTWARE PRODUCT LICENSE

The SOFTWARE PRODUCT is protected by copyright laws and international copyright treaties, as well as other intellectual property laws and treaties. The SOFTWARE PRODUCT is licensed, not sold.

1. **GRANT OF LICENSE.** This EULA grants you the following rights:

 - **Software**. If not already pre-installed, you may install and use one copy of the SOFTWARE PRODUCT on one Gateway COMPUTER, ("COMPUTER").
 - **Storage/Network Use**. You may also store or install a copy of the computer software portion of the SOFTWARE PRODUCT on the COMPUTER to allow your other computers to use the SOFTWARE PRODUCT over an internal network, and distribute the SOFTWARE PRODUCT to your other computers over an internal network. However, you must acquire and dedicate a license for the SOFTWARE PRODUCT for each computer on which the SOFTWARE PRODUCT is used or to which it is distributed. A license for the SOFTWARE PRODUCT may not be shared or used concurrently on different computers.
 - **Back-up Copy.** If Gateway has not included a back-up copy of the SOFTWARE PRODUCT with the COMPUTER, you may make a single back-up copy of the SOFTWARE PRODUCT. You may use the back-up copy solely for archival purposes.

2. **DESCRIPTION OF OTHER RIGHTS AND LIMITATIONS.**

 - **Limitations on Reverse Engineering, Decompilation and Disassembly**. You may not reverse engineer, decompile, or disassemble the SOFTWARE PRODUCT, except and only to the extent that such activity is expressly permitted by applicable law notwithstanding this limitation.
 - **Separation of Components.** The SOFTWARE PRODUCT is licensed as a single product. Its component parts and any upgrades may not be separated for use on more than one computer.
 - **Single COMPUTER.** The SOFTWARE PRODUCT is licensed with the COMPUTER as a single integrated product. The SOFTWARE PRODUCT may only be used with the COMPUTER.
 - **Rental.** You may not rent or lease the SOFTWARE PRODUCT.
 - **Software Transfer.** You may permanently transfer all of your rights under this EULA only as part of a sale or transfer of the COMPUTER, provided you retain no copies, you transfer all of the SOFTWARE PRODUCT (including all component parts, the media and printed materials, any upgrades, this EULA, and the Certificate(s) of Authenticity), if applicable, and the recipient agrees to the terms of this EULA. If the SOFTWARE PRODUCT is an upgrade, any transfer must include all prior versions of the SOFTWARE PRODUCT.
 - **Termination**. Without prejudice to any other rights, Gateway may terminate this EULA if you fail to comply with the terms and conditions of this EULA. In such event, you must destroy all copies of the SOFTWARE PRODUCT and all of its component parts.
 - **Language Version Selection.** Gateway may have elected to provide you with a selection of language versions for one or more of the Gateway software products licensed under this EULA. If the SOFTWARE PRODUCT is included in more than one language version, you are licensed to use only one of the language versions provided. As part of the setup process for the SOFTWARE PRODUCT you will be given a one-time option to select a language version. Upon selection, the language version selected by you will be set up on the COMPUTER, and the language version(s) not selected by you will be automatically and permanently deleted from the hard disk of the COMPUTER.

3. **COPYRIGHT.** All title and copyrights in and to the SOFTWARE PRODUCT (including but not limited to any images, photographs, animations, video, audio, music, text and "applets," incorporated into the SOFTWARE PRODUCT), the accompanying printed materials, and any copies of the SOFTWARE PRODUCT, are owned by Gateway or its licensors or suppliers. You may not copy the printed materials accompanying the SOFTWARE PRODUCT. All rights not specifically granted under this EULA are reserved by Gateway and its licensors or suppliers.

4. **DUAL-MEDIA SOFTWARE.** You may receive the SOFTWARE PRODUCT in more than one medium. Regardless of the type or size of medium you receive, you may use only one medium that is appropriate for the COMPUTER. You may not use or install the other medium on another COMPUTER. You may not loan, rent, lease, or otherwise transfer the other medium to another user, except as part of the permanent transfer (as provided above) of the SOFTWARE PRODUCT.

5. **PRODUCT SUPPORT.** Refer to the particular product's documentation for product support. Should you have any questions concerning this EULA, or if you desire to contact Gateway for any other reason, please refer to the address provided in the documentation for the COMPUTER.

6. **U.S. GOVERNMENT RESTRICTED RIGHTS.** The SOFTWARE PRODUCT and any accompanying documentation are and shall be deemed to be "commercial computer software" and "commercial computer software documentation," respectively, as defined in DFAR 252.227-7013 and as described in FAR 12.212. Any use, modification, reproduction, release, performance, display or disclosure of the SOFTWARE PRODUCT and any accompanying documentation by the United States Government shall be governed solely by the terms of this Agreement and shall be prohibited except to the extent expressly permitted by the terms of this Agreement.

7. **LIMITED WARRANTY.** Gateway warrants that the media on which the SOFTWARE PRODUCT is distributed is free from defects in materials and workmanship for a period of ninety (90) days from your receipt thereof. Your exclusive remedy in the event of any breach of the foregoing warranty shall be, at Gateway's sole option, either (a) a refund of the amount you paid for the SOFTWARE PRODUCT or (b) repair or replacement of such media, provided that you return the defective media to Gateway within ninety (90) days of your receipt thereof. The foregoing warranty shall be void if any defect in the media is a result of accident, abuse or misapplication. Any replacement media will be warranted as set forth above for the remainder of the original warranty period or thirty (30) days from your receipt of such replacement media, whichever is longer. EXCEPT AS EXPRESSLY SET FORTH HEREIN, GATEWAY, ITS SUPPLIERS OR LICENSORS HEREBY DISCLAIMS ALL WARRANTIES, EXPRESS, IMPLIED AND STATUTORY, IN CONNECTION WITH THE SOFTWARE PRODUCT AND ANY ACCOMPANYING DOCUMENTATION, INCLUDING WITHOUT LIMITATION THE IMPLIED WARRANTIES OF MERCHANTABILITY, NON-INFRINGEMENT OF THIRD-PARTY RIGHTS, AND FITNESS FOR A PARTICULAR PURPOSE.

8. **LIMITATION OF LIABILITY.** IN NO EVENT WILL GATEWAY, ITS SUPPLIERS OR LICENSORS, BE LIABLE FOR ANY INDIRECT, SPECIAL, INCIDENTAL, COVER OR CONSEQUENTIAL DAMAGES ARISING OUT OF THE USE OF OR INABILITY TO USE THE SOFTWARE PRODUCT, USER DOCUMENTATION OR RELATED TECHNICAL SUPPORT, INCLUDING WITHOUT LIMITATION, DAMAGES OR COSTS RELATING TO THE LOSS OF PROFITS, BUSINESS, GOODWILL, DATA OR COMPUTER PROGRAMS, EVEN IF ADVISED OF THE POSSIBILITY OF SUCH DAMAGES. IN NO EVENT WILL GATEWAY, ITS SUPPLIERS' OR LICENSORS' LIABILITY EXCEED THE AMOUNT PAID BY YOU FOR THE SOFTWARE PRODUCT. BECAUSE SOME JURISDICTIONS DO NOT ALLOW THE EXCLUSION OR LIMITATION OF LIABILITY FOR CONSEQUENTIAL OR INCIDENTAL DAMAGES, THE ABOVE LIMITATION MAY NOT APPLY TO YOU.

9. **Miscellaneous.** This Agreement is governed by the laws of the United States and the State of South Dakota, without reference to conflicts of law principles. The application of the United Nations Convention on Contracts for the International Sale of Goods is expressly excluded. This Agreement sets forth all rights for the user of the SOFTWARE PRODUCT and is the entire agreement between the parties. This Agreement supersedes any other communications with respect to the SOFTWARE PRODUCT and any associated documentation. This Agreement may not be modified except by a written addendum issued by a duly authorized representative of Gateway. No provision hereof shall be deemed waived unless such waiver shall be in writing and signed by Gateway or a duly authorized representative of Gateway. If any provision of this Agreement is held invalid, the remainder of this Agreement shall continue in full force and effect. The parties confirm that it is their wish that this Agreement has been written in the English language only.

"Rev.3 9/24/98".

Mission

To help everybody unlock the power of their computer to achieve their fullest personal, professional and lifestyle potential.

Deep inside one of America's leading computer companies you'll find a group of very smart, very dedicated people who have nothing to do with manufacturing computers.

With fresh insights and breakthrough techniques, the Survive & Thrive team is transforming the way we acquire technology skills. And putting a human face on the digital revolution. Yours.

Online Learning Subscription

Flexible and affordable, Online Learning gives unlimited access, anytime, anywhere. With one click, you get cutting-edge curriculum, message boards & online community.

Learning for your lifestyle

- Discover Digital Music and Photography
- Brush up your software skills
- Power your productivity

Start anytime - learn anywhere

www.LearnwithGateway.com

Learning Library

Delivering the benefits of classroom learning experience without the classroom, Gateway's Learning Library provides a step-by-step approach using powerful CD-ROMs to allow you to learn at your own pace, on your own schedule.

Offers include the following Learning Libraries:

- Microsoft Office XP Professional (Also in Spanish!)
- Microsoft Works Suite

Classroom Learning

Come to a local Gateway® store classroom to enjoy the face-to-face learning experience and state-of-the-art facilities.

Courses include:

- Get Started with Your PC
- Use and Care for Your PC
- Create and Share Digital Photos
- Use Your PC to Explore Digital Music
- Communicate and Connect to the Internet
- Capture, Create and Share Digital Movies

Call, click or come in!

For More Information about this and other Gateway Solutions, Services, and Special Offers visit us online at www.gateway.com/home, phone us at 800-Gateway or come in to a store near you!

We are located in most major metropolitan cities throughout the United States!

Topics

Look for these and other exciting topics from Gateway that will allow you to further explore the digital lifestyle and take advantage of the power of your PC.

- Windows® XP
- Digital Music
- Quicken®
- Microsoft® Word
- Digital Photography
- America Online®
- Microsoft Excel
- Digital Video
- Internet
- Microsoft PowerPoint®
- Microsoft Money
- Home Networking
- PC Security